Creating Manga

FROM DESIGN TO PAGE

Ryuta Osada

THE CROWOOD PRESS

First published in 2010 by
The Crowood Press Ltd
Ramsbury, Marlborough
Wiltshire SN8 2HR

www.crowood.com

British Library Cataloguing-in-Publication Data
A catalogue record for this book is available from the British Library.

ISBN 978 1 84797 155 5

Typeset by Simon Loxley

Printed and bound in Malaysia by Konway Printhouse Sdn Bhd

Creating Manga
FROM DESIGN TO PAGE

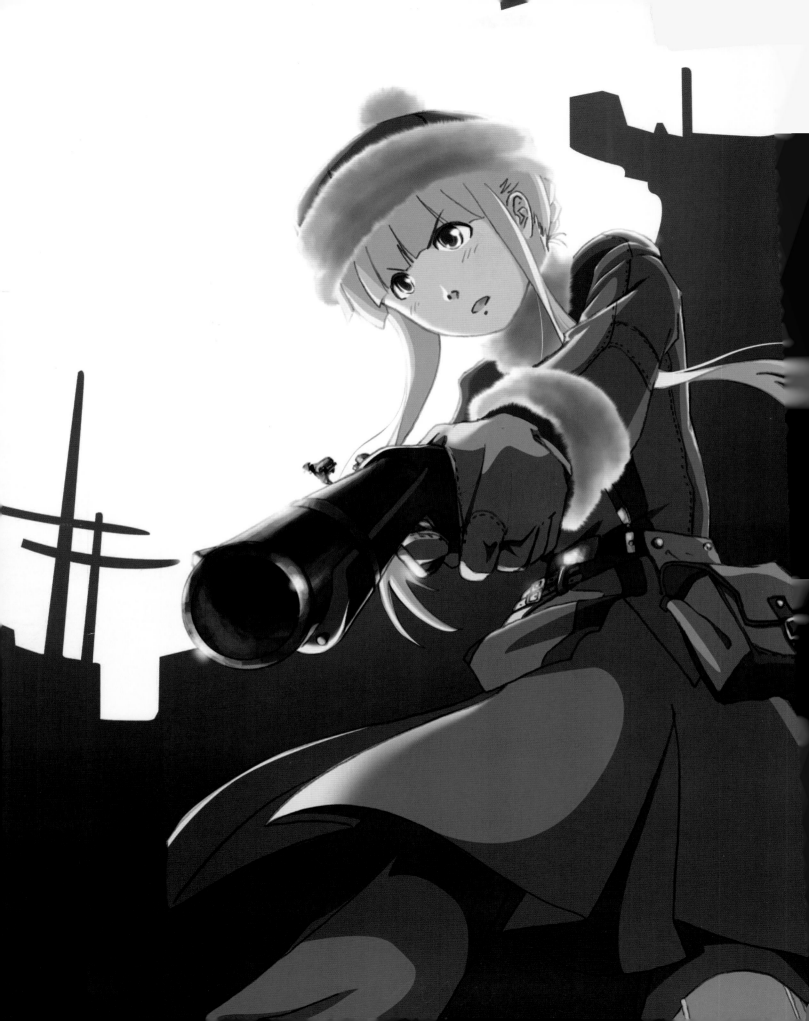

CONTENTS

INTRODUCTION

Manga originally meant 'doodles' and 'sketches'. 'Hokusai Manga' by Katsushika Hokusai (a famous Ukiyo-e artist of 'Great Waves') was a collection of sketches that contained almost no element of what we today know as Manga. It is said that comic-style drawings, with multiple illustrations separated by frames to create a sequence, were first introduced in Japan by *Japan Punch*, the Japanese edition of *Punch*. Until recently, 'Ponchi-e' (Japanese for 'Punch's illustration') was one of many words to describe Manga and cartoon. Then came moving images, notably Disney's animation, which determined the direction that Manga should take. The Japanese Manga broke away from American and British comic styles and began exploring their own style. They aimed at adapting the techniques and methods of moving images in order to capture the dynamics and drama of the scene.

Today, Manga is accepted by many people around the world, and many people try to create their own Manga. I believe that just as Manga grew out of Western-style comics in order to develop its own style, each country would develop its own styles of Manga. And you might be the one who would create a new style of Manga.

About this Book

The aim of this book is to demonstrate how a Manga is created from the very beginning, so that you can retrace the process and understand the concept behind the techniques. The Japanese word for 'learn' is 'Manabu'. This is derived from 'Maneru', to copy or mimic. As you copy the techniques and methods, you retrace the process of how and why these techniques and methods were invented and developed. This experience lets you understand the concept behind them.

Why were they invented, to what purpose? How do you apply them? What are their limitations? When and where should you use them? The Japanese consider these concepts more important than the techniques themselves. This is because they expect their students ultimately to exceed their masters, and to create and improve various techniques.

Although the techniques in this book are modified to suit my own style and workflow, understanding these concepts leads you to create your own techniques and methods to suit your own style. Be bold, experimental and critical. Be conscious of what you are doing, and think why it is successful and why it is not. Keep training yourself, and you will one day become a master of this art.

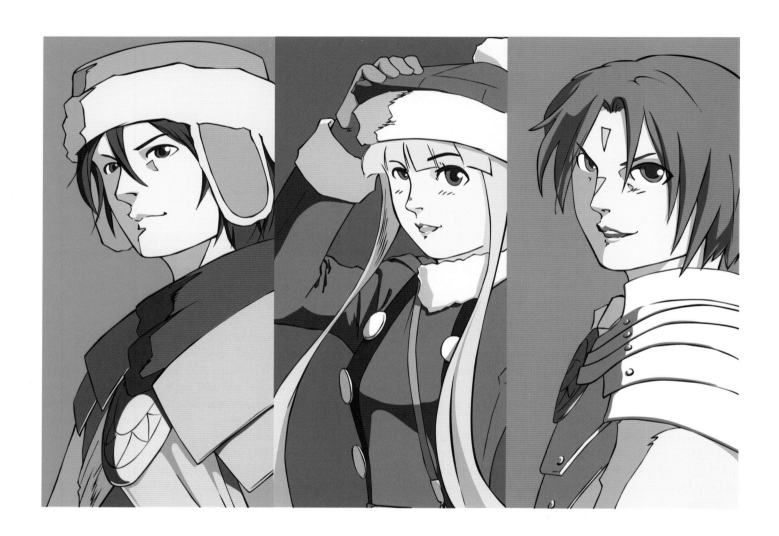

THE SAMPLE MANGA

The Sample Manga on the following pages is created to give you an insight into Manga creation. The characters and the scenes in this Sample Manga are referred to as examples in later chapters.

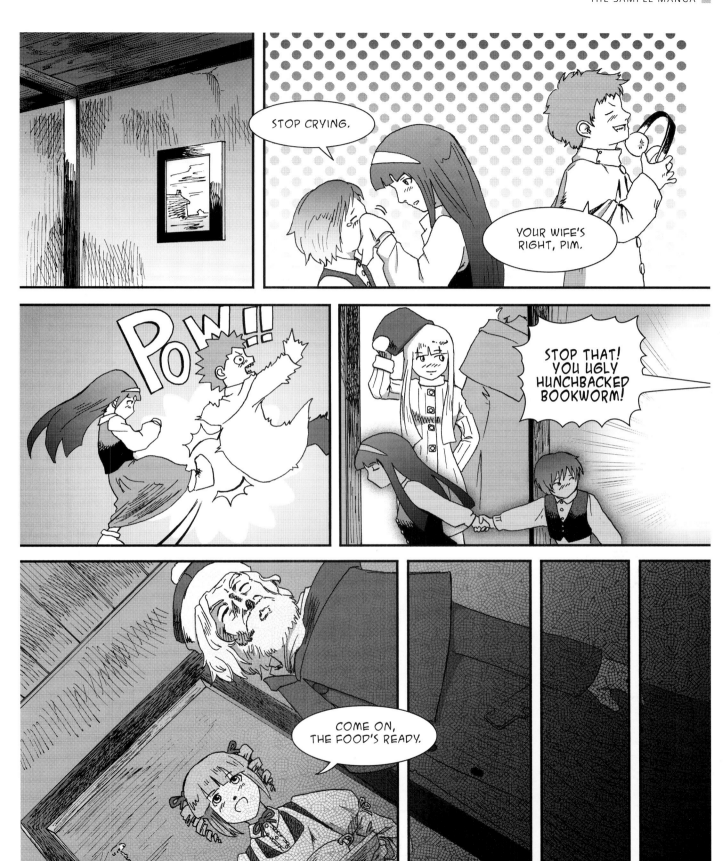

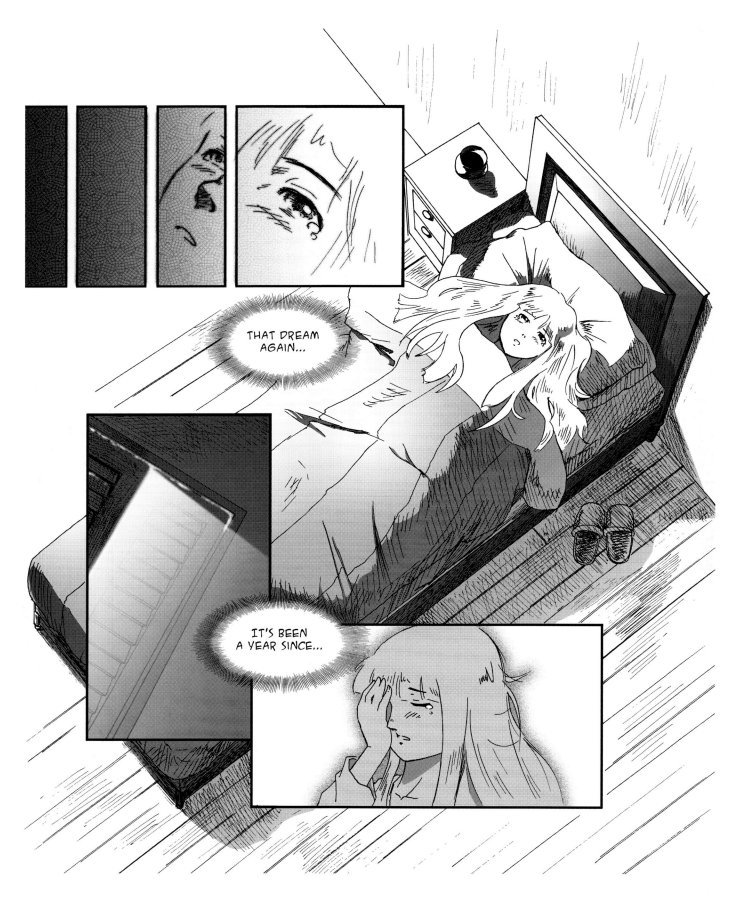

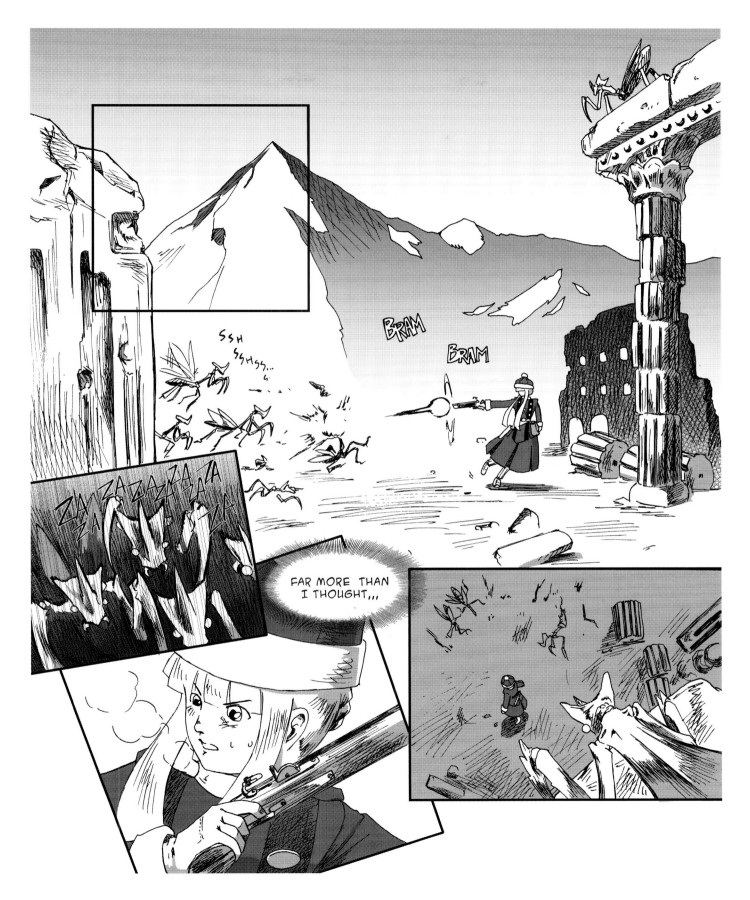

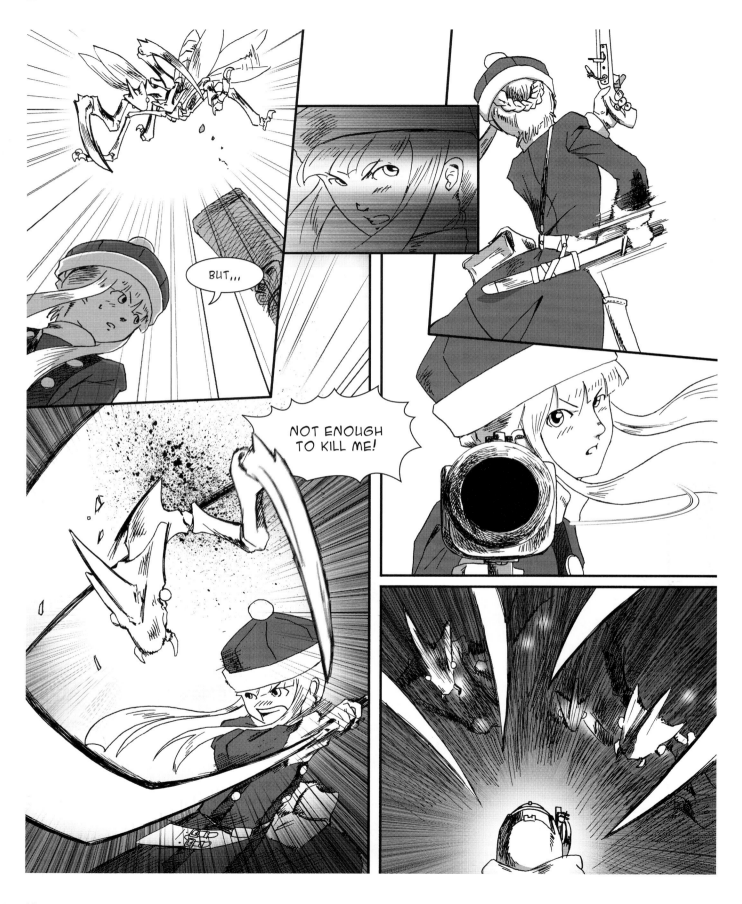

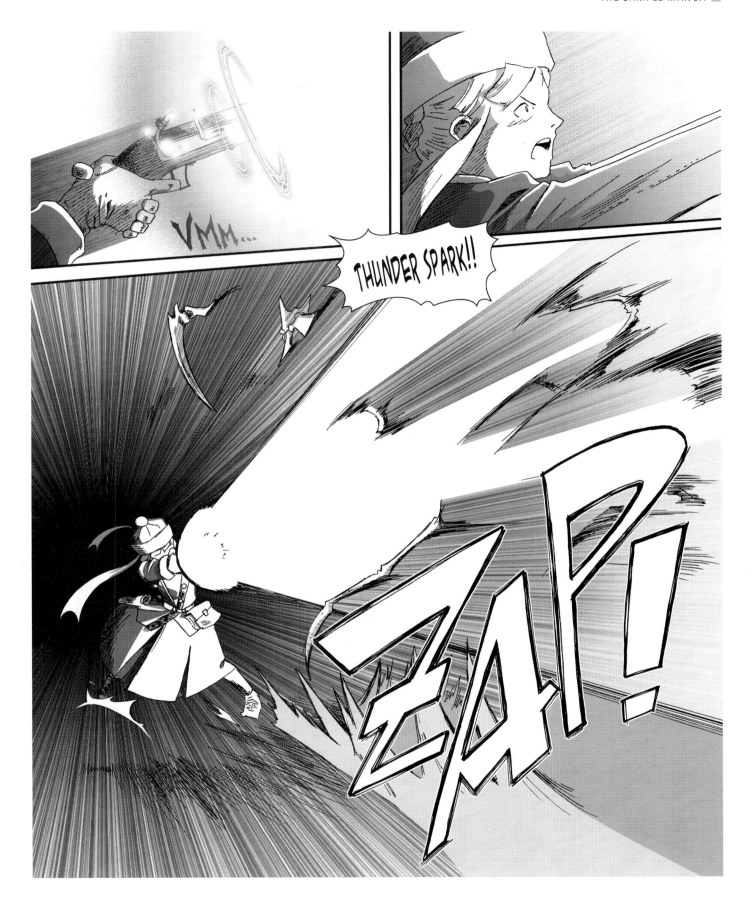

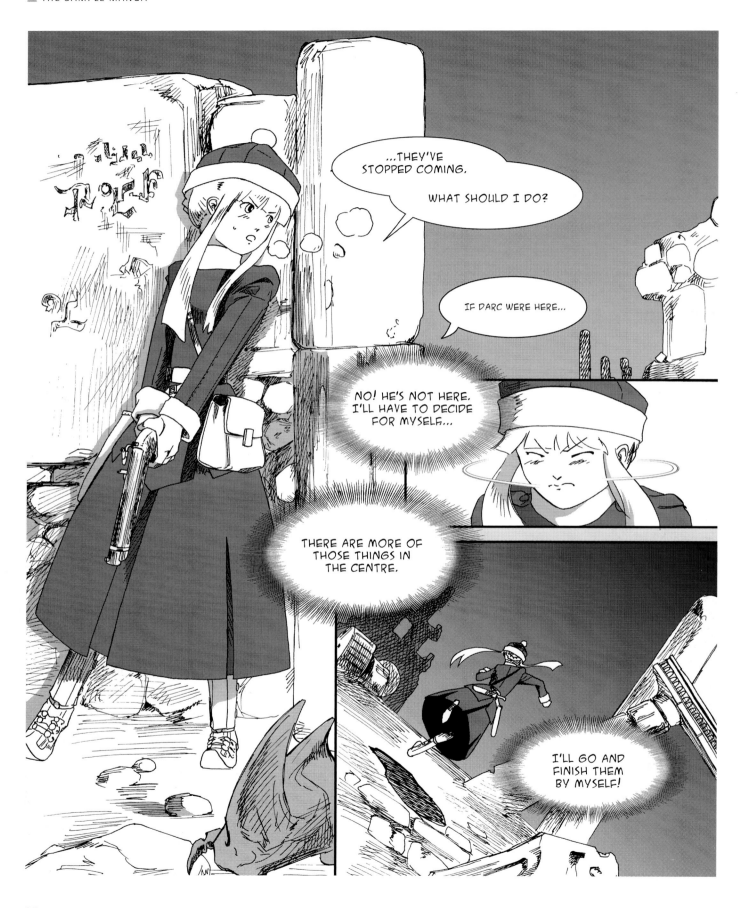

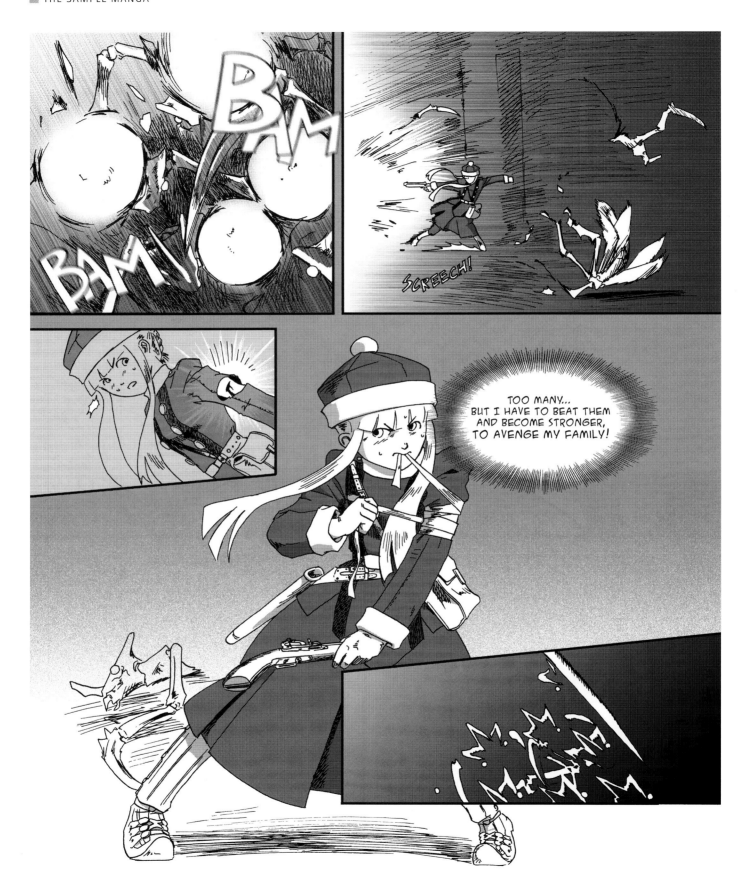

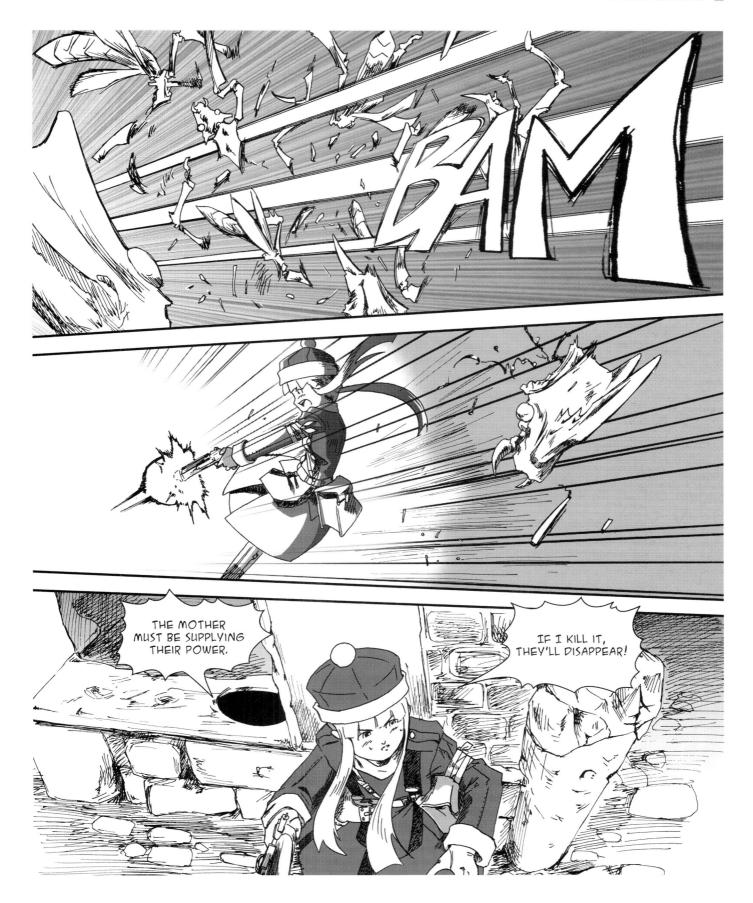

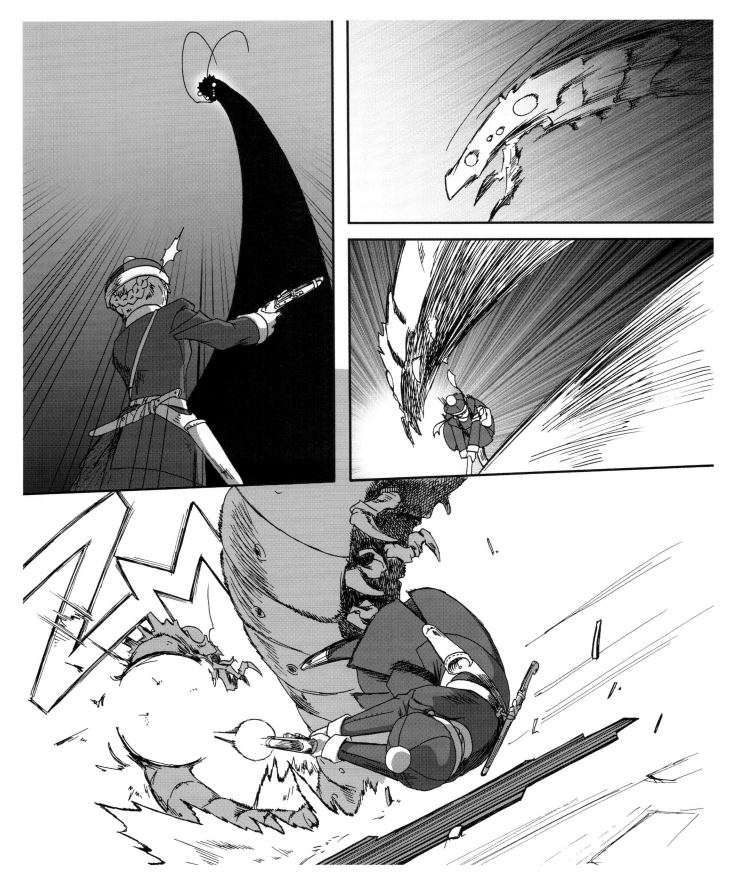

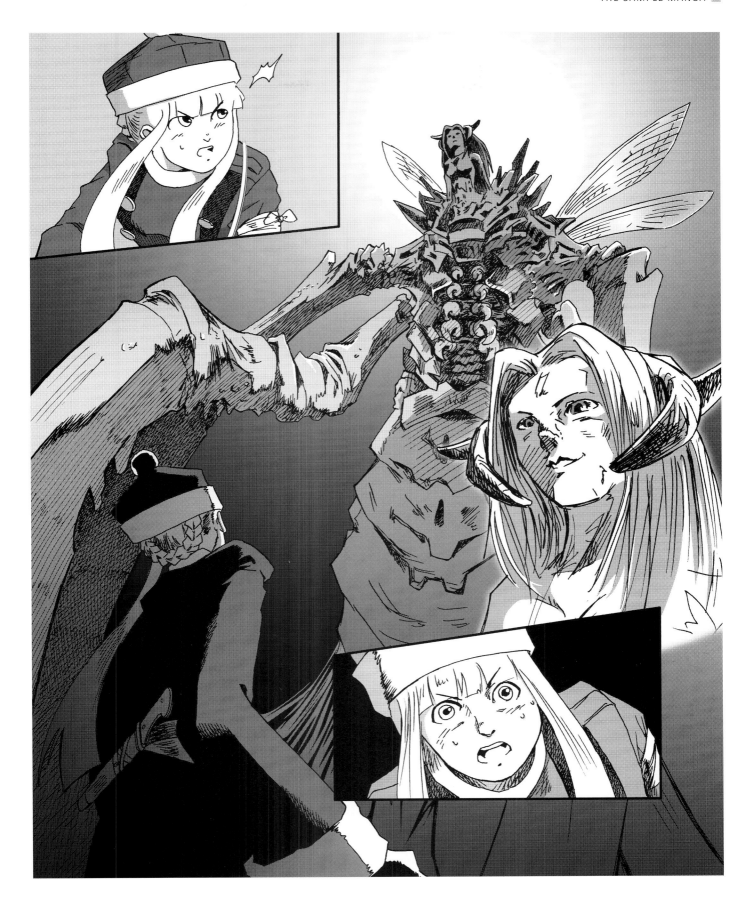

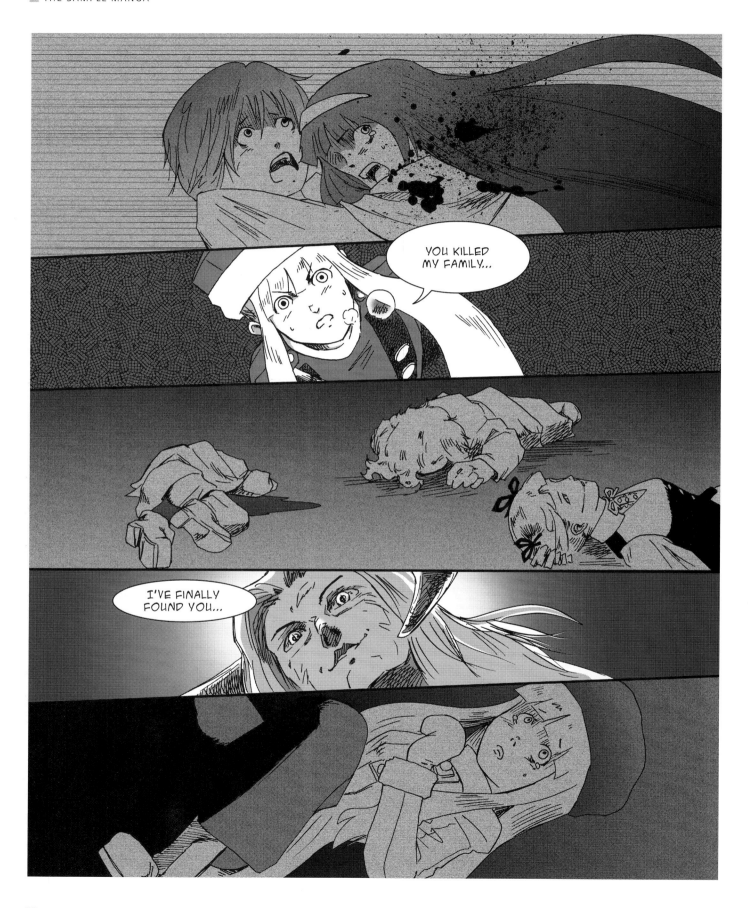

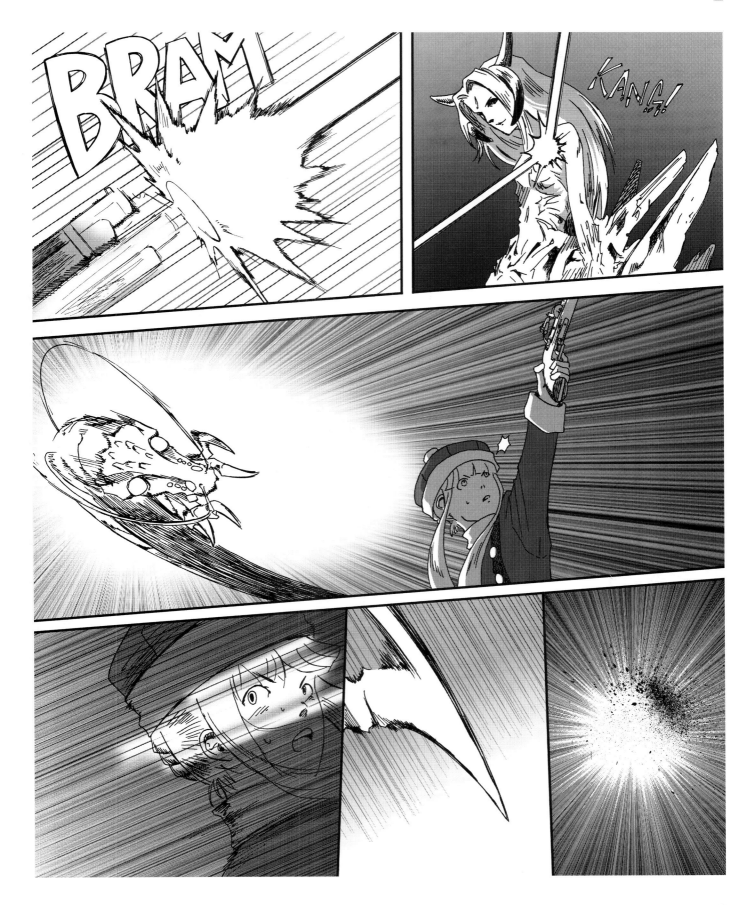

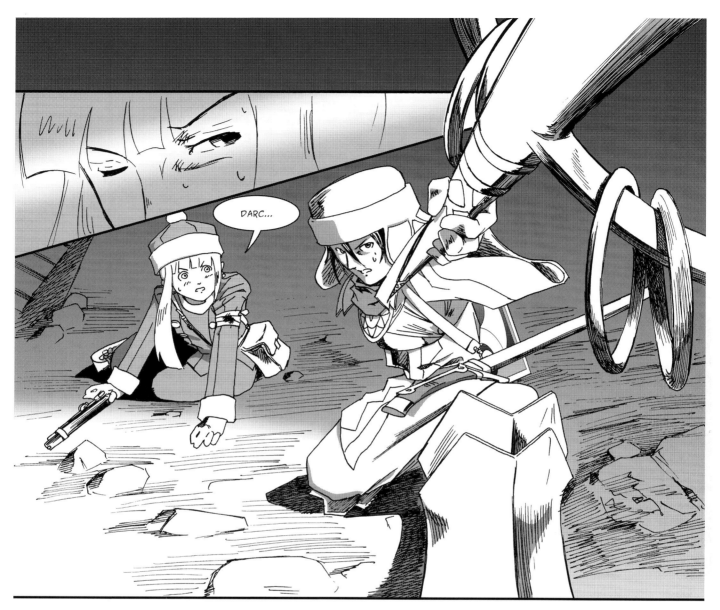

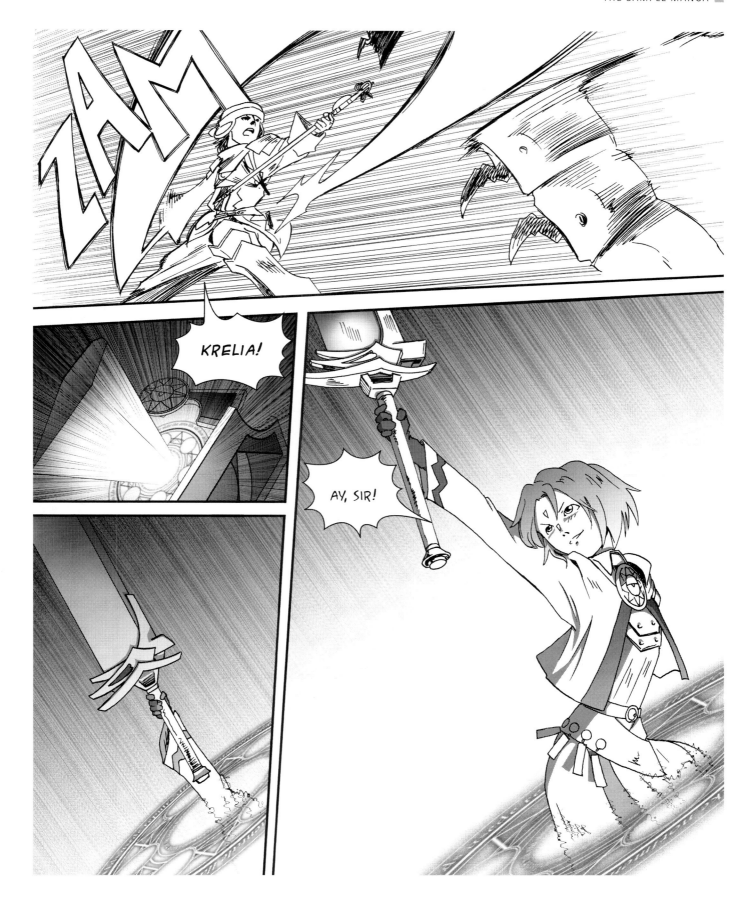

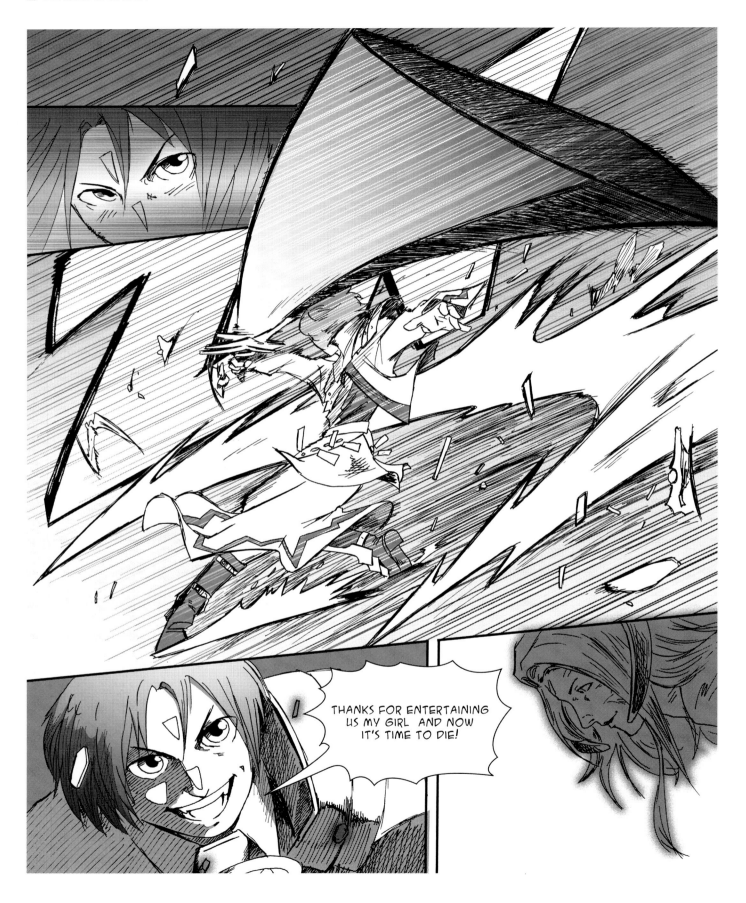

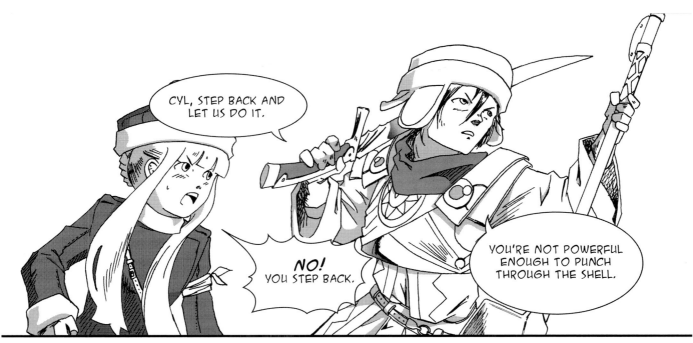

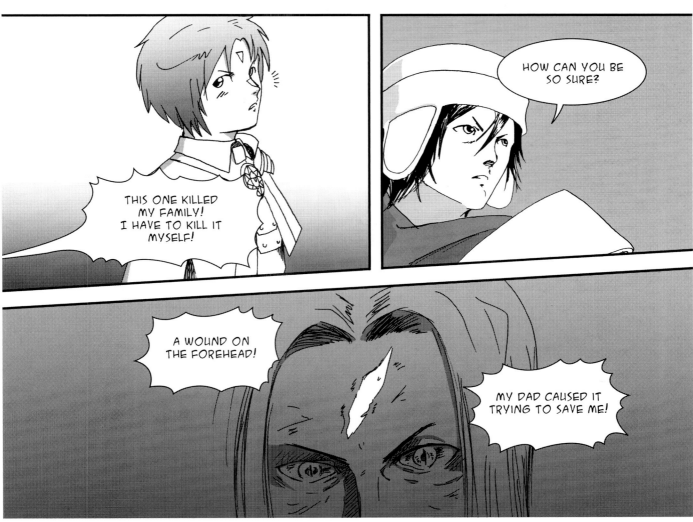

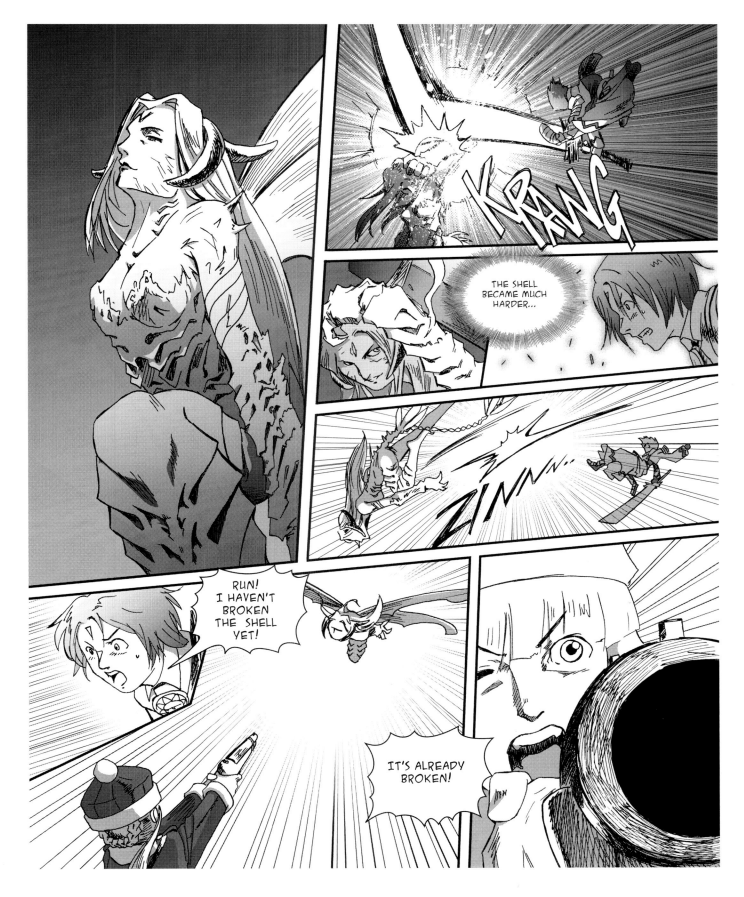

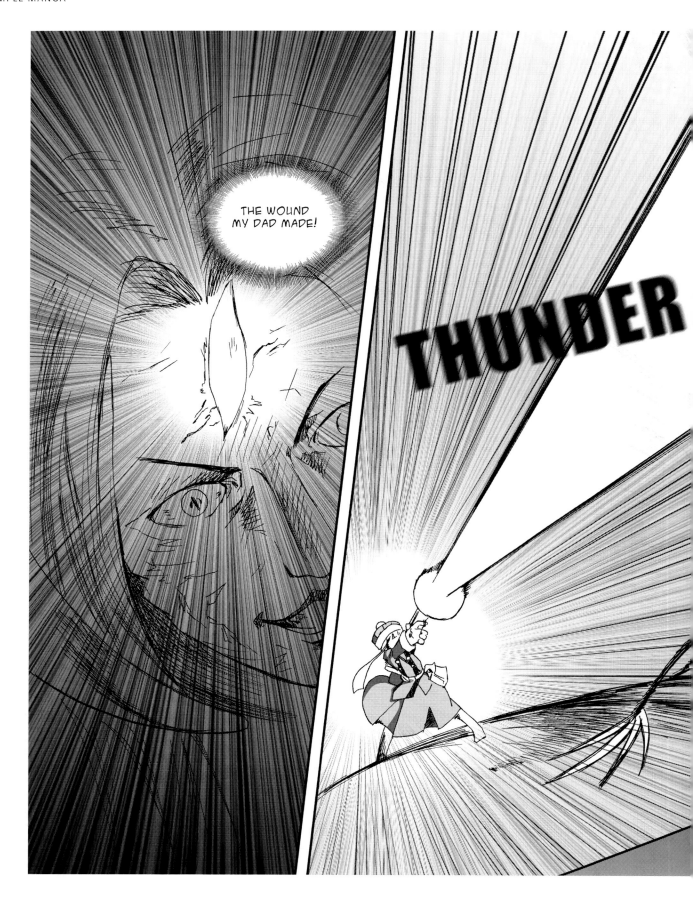

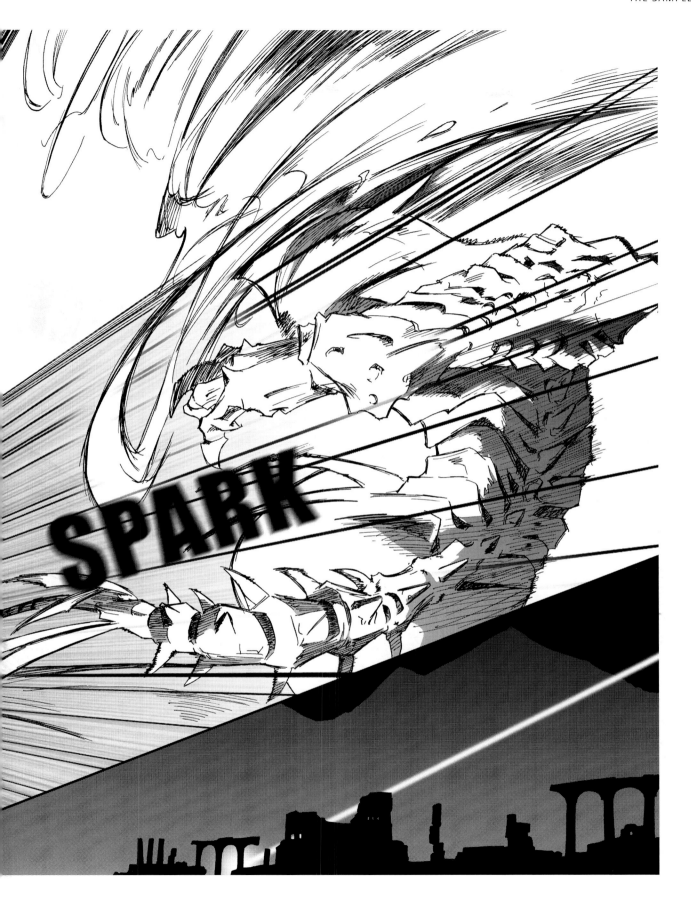

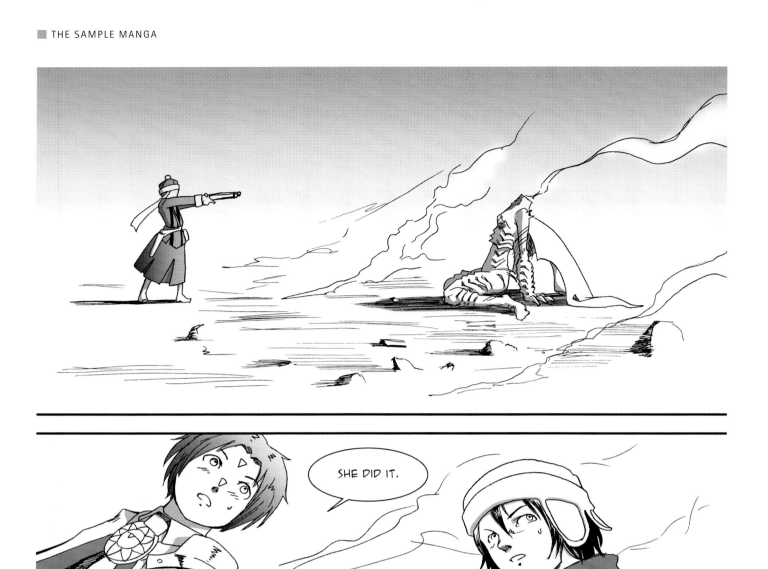

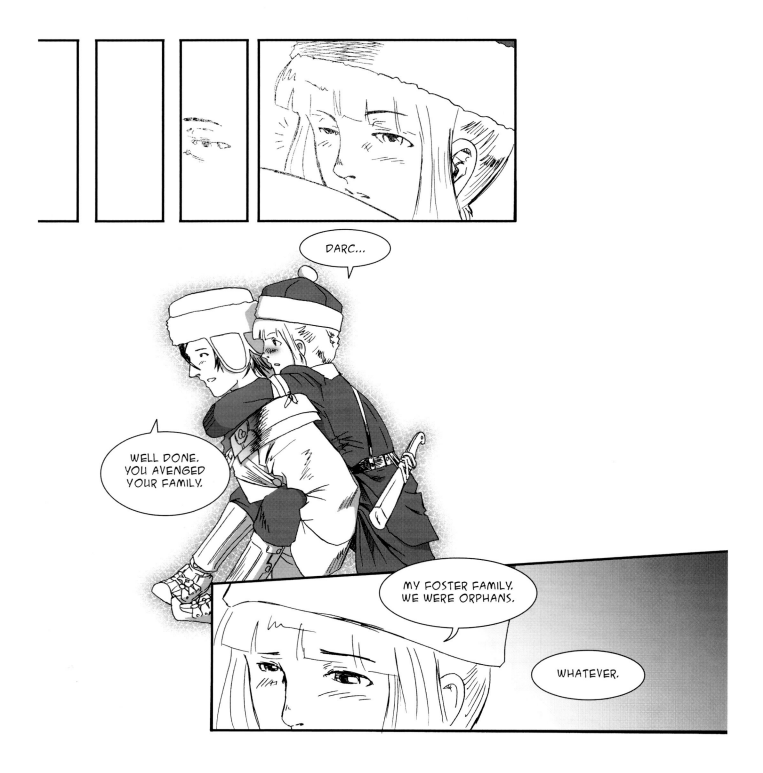

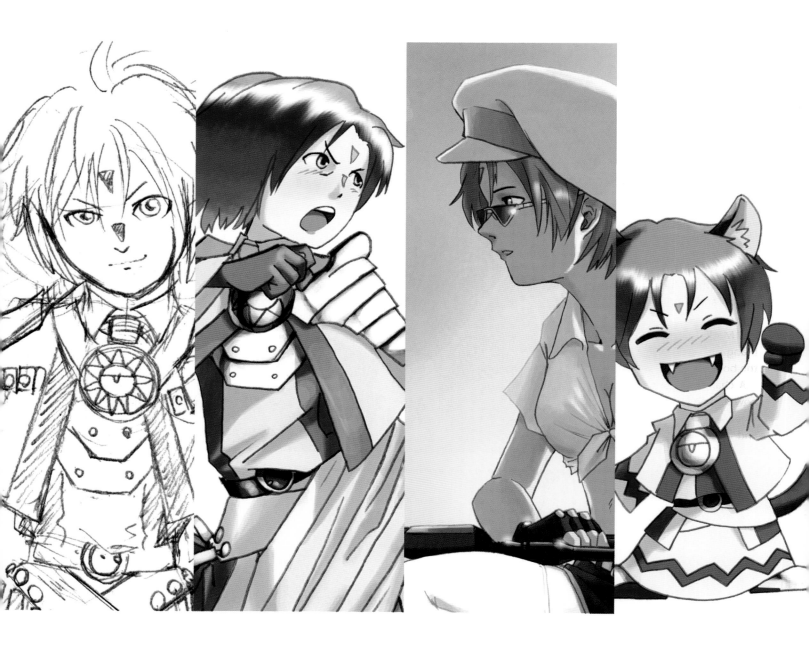

CHARACTER DESIGN

Undoubtedly characters are the most important aspect of telling a story, and they determine its success. A good character creates impact for your readers, drawing them into the story, and they will remember him or her long after they have finished reading it. This and the following two chapters explain how to create and draw a character, and also how the characters in the Sample Manga were created. The characters from the Sample Manga appear in most of the illustrations, to guide you through the book.

A character is made up of various elements: how he looks, how he behaves, how he thinks; even the way he appears in a scene can define his character. In other words, by examining and mixing these elements wisely, you can create a character

that is natural, memorable, moving and 'shocking'. And of course when you have finished designing your characters, they must be put into a scene, with appropriate actions and expression to create the drama.

Deciding the General Concept

What you have to do first in order to design a character is to establish the general concept, or direction: this is the skeleton. Watch a detective drama and see how the victim's face is re-created from a skull, and you will understand that bone

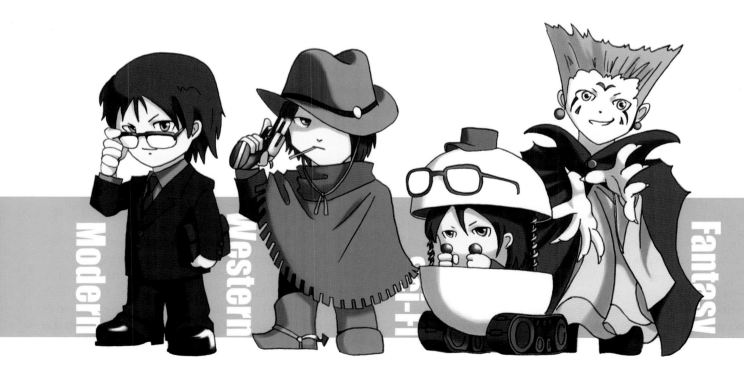

Examples of world setting. From the left: modern, Western, science fiction and fantasy.

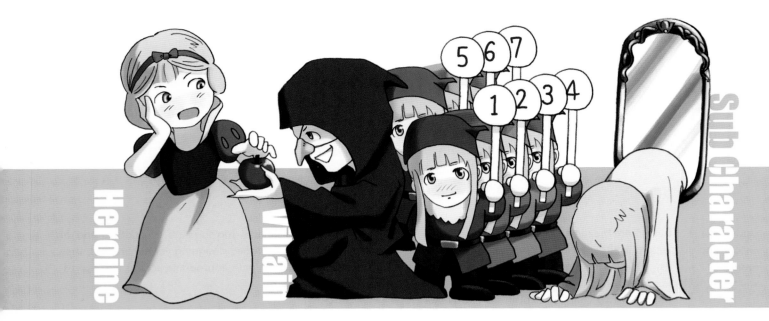

Examples of roles. From the left: heroine, villain, mobs and sub-character.

structure virtually determines their appearance. The same can be said of character designing.

It is also important that if you are working with a scriptwriter, you and he must agree with the characters' concepts even at this early stage, so you are not working at cross purposes.

Below are the elements of the general concept, though they don't have to be followed in this order – indeed, there is no need to observe these stages every time. They are really just a reference, or my suggestion, and if you have another method that you are more comfortable with, then go with that.

World Setting

First of all the world setting must be decided, and this includes the basic story line. This will guide you through the process.

Role

Perhaps the most important element is the character's role. Is he/she a key character? A mob character? Serious or comical? Simply speaking, by determining the role (and importance) of the character, you will know how much exposure he/she needs in your story. It often happens that an unimportant character overshadows the main characters and sometimes completely takes over the story, thanks to their strong personality and design.

Basic Information

This element involves the very basic aspects of the character: age, sex, race. Most of these are automatically decided once the role has been set (for instance, no one wants a long-bearded old man as a hero, unless you're drawing a very special type of Manga).

Atmosphere

'Atmosphere' may be defined as the general impression of a character, and includes both physical and mental (or visual and non-visual) aspects. Although these two things look different, they are in fact inseparable, just like the 'heads' and 'tails' of a coin. You don't, however, have to think about it in detail: just make it clear what kind of character you want him or her to be.

Personality

Personality is something you need to think about more than appearance, since appearance is an interpretation of the character's personality (not the other way round). Is he introvert or extrovert? Quiet or talkative? Clever or stupid? Generous or mean? Kind or cruel? One writer tries to imagine what kind of music her characters might like when she has created them, and it is helpful to visualize their personality. Also if a character has some special abilities, it might be better to decide this at this stage.

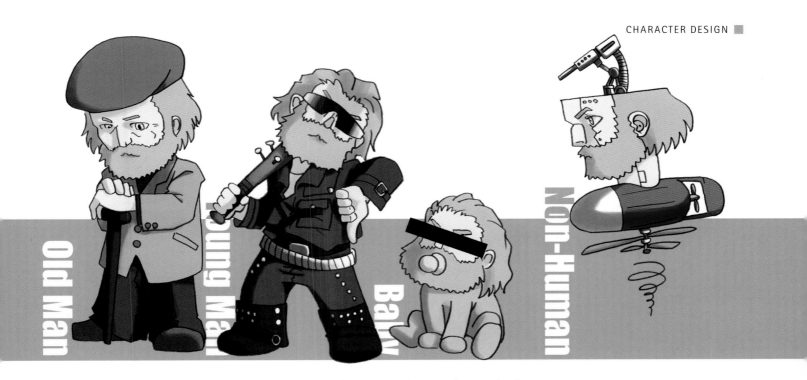

Old Man | Young Man | Baby | Non-Human

Examples of basic information, in this case, the age of a character.

Appearance

Now you must decide on the character's physical appearance, the most obvious feature of Manga. If you have thought about the previous five elements, you have a fairly good idea of what your character is going to be like. Now write this down, and what he/she looks like before you start drawing. It's often a good idea to take a break before making any definitive decisions, because you might come up with better ideas, or you might find mistakes. And it is much easier to change a few words from your notes than scrap a design that took you hours.

The illustration shows different types of fighter, and you can

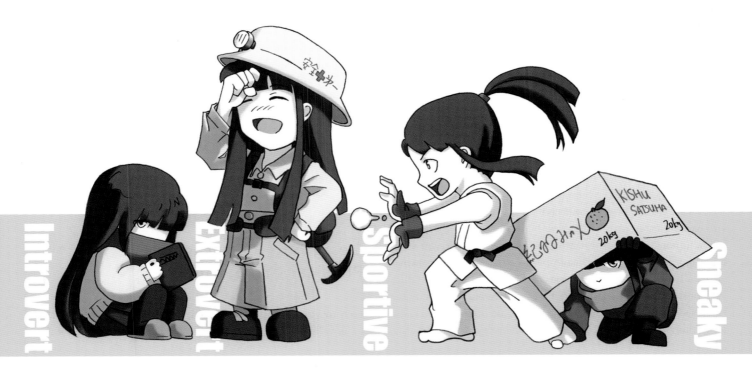

Introvert | Extrovert | Sportive | Sneaky

Examples of atmosphere. From the left: introvert, extrovert, sporty and sneaky.

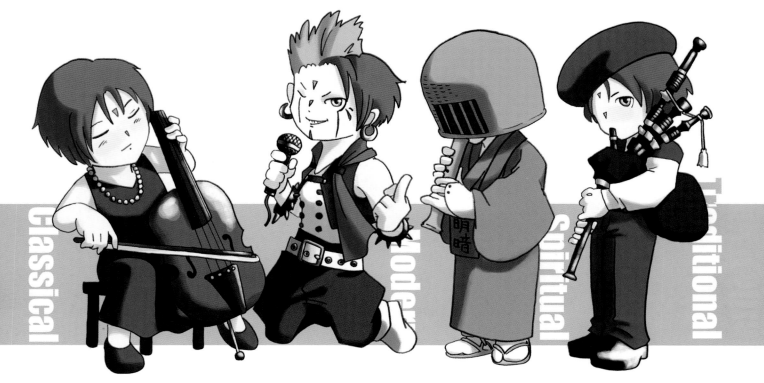

Examples of personality expressed as musicians. From the left: classical, modern, spiritual and traditional.

see how a single fighter can differ according to his physical and cultural appearance.

Idiosyncrasies and Mannerisms

Including individual traits should be considered rather as the finishing touch to your character. When used correctly, idiosyncrasies and mannerisms can be powerful tools that make your character stand out. Even so, it is as well not to use too many.

Going Against the Stereotypes

Now you've learned the rules, the next step is to go against the rules. As long as you keep following the rules you'll never be better than them, so now is your chance to push the boundaries and explore other possibilities.

All humans have some distinctive feature, and if you look around, you will easily find examples. Father Christmas always wears a red coat; Sherlock Holmes must wear a deerstalker and Inverness cape no matter where he is; glasses and a camera are essentials for Japanese tourists; and Nazis are cold-blooded and authoritarian blond guys. Stereotypes are everywhere: not only in characters, but in plots, roles, speeches.

The drawings used to illustrate stories also use stereotypes, otherwise you wouldn't recognize what is being described. And

Manga, too, employs a vast library of these – in fact it is built on these stereotypes, for Manga is nothing but a collection of symbols that rely on stereotypes.

So what is a stereotype? It is a series of expectations. For example, imagine a doctor, and you'd expect them to be someone intelligent wearing a white coat – not a patch-worked man with black-and-white hair (as in Tezuka's Black Jack), or a muscle-bound half-naked man wearing a scarlet cape (as in Super Doctor K). Using stereotypes is the surest way to deliver the message to your audience. But because everyone knows them, they are predictable. What you have to do is betray their expectations and surprise them with your characters. However, you need to be careful to keep the balance of your story. These unusual characters are like a strong medicine that can cure illness, but will also harm you if you misuse it.

Designing a Character's Physical Appearance

By now you probably have a fairly good idea of what your character will be like, and this section explains how to design a character's physical appearance. (For costume design, go to the next section.) This would include the use of focal points, and the depiction of the facial features.

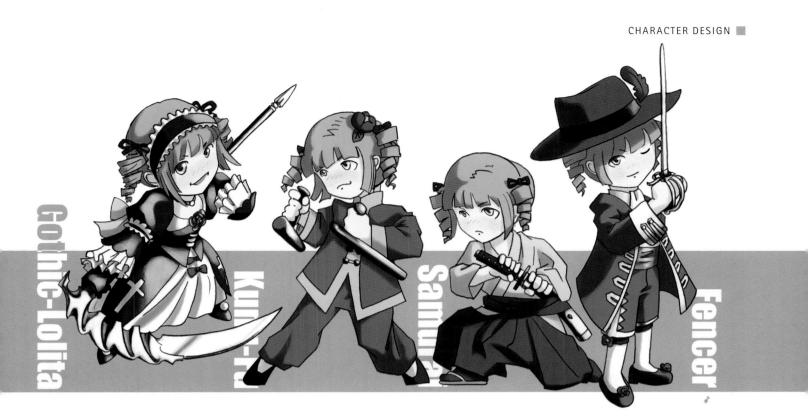

Examples of appearance. From the left: Gothic-Lolita, Kung-fu, Samurai and fencer.

Focal Points

A focal point is simply a feature that would make the character striking (and memorable). This can be anything – for example, a scar, an eye patch, a tattoo, cosmetics, accessories, hair colour, extra eyes, fangs, even some idiosyncratic posture. Krelia's facial mark in the Sample Manga is one. However, to reiterate, it is a mistake to overload a character with focal points – and besides, they are not compulsory: not every character has to be given a focal point.

It is quite tempting to add face marks (and face paintings and cosmetics, just like in *Othello*) to your character, but be careful not to put the lines over wrinkles. You might think you can get away with it, but Manga is mostly black and white, so you are drawing them as black lines (unless you spend a lot of time drawing them with tone). Putting lines where there would be wrinkles makes the character look old and ridiculous.

Age

In general, the age of a character is expressed through the following elements: the eyes, the nose, wrinkles and posture.

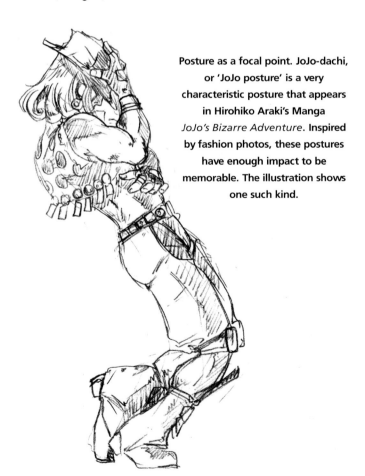

Posture as a focal point. JoJo-dachi, or 'JoJo posture' is a very characteristic posture that appears in Hirohiko Araki's Manga *JoJo's Bizarre Adventure*. Inspired by fashion photos, these postures have enough impact to be memorable. The illustration shows one such kind.

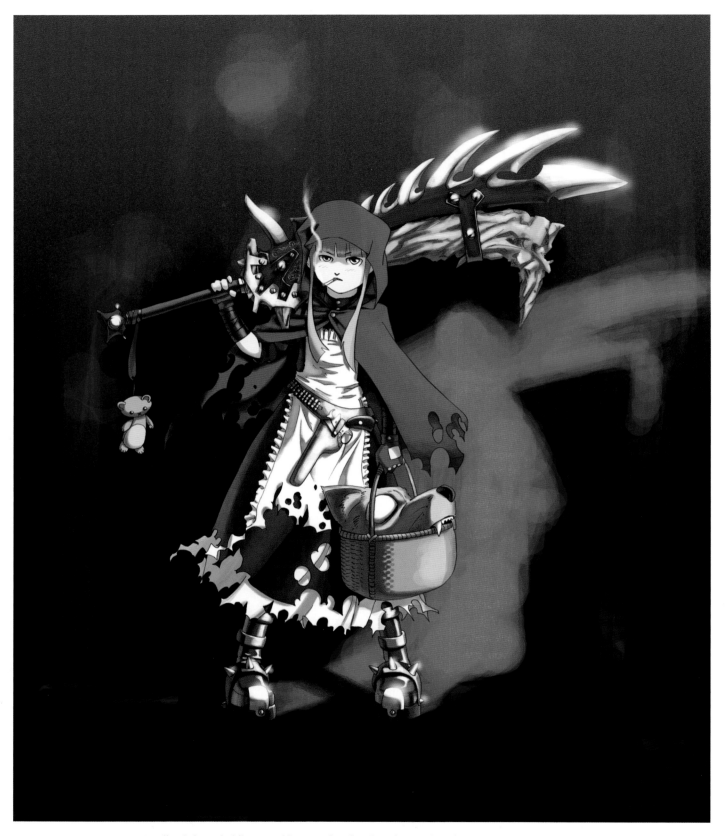

Usually, Little Red Riding Hood is a cute but fragile girl. But what if we changed her and made her the polar opposite? This illustration shows 'Dark' Little Red Riding Hood as a wolf hunter.

This illustration shows major wrinkles on old people's faces.
The right side of the face is left plain to show how a face can change
by adding wrinkles.

The face marks of Bianca from *Othello* in the *Manga Shakespeare*
series. You can see that some face marks actually run into the place
where the wrinkle would be. In order not to make these marks
look like wrinkles, you need to show that these marks break out
of wrinkle lines at some point. In this case, the lines under the eyes
are extended to the forehead and to the ears. This suggests that
these lines are not wrinkles but marks.
(Illustration with the permission of SelfMadeHero)

THE EYES

The size and shape of the eyes are important in depicting a character's age, and the younger he/she is, the bigger and rounder his/her eyes are. This is because the eyes don't grow as much as the other parts of the body, so when someone is young, the eyes look large in relation to the body. This is also the reason why Manga/Anime characters look younger than their supposed age.

If you are drawing an old person, make sure not to draw their eyes in the same way as those of the younger characters. And if you think your character looks older than you want, make his eyes bigger and rounder.

THE NOSE

A small nose, as you see in most Manga, makes a character younger. Manga draws the nose in this way because many Japanese have a flatter nose, and not as pronounced as the nose of white people. Coincidentally a smaller, flatter nose is a sign of immaturity. And as you see in the illustration on page 48, a clearly drawn nose makes a character look mature.

WRINKLES

Wrinkles are perhaps the most apparent sign of ageing, particularly around the mouth. So if a character looks too old, try removing or reducing these lines.

POSTURE AND GENERAL FIGURE

Ageing undoubtedly affects the whole body and its movements; a hunched back and shuffling are common examples. When drawing young children, make sure their bodies are different from that of an adult. Their bodies tend to be tubular, their heads larger and their legs shorter.

Gender

Almost all art books tell you how to draw the female and the male figure, and Manga follows the same principle, as it is a collection of drawings. The difference is that characters in Manga act and talk in a sequence, and these actions often give more clues to the character's gender than the figure itself.

Men and women behave differently, and how they behave also differs according to culture. You might have noticed that in Manga or Anime, sometimes a girl puts her hands on her mouth when she is surprised, or shouting or laughing. This is a Japanese female gesture that can be traced back over a thousand years because in the old days, the Japanese considered that baring the teeth and tongue was very rude.

Use these tools wisely and you can send small but effective messages to the reader.

It is worth observing transvestite and transsexual people because they tend to be more feminine/muscular than women/men. The reason for this is because they study the body

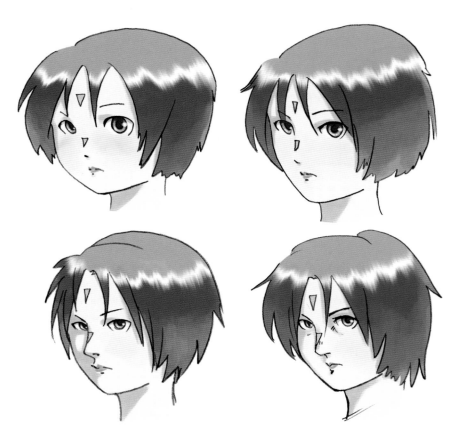

The size and shape of the eyes can affect how young the character would look. The distance between eyes and eyebrows is an important factor: the flatter the face, the wider the distance between them. Also putting more details on the face would age the character, just as you can see in the bottom illustration.

language of the different sexes, and use them consciously. A good example is the female role actors of the Kabuki play, who are considered more beautiful, elegant and feminine than women.

Race

Have you ever wondered why Manga/Anime characters don't look like Japanese people, even though they are? The answer is simple, in that white people recognize them as white because they don't have features that are traditionally associated with Asian people, while Japanese see them as Japanese because they don't have features that distinguish them as white or black people. This implies that if you understand these features and use them appropriately, you can control the racial appearance of your characters.

HUMAN AND NON-HUMAN

In drawing Manga, you also need other, non-human creatures: it might be other humanoids such as elves, fairies, androids; or it may be non-humanoid types such as robots, monsters, animals, spacemen. Humanoids are easy to design, since they have more or less the same physical structure as humans. Non-humanoid types are more challenging, however, and you will

have to study how they move, react and interact with other characters. Imagine if one of your characters is very short or very tall, and he is talking to another character: because their height is so different, you can't put their heads in one panel. With regard to layout, this could be resolved by making the taller one bend down, or the smaller one fly in order to bring their heads to approximately the same height.

Be aware also that non-humanoid characters would encounter difficulties trying to interact with various objects: thus with a hand like a crab, they would be unable to engage in most human activities; and a character with a tail or wings would find it very difficult to sit on a chair with a backrest.

Robots and mechanical characters are by far the hardest to depict, and require considerable skill to design. They have more complicated shapes and are daunting to draw; moreover their bodies are solid metal (in most cases) so you have to be very accurate in depicting how each joint moves, particularly the shoulders and groin.

The Part System

In Manga and Anime, many characters must be drawn (designed) to a tight schedule, and many artists use what may be called the 'part system' to solve the problem.

This involves creating various types of character while retaining

An example of various
non-human races.

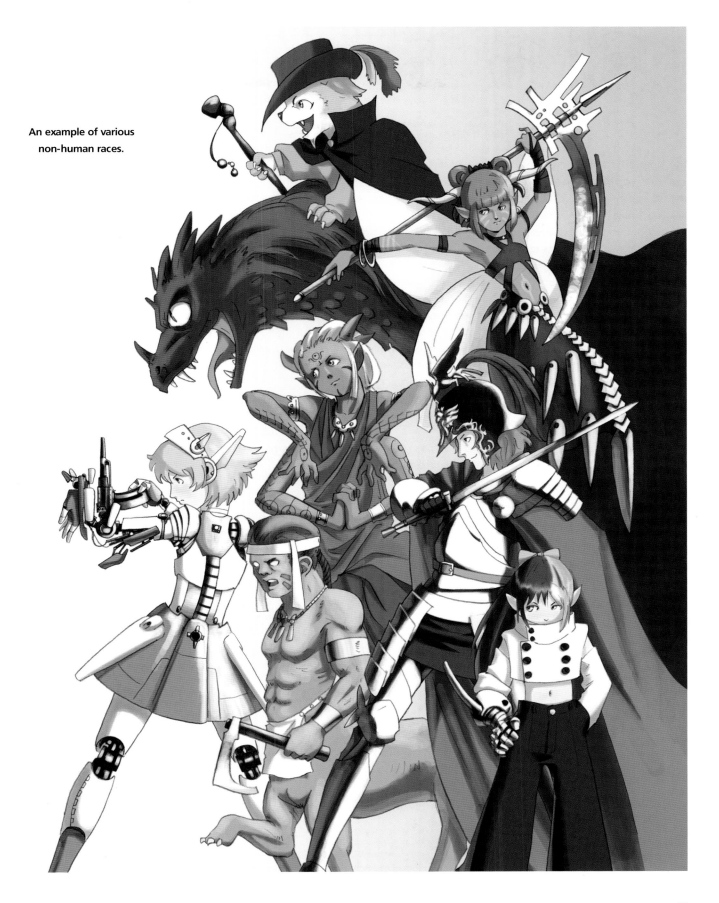

Examples of the shapes of eyes.

the simplicity and the symbolic nature of Manga/Anime. For example, you may have to create different types of the letter 'A', and so you create 'A' '**A**' '*A*' and '*A*'. All are fine, but '*A*' and '*A*' are too similar, and it is hard to keep a consistent difference throughout your story, especially when you have to draw them small, because then many details disappear.

But what if you are allowed to use four letters, say 'w' 'o' 'r' 'd'? You can create twelve patterns ('word' 'wodr' 'wdro' 'wdor' 'owrd' 'owdr' 'odrw' 'odwr' 'rwod' 'rowd' 'rodw' 'rwdo') with clarity and no effort. The part system is a visual interpretation of this example, in that you prepare several patterns for each body part and combine them to create a character. For example, if you have three patterns for the eyes, four for the hair colour, two for the skin colour, three for the hairstyle and two for face outline, you'll have 3 x 4 x 2 x 3 x 2 = 144 patterns (characters).

THE EYES

The eyes are the most important part of a character: they give away almost everything, just like the old saying. One of the reasons why Manga/Anime characters tend to have large eyes is that larger eyes are better at expressing emotion. Here are a few tips when drawing eyes:

Age: As discussed above, the age of a character affects the size and shape of the eyes.

Shape: Usually, round-shaped eyes look kind and soft, while sharply shaped eyes give an aggressive, powerful and strict impression. Eyes depicted on a slight slant (at right in the illustration) represent kindness, softness and 'air-headedness'.

Highlights: The character of a person can be altered by changing the place of the highlights in the eyes. Adding a highlight to the top part of the eyes, which is the usual place for many artists, creates an impression of liveliness and activity. Put the highlight on the lower part, and you create an introverted, passive and somewhat negative impression. This is also the case with cast-down eyes. And how about not adding highlights? The eyes then become lifeless, and suggest the character is dead, shocked or non-human (for example, android).

Brightness: The brightness of the eyes – and that includes the highlights – also determines the character's feelings: the brighter the eyes, the happier and livelier the character. On the other hand, dim eyes express sadness or tiredness. This is not applicable to every situation, but it does give a good indication of how the character feels.

THE NOSE AND LIPS

The nose and lips are two of the least noticeable features; they are essentially immobile and don't have a strong outline. They tend to be simplified, and are quite often left out altogether.

HAIR

There are many different kinds of hairstyle. The length of a person's hair often suggests how active they are; thus a short hairstyle maybe suggests someone active and sporty, and long hair someone less active. For a man, having long hair

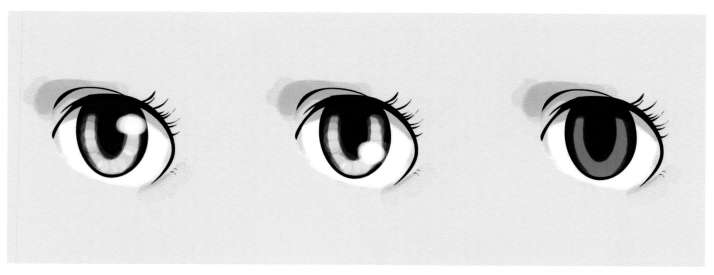

Putting, or not putting highlights in the eyes can change the impression they make.

can be a negative sign, indicating that he is cowardly and image-conscious.

How a person's hair is trimmed and cared for is also a good indication of their social background. Thus someone from a conservative and strict background would have a conservative hairstyle; a person who is rich and well educated an immaculately trimmed but plain hairstyle; someone who is not particularly clever but outgoing an unusual hairstyle; and the strict and disciplined, almost militaristic, a tightly set hairstyle.

Having a fringe makes the wearer younger – also a heavy fringe makes a character look quiet and introverted.

Finally the set of a person's hair changes according to their situation; thus people tend to have well groomed hair in public but not in private. Equally, you can change the hairstyle to make it appropriate to the situation and to enhance the feeling of the scene. It can also be used to show how a character is adapting to a situation. Making the hair untidy can suggest they have been caught off guard.

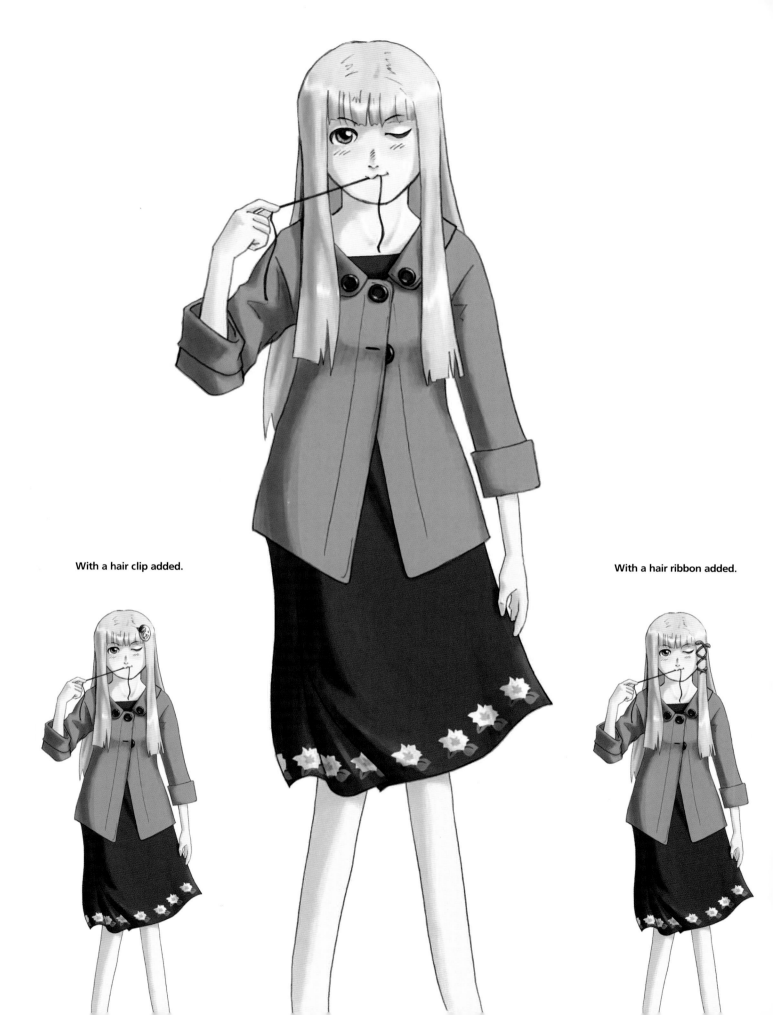

With a hair clip added.

With a hair ribbon added.

CHARACTER DRAWING

This chapter explains how to depict the drama in the story, and shows how in Manga costume design is used to suggest aspects of the character, and reveals how different emotional states can be conveyed.

Costume Design

Costume is far more varied than physical features, and decides the general identity of the character; also a character can be made to look quite different by altering his or her costume. Furthermore a costume is not only clothing, but everything that can be associated with that character, such as weapons, books, CDs, food, drinks and even furniture.

To design a costume you'll need references, and for this it may be necessary to borrow or buy some reference books. The internet (especially Google images) is a very helpful tool. The more you consult references, the better your chances of successful designing.

The one crucial difference from character design is that because you are drawing on a sheet of paper, copying clothes straight out of a magazine isn't a good idea. For the illustration here, I copied the clothes straight from a magazine, and you'll see they are too plain. Adding a focal point solves the problem: it can be anything – accessories, patterns, ties, ribbons.

It is also important to think where to put the focal point. The best place to put it is the upper chest, which is closest to the face. On the other hand, feet are the worst place to put the focal point since they hardly appear.

With a bow added.　　**With a tie added.**　　**With a cap added.**　　**With streaks of red added to the hair.**

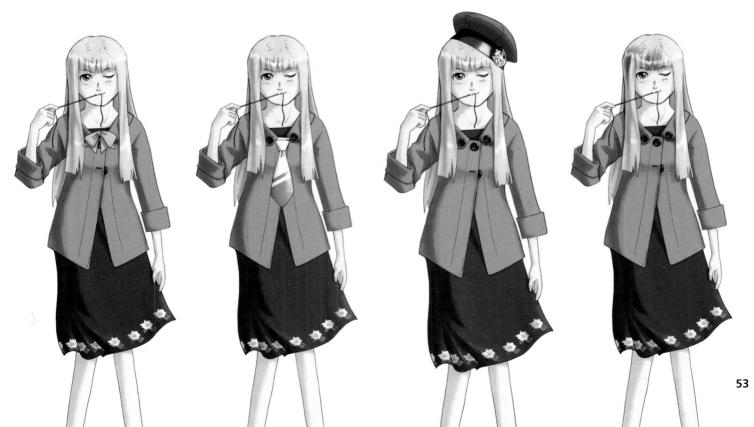

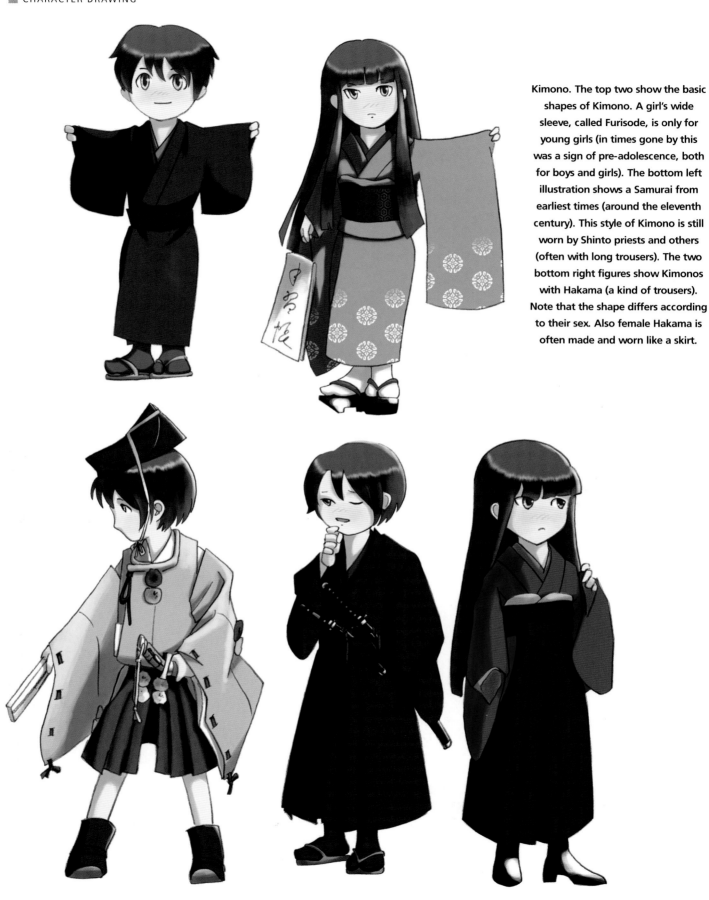

Kimono. The top two show the basic shapes of Kimono. A girl's wide sleeve, called Furisode, is only for young girls (in times gone by this was a sign of pre-adolescence, both for boys and girls). The bottom left illustration shows a Samurai from earliest times (around the eleventh century). This style of Kimono is still worn by Shinto priests and others (often with long trousers). The two bottom right figures show Kimonos with Hakama (a kind of trousers). Note that the shape differs according to their sex. Also female Hakama is often made and worn like a skirt.

Before you start actually designing, you need to make sure the characters fit in the world around them (unless they are outsiders). Keeping characters consistent is an important factor in making them part of a world; it also helps distinguish what faction (or culture) they belong to. The factors you need to consider to maintain consistency are many, but the most obvious is the world setting (location, time period, and so on). Another way to achieve this is to use a colour code: for example, faction A mainly uses blue while faction B uses red. Using the same shape is also useful. For example, in the film of *Lord of the Rings*, Elven artefacts are designed with flowing curves, while Dwarven items use straight, geometric lines.

The following are some examples and tips for various types of costume.

Kimono

The Kimono is developed from an undergarment and became popular during the fifteenth to sixteenth centuries. There are several points that make them different from Western clothing, and these must be considered when drawing them.

Unlike Western clothing, the left side is always to the front when wearing a Kimono. Only when someone has passed away is it worn the other way round.

The male ties the sash around the hipbone, not the waist. Even women, until the eighteenth century when the sash became too wide, tied the sash around the hipbone. This is one of the main reasons why the Kimono worn (and drawn) by Western people looks strange. Wearing the Kimono round the hipbone reduces ugly creases when a sash is tied.

The bottom hem is an important indicator as to whether someone is wearing a Kimono correctly. If you're not used to wearing a Kimono, the bottom hem spreads, just like wearing a skirt. A tightly closed hem makes the Kimono look beautiful.

Gothic-Lolita

Gothic-Lolita, or Goth-Loli, is a very popular fashion style in Japan; there are plenty of examples in Manga/Anime. Gothic-Lolita is, just as the name implies, developed from Gothic fashion, but the difference is that Gothic-Lolita is less focused on the dark and sinister aspects of Gothic fashion and more on cuteness.

The name 'Lolita' suggests that Gothic-Lolita is a very 'girly' style of fashion, but it can be divided into two types, one based on men's costume (usually from around the nineteenth century) and the other on girls' costume. Although this style is based on period costume, it is exaggerated and modified to create entirely different images. In my opinion, they don't look as stiff

as the actual costume, but are somewhat flimsy, shorter and a lot more fluffy.

The key words for designing Gothic-Lolita costume are frills, lace and ribbons: just put as much lace and as many frills as possible. Headgear is also an essential accessory for Gothic-Lolita, and every kind – hat, cap, headband, bonnet, ribbon – is used in Gothic-Lolita fashion. You can use tartan check if you want something extra, as tartan and Gothic-Lolita work well together. Lastly, footwear can be varied depending on how you want your character(s) to be. You can use ordinary shoes, or go back to original Gothic fashion and give your character heavy studded boots. Both work well with Gothic-Lolita fashion.

Science Fiction

When you imagine sci-fi, you probably imagine a *Star Trek* style or *Star Wars* costume. However, since you are trying to create a striking character, this is not so original, particularly as sci-fi is a huge genre and your story is not necessarily set in the future. Therefore take some time to think things through before deciding the general direction of your artwork.

The hardest thing when designing a costume for sci-fi is that it must be designed so the reader can sense the continuity from the present world, while at the same time making the costume striking and different. It is also daunting to have a lot of different cultures in your story. Much science fiction is set in the space-travelling era and has a vast collection of different spacemen, both humanoid and non-humanoid, and cultural settings should be created for each of these races, and costumes that reflect them.

Revealing Costumes

This style of clothing attracts a great deal of attention, which is why it is a good idea to occasionally include it in your story. The success of this kind of costume depends on how much you can emphasize the character's physical appearance; inevitably it is people with an excellent physique who wear this kind of costume, and it makes sense to design the costume to show their well shaped body. For a female, large breasts, a tiny waist and broad hips are points to emphasize; for the male it will be his chest, shoulders, abs, upper arms and thighs.

Another thing to consider is not to make the costume too plain, while at the same time not obscuring the body with ornaments. The classic way to do this is to put a pattern on the costume ('S' for Superman, for example), and provide a cape or some sort of accessory.

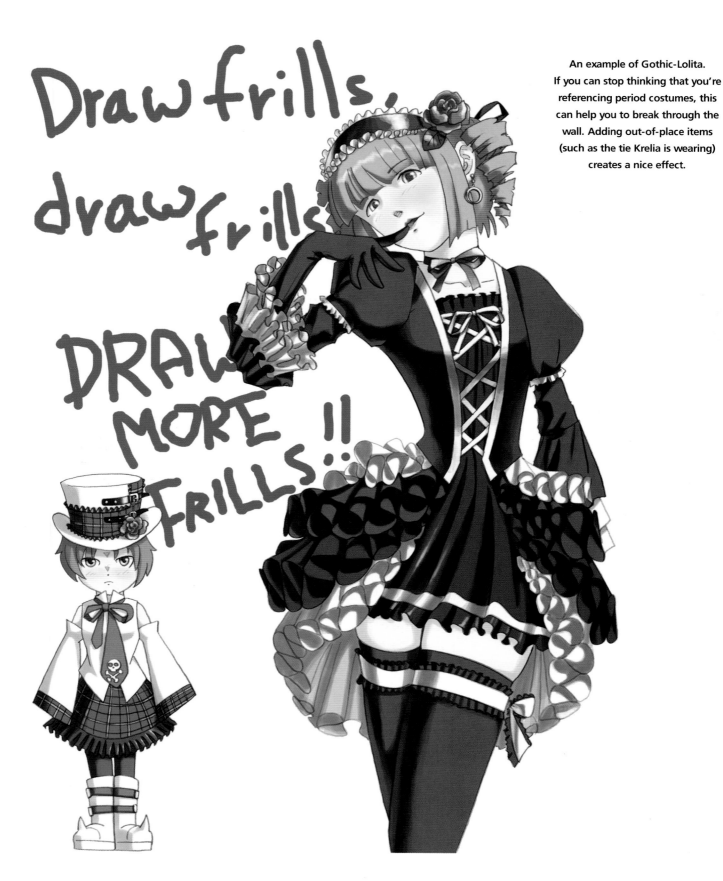

Draw frills, draw frills DRAW MORE FRILLS!!

An example of Gothic-Lolita. If you can stop thinking that you're referencing period costumes, this can help you to break through the wall. Adding out-of-place items (such as the tie Krelia is wearing) creates a nice effect.

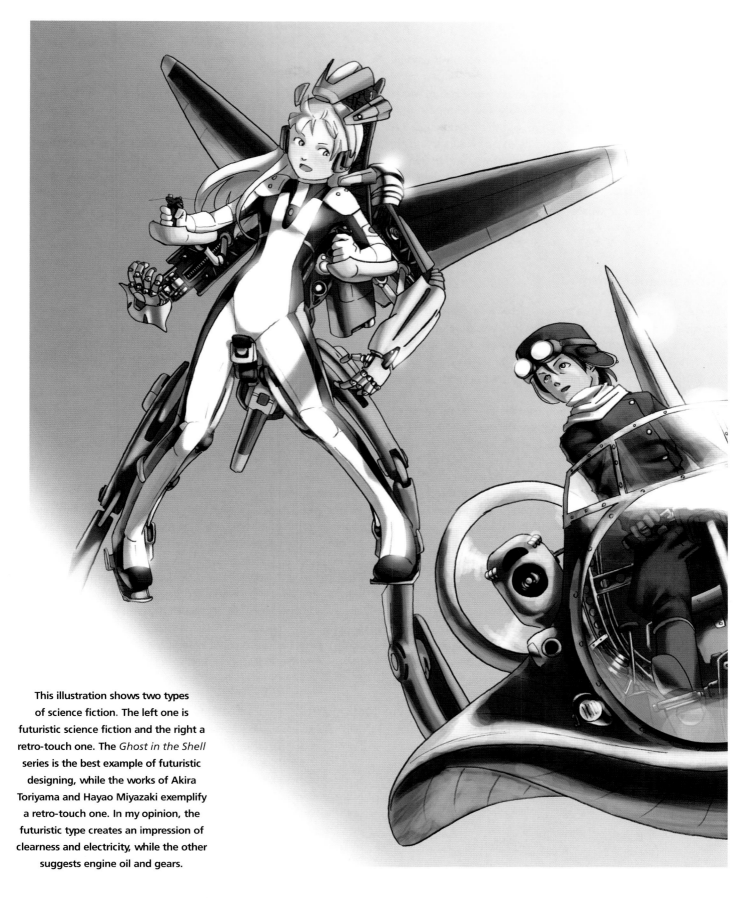

This illustration shows two types of science fiction. The left one is futuristic science fiction and the right a retro-touch one. The *Ghost in the Shell* series is the best example of futuristic designing, while the works of Akira Toriyama and Hayao Miyazaki exemplify a retro-touch one. In my opinion, the futuristic type creates an impression of clearness and electricity, while the other suggests engine oil and gears.

Fantasy

Just like sci-fi, fantasy is a huge genre, and not the medieval sword-and-magic stuff you might first expect. As with a sci-fi costume, you need to think hard about the world before moving on to the actual drawing. Both fantasy and sci-fi have few limits with regard to the world setting, but this freedom can be a problem in itself. You could spend hours and hours trying to imagine the world, or you might get carried away and do something wrong. Try your best to avoid another *Lord of the Rings* design, and let your imagination wander freely: this is a very free genre, and you can do whatever you want, so be experimental and bold.

Anthropomorphism

Choujuu-Giga is an illustrated Japanese scroll from the thirteenth century, and some claim that it is the very ancestor of Manga in that it employs anthropomorphized animals as the characters. Certainly without Disney, Manga/Anime wouldn't exist, but with many animations, even Disney, anthropomorphism is very evident.

Anthropomorphism has strong connections with Manga/Anime. Almost everything can be anthropomorphized – furniture, animals, weather phenomena, machines, books, there are even anthropomorphized versions of computer programs (Microsoft Windows, Mac OS series, Norton AntiVirus) called *OS-tan*. The most important point to remember is how to keep, and emphasize, the characteristics of the object you're going to anthropomorphize, both physically and mentally. Analysis and interpretation are the keys to successful anthropomorphism.

Below are my interpretations of World War II aeroplanes and tanks.

P51-D MUSTANG (USA)

The overall image of this fine aeroplane is 'cowgirl', and the reason I chose it is its popularity and the rough, tough image of the occupation. I used the cowboy hat to convey the main features of the aeroplane. The hat itself is basically the body of P51 turned upside down, with its radiator and bubble canopy showing, since they are the most characteristic parts of the aeroplane. Her skin is brown to complement the white (silver) hair, which is taken from the basic colouring of the P51. The striped ribbons represent identification markings. Her weapon is the famous Colt Single-Action Army, from many Western films.

An example of a revealing costume. In order to draw an attractive character, you need to have a good understanding of human anatomy.

A6MB2, TYPE 0, MODEL 21 (JAPAN)

Known as 'Zeke' or 'Zero', my concepts for this famous fighter are 'fire power', 'agility' and 'lack of armour'. It is a light plane so it seemed natural to portray it as a tiny girl. Her main costume is a Kimono, coloured green to represent the plane's camouflage (you can't see the green colour on the wings because you're looking at them from below). However, I changed the top to a sailor suit, to show that the aeroplane belongs to the Navy; also the sailor suit is a common item of girls' clothing in Japan.

This costume is designed to expose her skin as much as possible, so it reveals her stomach. This represents the fact that the aeroplane was designed with maximum reduction in weight to give it maximum agility and speed (although this did result in fragility and lack of armour plates). The choice of weapon, the Japanese sword, refers to the aeroplane's armaments: the powerful but hard-to-hit 20mm, and the slightly underpowered 7.7mm.

In personality this character would be serious and stubborn, and she would never stay in the base while others went to battle, no matter how dangerous it was.

TANK, INFANTRY, MKII, MATILDA II (UK)

'Impenetrable armour' is the concept of this fine tank. The inspiration behind this character is the Goddess Britannia, whom you can see on the 'tails' side of a 50p coin. This is also the reason why her shield is painted with the Union Jack. The shield is a visual interpretation of her heavy armour (the cannon-like protrusions on top of the shield are smoke dischargers originally on the side of the turret). The colouring is taken from camouflage observed in the course of my research (possibly desert camouflage).

As regards her personality, including a tea set is a must, and then something to suggest endurance in harsh conditions.

SD.KFZ.182, TIGER II (GERMANY)

This character is undoubtedly male, and the concept is 'firepower', represented by the massive actual-sized cannon he's carrying. His helmet is an adaptation of the tank's characteristic turret and the famous Stahlhelm. His clothing is a modified Nazi's uniform. To represent the tank's notorious fuel consumption, he has been made a glutton (my first concept of him was as a fat guy). He is neither fast nor agile, being weighed down by the enormous cannon.

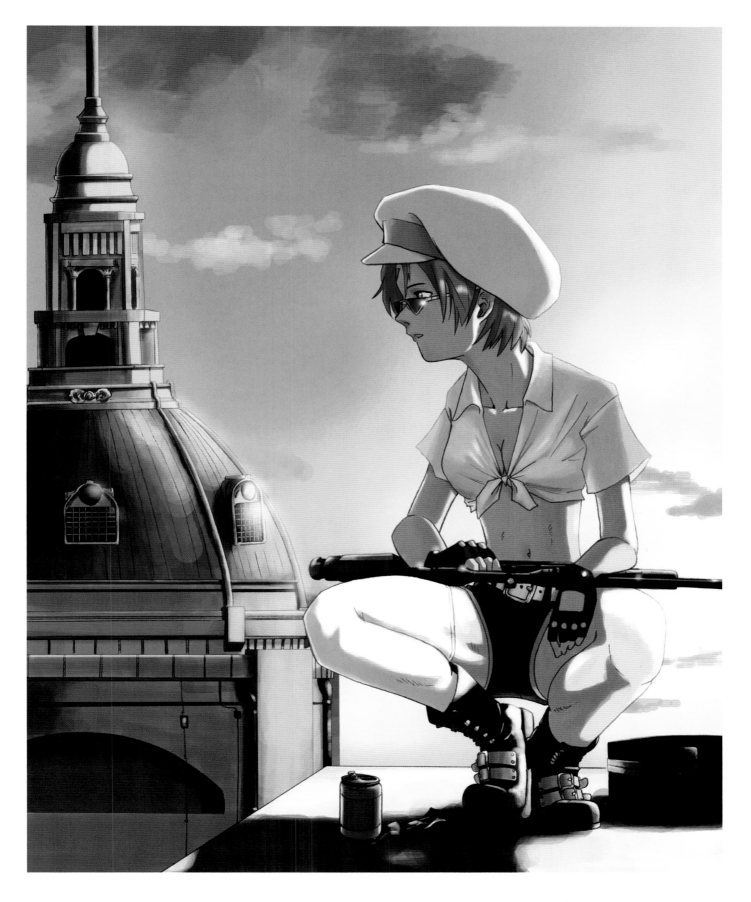

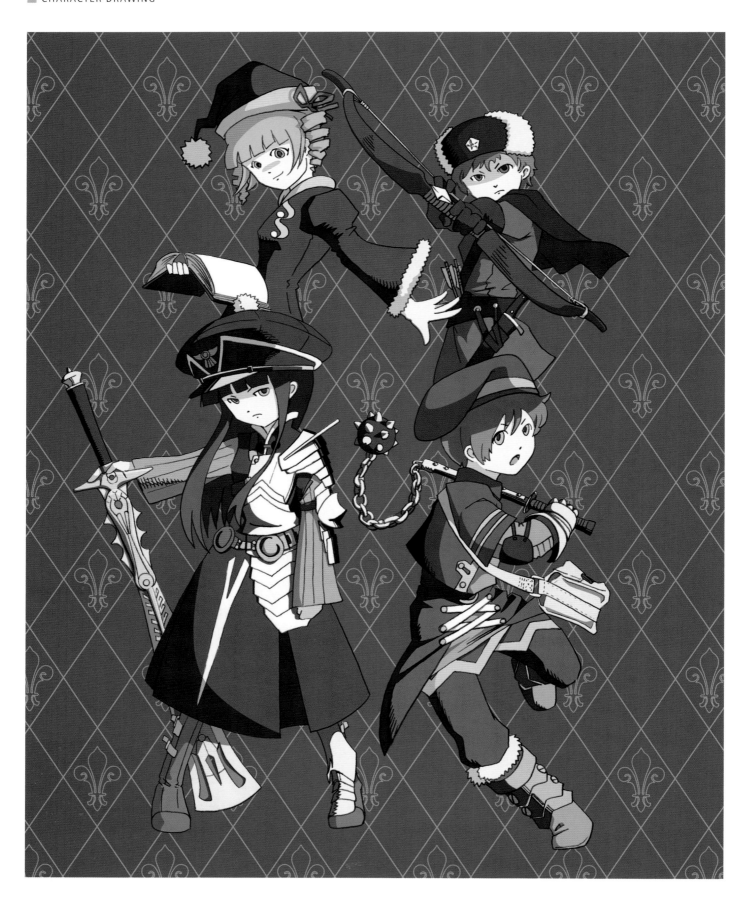

OPPOSITE: **Examples of fantasy characters. The top ones are rather traditional. The bottom ones, however, are inspired by military costumes and look more modern and interesting.**

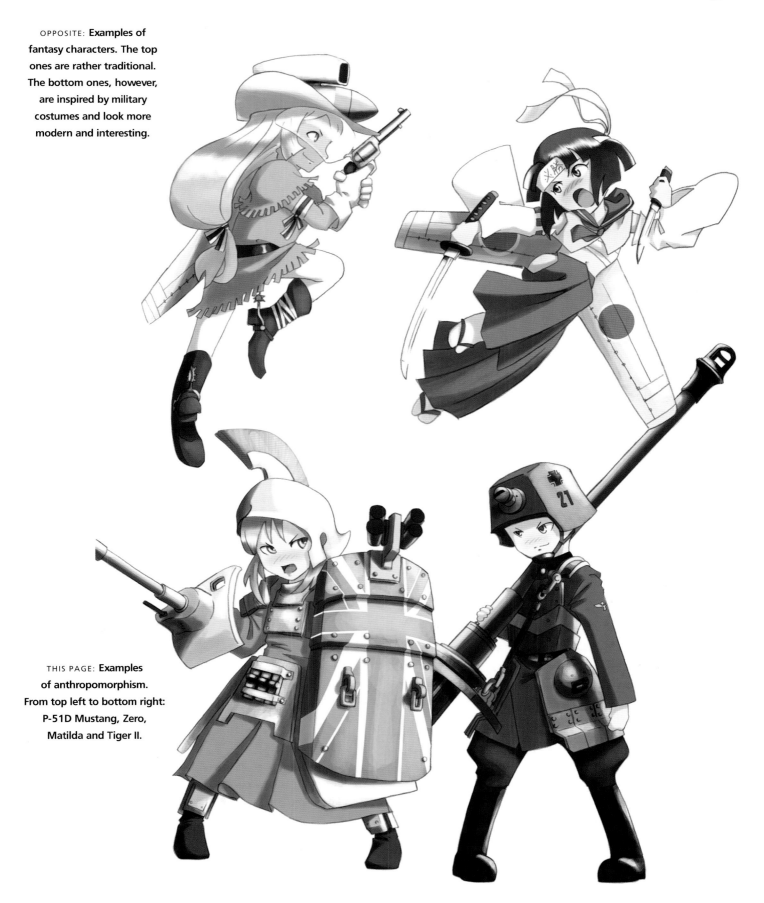

THIS PAGE: **Examples of anthropomorphism. From top left to bottom right: P-51D Mustang, Zero, Matilda and Tiger II.**

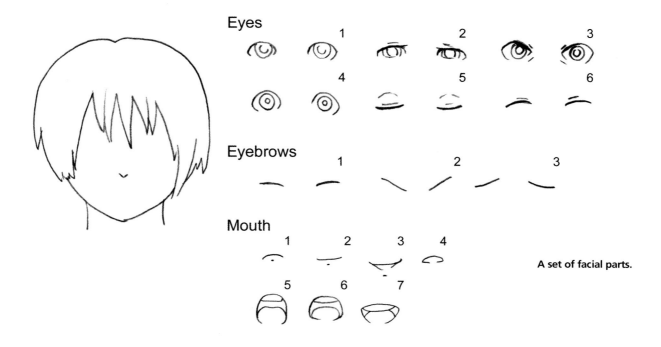

A set of facial parts.

Expressions

As suggested earlier, Manga is not a way of depicting the real world but of depicting 'your' reality. It is therefore important not to draw the characters' actions and expressions straight from photos and films unless you have a good reason for doing so. In order to maximize the drama, Manga has developed a series of techniques involving facial expressions, gestures and postures (and how to express movement), special effects, and using items (props and accessories). These are explained in the following sections.

Facial Expression

A person's face is made up of several parts, namely eyes, eyebrows, nose, mouth, wrinkles and cheeks. Facial expressions might be considered complicated, but they are basically the combination of these parts, and therefore we can re-create any facial expressions by combining these parts. With the 'part system' (see page 48) a variety of characters can be created by combining several face parts; in the same way you can prepare a series of patterns and combine these facial parts, and this is basically how Manga/Anime deals with facial expressions.

You might want to consider the tone of the scene. For example, if you are drawing a serious scene, avoid using over-simplified (and over-exaggerated) facial expressions, and keep to more realistic representations in order to maintain the serious tone; use hyper-stylized features in more comical scenes.

In the following section you will find a set of facial parts with various patterns – six for the eyes, three for the eyebrows and seven for the mouth – to demonstrate how each facial expression is created by combining them. Of course, you can't create the best expression by cutting and pasting the patterns, since all facial parts change their shape and size slightly in relation to the others (this is why some look a bit strange).

Note that the methods described here do not comprise the only way. Manga techniques offer such freedom of expression, if you have another method, then use that too!

SMILING AND LAUGHING

Smiles and laughs are the most widely used expressions and have countless variations. They are welcoming, and look better than a blank face so they are used not only to express pleasure or happiness but also to convey a neutral state. However, this makes facial expressions extremely diverse and very difficult to depict: be careful, or the facial parts don't hang together.

Generally, as a smile grows bigger, the eyes become narrower and the distance between the nose and mouth becomes shorter. A common mistake when drawing a wide smile with open eyes is not making the eyes narrow, and the smile then seems artificial. Shortening the distance between eyes and nose, and nose and mouth will also help make the smiling face appear more natural.

A happy, welcoming smile is not the only type of smile, and each one should be approached in a different way. For example, if you are drawing a happy smile, it looks better when the

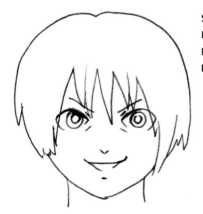

Smile 1
Eyes: 1
Eyebrows: 1
Mouth: 2

Smile 2
Eyes: 6
Eyebrows: 1
Mouth: 2

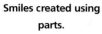

Smiles created using
parts.

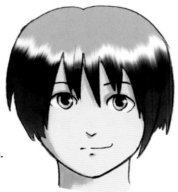

Smile 3
Eyes: 3
Eyebrows: 2
Mouth: 3

Smile 4
Eyes: 4
Eyebrows: 1
Mouth: 7

Examples of smiling.

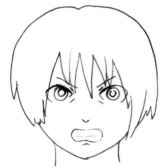

Angry
Eyes: 3
Eyebrows: 2
Mouth: 8

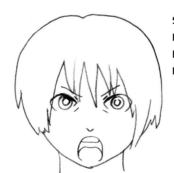

Shouting
Eyes: 3
Eyebrows: 2
Mouth: 5

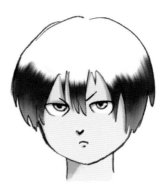

Angry and shouting face created using parts.

A sulking face.

character's face is lit up. If he is smirking and looking up with a lowered head, he appears confident and strong. But if he is smirking with his head held high and looking down, this gives the impression that he is being playful and perhaps overconfident.

ANGER AND SERIOUSNESS

Showing anger and seriousness are essential facial expressions when depicting action and movement, and they also serve to build up tension. When creating an action Manga it is essential to know how to convey these emotions, and how to depict the power and tension radiating from within the character. Wide open eyes and mouth are generally associated with this facial expression; clenching the teeth is also a good way, although this changes the nuance of the expression slightly. Basically, an open mouth suggests the release of power within, while a closed mouth suggests that the character is holding power inside: it is not yet released. An open-mouthed expression best represents insolence and energy, and a closed mouth defensiveness and passivity. Be careful, however, when you draw the mouth wide

open, because it could suggest your character is laughing: this happens if you draw the mouth too wide horizontally.

When drawing wide open eyes, adding in wrinkles around them (and the eyebrows) helps to emphasize (and naturalize) them. It is also important to make the shape of the eyes sharp, because just making them wider tends to make the character look insane. Occasionally it is effective to add a little colour to indicate the character is flushed, to show that he is excited.

Another form of angry facial expression is sulking. To convey this effectively make the mouth tightly shut, to represent the character's efforts to keep quiet, and the eyes half closed and not wide open.

A serious face has sharp eyes – though not as sharp or as wide as angry eyes – and a closed mouth. It is not advisable to draw the mouth open, because an opening mouth represents communication and here, the focus of attention is on the outside world: so unless the character is actually talking, he is focusing on himself, and a closed mouth represents this. This is different from real life, when our mouth tends to be open when we concentrate: this is generally because we are too busy doing things to remember to close it.

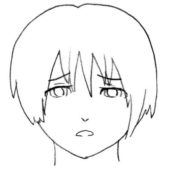

Sadness 1
Eyes: 2
Eyebrows: 3
Mouth: 4

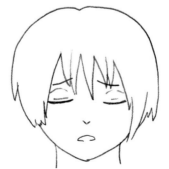

Sadness 2
Eyes: 5
Eyebrows: 3
Mouth: 4

A sad face created using parts.

SADNESS AND CRYING

Sadness is depicted by narrowing (or closing) the eyes, and by drawing a tightly closed mouth. By drawing the mouth closed, you imply that the character is trying to contain overwhelming emotion. Depicting tears welling up is a good way to express sadness. I generally use two techniques to draw eyes with tears: one is to blur the iris, and the other is to add more highlights in the eyes, and make the colour brighter. The first is suitable for black and white images, and the second for coloured ones. The skin colour also changes, and the cheeks, nose and around the eyes (and the eyes themselves) need to be coloured pink, thereby conveying that the character is flushed with emotion.

Two types of tearful eyes.

FEAR

Wide open eyes and a slightly opened mouth convey fear. I usually brighten the eye colours, but with fewer (or no) highlights (this is the third rule of the eyes). The skin should be pale, without any flush of colour. In black and white images you can also use icons (or tones) to express the paleness of the skin (*see below, page 76*).

When characters scream, you might think that the eyes should be narrowed, just as for smiling. However, in these circumstances the eyes would actually be wide open, so as to look at what is frightening them: when you are terrified, you almost always gaze at the cause of your terror. If the character is looking in a different direction, the onlooker would feel they weren't really terrified.

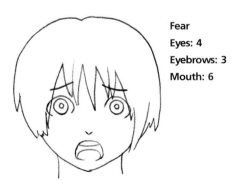

Fear
Eyes: 4
Eyebrows: 3
Mouth: 6

A fearful face created using parts.

PAIN AND FROWNING

These two facial expressions seem quite different at first glance, but in fact they have a lot in common, perhaps because both suggest someone fighting against massive stress. The character has narrowed (or tightly closed) eyes and clenched teeth. Also, adding sweat drops and exaggerated wrinkles, as in the depiction of an angry face, will help to enhance the feeling of stress.

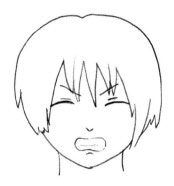

Pain
Eyes: 6
Eyebrows: 2
Mouth: 8

A face in pain created using parts.

SURPRISE

A person's reaction when they are surprised is quite similar to fear, in that both eyes and mouth open wide. The eyebrows differentiate the terrified expression from the surprised one: when feeling fear, the eyebrows go down, but when surprised, they are raised up and become arched. The skin colour also changes, and it is sometimes effective (though not always) to add a touch of red to the face: making the character look flushed is a way of conveying that they are excited.

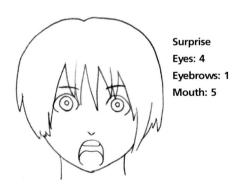

Surprise
Eyes: 4
Eyebrows: 1
Mouth: 5

A surprised face created using parts.

LOOKING RELAXED

Traditionally, a relaxed expression is depicted by softly closed eyes, often accompanied by a smiling mouth. It is important to express softness, so avoid drawing in shadows on the face that

are too strong, or using any strongly contrasted colours, because these will destroy the calmness and softness of the character's overall expressions.

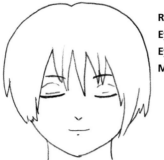

Relaxed
Eyes: 5
Eyebrows: 1
Mouth: 2

A relaxed face created using parts.

MADNESS

Wide open eyes constitute the most obvious feature of the facial expression conveying madness. Quite often the irises are drawn smaller to further emphasize how wide open the eyes are (sometimes, especially in Anime, these eyes are lit like torches). In fact you have to exaggerate everything to convey the lunatic inside the character. It might even be a good idea to change the drawing style to show that he is completely 'other-worldly'. When I draw, I put heavy lines under the eyes to create an impression of unease.

BREAKING THE RULES

By now you will have learned something about how to draw most of the facial expressions necessary for a Manga. But as humans we can make much more complicated expressions – and sometimes even an expression conveying more than one emotion. You might be required to draw these sometime in the future, and if you find drawing such complicated facial expressions difficult, you must have the courage to try another way. Stephen Jay Gould, a famous American biologist, wrote in his essay how he was amazed that Michelangelo's *Statue of Moses* could convey two quite different emotions at once. He then analysed the statue and found that Michelangelo achieved this by picking out the expressions partly from one emotion and partly from the other.

More than one emotion can be expressed at one time by combining the elements of these emotions, just as the great artist did. Fortunately in Manga you have more than facial expressions up your sleeve (such as icons, background effects and so on), so in fact you have more freedom than Michelangelo!

It has been explained at length how to express emotion, but what if the means of conveying an expression is removed? You might think that this is contradictory, but hiding a part, or all of a face removes the character's facial expression and as a result makes him seem cold and inhuman – in the same way the ancient Gladiators wore a full face helmet so they were made to think they were fighting an impersonal 'enemy', and not a living human being.

Hiding the eyes is the most commonly used, and the most effective way to achieve this. This is good for a Manga charac-

Sad smile
Eyes: 2
Eyebrows: 3
Mouth: 2

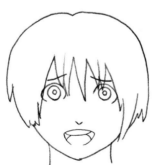

Confused smile e
Eyes: 4
Eyebrows: 3
Mouth: 7

Faces with complicated expressions created using parts.

Annoyed/sulking
Eyes: 2
Eyebrows: 2
Mouth: 1

Apologetic
Eyes: 1
Eyebrows: 3
Mouth: 2

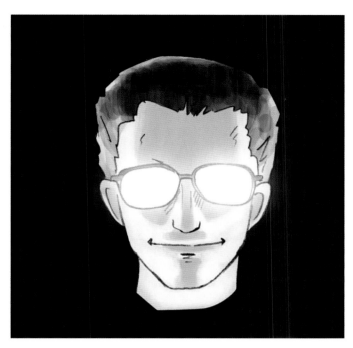

Hiding eyes behind glasses is a good way to make a character seem inhuman. Here, the effect is further emphasized by the reflection on the glasses, the dark background and reversed lighting.

ter, because even while hiding the most expressive part, you still have other parts that can be used to express emotion when necessary. Although it is common to use items and accessories (such as sunglasses and masks, as well as tall collars) to hide emotion, shadows and reflections on glasses are also used to hide the eyes for a short period of time.

Gesture and Action

Body language and action are just as important as the facial expressions in depicting drama. Proper body language enhances emotion, and well balanced actions create drama, thus giving the reader a strong message. In this section, 'gesture' refers to the way to represent the inner feeling of a character, and 'action' the way to react to the outer world.

BASIC RULES OF GESTURE

How a character is standing in relation to the others gives a clue to his general attitude towards them. Look at the illustrations: the first one shows a man facing a girl; this is an ordinary state, and it shows he is friendly and attentive. In the second one he is not fully facing the girl, which shows he is not wholly friendly; he might be on his guard, or even slightly hostile. In the last one he is showing his back to her, and this depicts rejection: he is not friendly at all, and is possibly hostile.

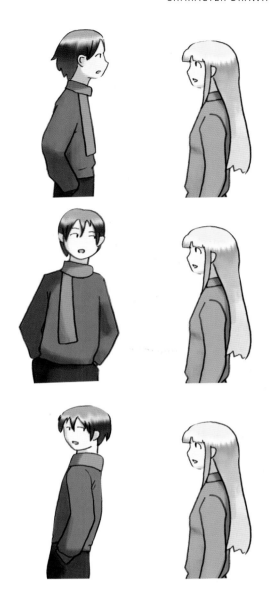

Three examples of people engaging in conversation.

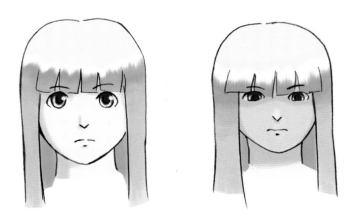

The shape of the face is important to create an overall impression.

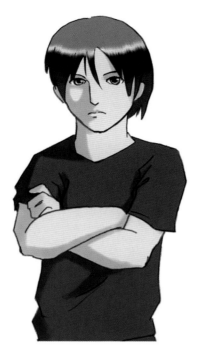

Crossing arms is a sign of defensiveness, alertness and hostility.

Noh, a traditional Japanese theatrical play, developed certain techniques to represent emotions while wearing a mask (the Japanese saying 'face like a Noh mask' means 'blank face'). Raising the head and thereby making the mask lighter gives a positive impression, whereas lowering the head to cast a shadow over the mask gives a negative impression. Manga/Anime artists use this technique to convey the emotion of the characters, and this effect can be further enhanced by controlling the shadows across the face.

Crossing your arms is usually regarded as an expression of rejection, defensiveness or hostility; it is also said that you are unconsciously trying to protect yourself. Furthermore, if you're right-handed, your right arm is placed on the outside, and if you're left-handed, then it's the other way round.

Palms are also an important part of conveying emotions. In general, turning the palms down to someone represents rejection. However, if the palm is facing upwards, this conveys welcome and acceptance.

Legs also give messages. Thus if someone is sitting with his legs crossed, he is relaxed. Standing with the legs wide apart represents confidence and power. Standing with the heels touching gives the impression of being well disciplined, even militaristic.

As already mentioned (*see* page 44), mannerisms and idiosyncrasies can be a very effective way to denote emotions. For example, if your character has a certain idiosyncrasy that is linked to a certain emotion, you can use this to reveal his emotions more effectively. In this way, you can create a scene where his idiosyncrasy betrays him.

A variety of items can be used to represent emotions. One notable example is a cigarette. Smoking denotes either relaxation or stress, depending on the situation. The use of such items often has a strong connection with the character's idiosyncrasy.

Cultural difference is of less importance. It is often confusing when introduced without explanation. However, it can be a very powerful way to give diversity to your story, if used appropriately.

SAMPLES OF VARIOUS GESTURES

Below are various gestures demonstrated by the three main characters from the Sample Manga: Darc (left), Cyl (centre) and Krelia (right). They are posing in different gestures to show that there are many ways to express certain expressions with slightly different nuances.

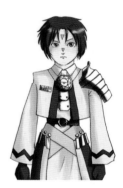

Normal, or blank state.

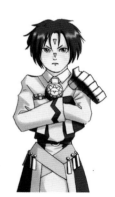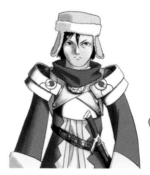

Serious.

Normal: This is the blank state and the basic stance. These images are of an earlier design (and drawing style), and are slightly different from those in the Sample Manga.

Serious: This is a serious, or concentrating expression. As you look at these three figures, you can see that even though their facial expressions are virtually the same, their impression differs. This is achieved by the position of the arms, as well as the height

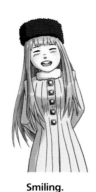

Smiling.

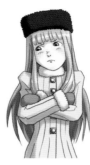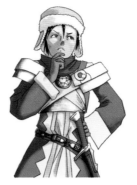

Thinking.

of the shoulders. A raised shoulder generally gives you the impression that the person is angry.

Smile: Exposing the front of the body is a sign that the character is welcoming. In the centre, Cyl is holding her arms behind her back, which makes her seem quite welcoming. Also note how the way the characters position their faces varies the impression they make. Cyl, in the centre, is facing the front and is looking up slightly, which creates a very positive impression. On the other hand, Krelia, to the right, isn't facing the front and is looking up to you; this makes her look sly and challenging, even though her overall appearance is not hostile. The impression made by Darc, to the left, is not as wholeheartedly welcoming as Cyl's, but not as challenging as Krelia's.

Laughter: Strong emotions, such as laughter, often reveal a character's real personality. Here, Darc's gesture, with widespread arms and a body arching backwards, creates the impression that he's open and welcoming. Cyl is pointing at something, most likely the cause of her laughter. When you are drawing this gesture, be careful not to make her look mean; this is because the gesture implies that she is laughing at something, and this is inherently a negative action.

Thinking: Putting a hand on the chin is the gesture most associated with 'thinking'. It is better if the eyes do not look directly at people, including the reader, because the character is now self-contained and 'closed' to the outside world. Placing the arms in front of him is one way to express this 'self-containment'. Also note that people tend to look up when they are trying to remember something; when they are looking for a solution, they tend to look down.

Sadness: Lowering the head best illustrates this emotion – though as you can see in Krelia's example, it is possible to make the face look up. In this case, it looks as if she is about to say something out of her sadness. Holding the hands to the chest, as in Cyl's and Krelia's examples, indicates their effort to contain their emotion.

Puzzled: When you are puzzled, you are thinking, but you are also examining the situation. This 'examination' is the difference between 'thinking' and 'puzzled'. The eyes' direction can be anywhere. Darc is closing his eyes, showing his utmost concentration. Cyl is looking at something, and her eyes and face are

Sad.

Laughing.

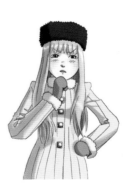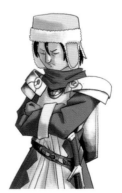

Puzzled.

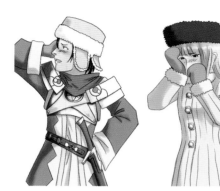 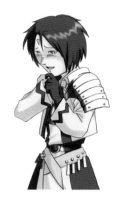 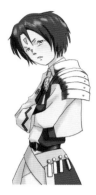

Embarrassed.

Cold stare.

both facing the same direction as her body, indicating that she is giving it her full attention. Krelia's hand is scratching her head and her eyes are wandering, showing that she is not as confused as the others.

Embarrassed: When people are embarrassed, they find it very hard to look straight at others, and their hands start searching for something to occupy them. Hiding the face conveys a strong message that the character is feeling embarrassed, just like Cyl in this example. Japanese girls try to pull down their fringe to hide their eyes when they are embarrassed, or their hands start playing with their hair (playing with the hair in fact denotes uneasiness). Darc's gesture, with widespread arms and open countenance, means he has more or less accepted his embarrassment. But in many cases it is more natural for an embarrassed person to display signs of rejection, such as folding his arms in front of his body and avoiding facing others.

Surprised: The body and face of all three characters are facing front, which shows that whatever has surprised them is demanding their full attention. Notice that the hair is drawn spread out, to depict 'shock'. If the tone of the scene were comical, or if they were Chibi characters, their hair would literally stand on end. The arms are usually raised, so they are ready to defend themselves from danger. Also notice the Japanese gesture of hiding the mouth, as explained earlier (*see* page 47).

Cold stare: This gesture is full of rejection. The characters' eyes

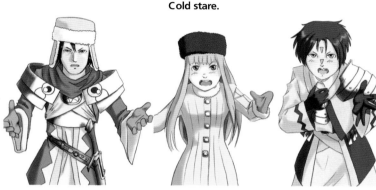

Arguing.

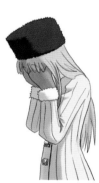

Crying.

are looking down, and not directly at you because you are not important to them. In the illustration Cyl's hand is not only keeping her hair out of the way, but by putting her arm between you and her, she is also blocking you out.

Arguing: Arguing is an attempt to deliver a message from one to another. Here, both face and body of the characters are directed forwards, to show they are paying you their full attention. The hands are spread out with the palms upwards, to show they are trying to share their feelings with you. Krelia's gesture, with one hand placed on her chest, indicates she is giving something from her heart.

Crying: Crying is a stronger version of sadness, and basically follows the same principle.

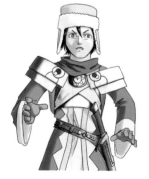 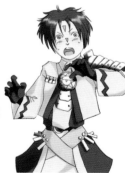

Surprised.

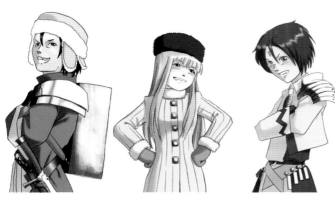

Grinning.

Annoyed.

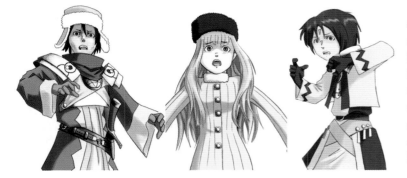

Fearful.

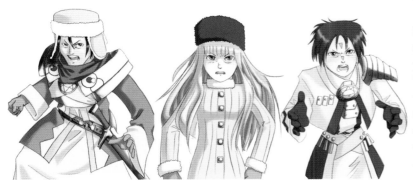

Anger, fighting.

Grinning: The most important aspect of grinning is confidence, to the point of arrogance. This feeling of arrogance is best expressed when a character is looking down on you, just as Darc and Cyl are doing. If a character were not looking down on you, as Krelia in this illustration, the implication of arrogance would be lessened.

Fear: In terms of gesture, fear is very similar to surprise, because both are a reaction to danger. The arms are usually placed in a defensive position. Cyl's example shows she is cornered, and she is pressing her body to the wall behind her in an attempt to make her body as flat as possible. Making the body recoil represents the instinct to keep as far away from danger as possible.

Anger, fighting: These two emotions are basically a 'burst of

energy'. The body language is either bending forwards (or crouching) to show a readiness to fight, or stretched out to increase height and intimidate the opponent. In most cases the legs are spread wide to support the body firmly. Cyl's hair, in the centre, is spread, as when depicting surprise: in this instance it represents the anger emerging from within her.

Annoyed: This expression is full of rejection and discomfort. Adding a hint of hostility and anger is a good way to emphasize how much the character is annoyed.

Posture and Action

In order to understand how to draw a figure in action, you first need to understand how to draw a figure properly. If you don't, you cannot draw any credible action.

Two things must be considered when drawing a figure: proportion and balance. Proportion requires a number of things, the most obvious being the size and length of each body part. Less obvious are perspective and flexibility. Understanding perspective is essential to drawing dynamic movement and to creating drama, and flexibility to creating figures in action that are credible. Balance not only creates stability for the figure, but can also be used to suggest additional movement. I also use it to refer to the co-ordination of an entire body.

A successfully drawn figure satisfies these conditions.

PROPORTION

Although many Manga and Anime story themes feature characters whose bodies are exaggerated, their bodies are still based on actual human bodies, and therefore acquiring an understanding of the human anatomy is the first step in drawing a credible figure.

Most art books claim that the overall height of a human should be eight times the length of the head. I draw the head slightly bigger, so that the overall height is from 7.5 to six times the length of the head (this is simply because I don't find such

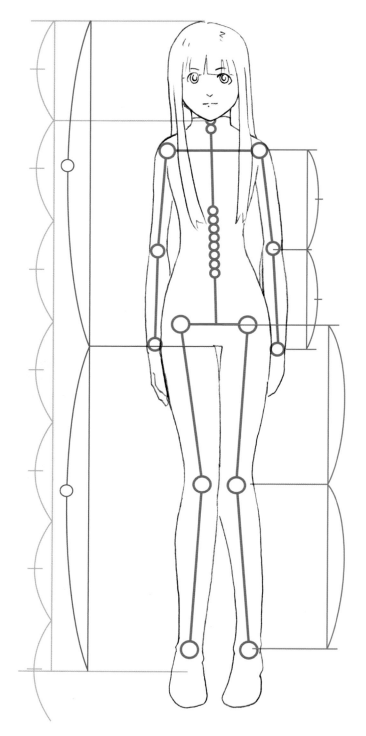

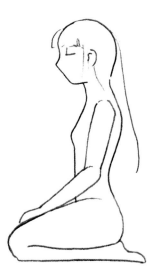

LEFT: **This diagram shows the proportion and basic bone structure. The arcs represent the length of body parts in relation to the others. The red lines and circles represent bone structure. The circles are supposed to be the joints.**

ABOVE: **This shows a girl sitting in** *seiza* **fashion. When sitting in this way, it becomes apparent that the thighs and shins are of almost equal length.**

'artistically perfect proportions' realistic). In general, if the character is shorter, this ratio shortens slightly.

The legs should be slightly shorter than, or the same length as, the rest of the body. If they look too short in this proportion, this is usually because they have been drawn too thick, or the thighs too long. The knees and ankles provide an indication of how thick the legs should be: these parts are not covered with muscle and fat, so they reveal the basic thickness of the legs.

Another way to make the leg look longer is to draw the shins slightly longer than the thighs.

The thigh is almost as long as the shin, and when you sit down on the floor with your legs folded under the body (*seiza*, in Japanese), your feet come just under your hip.

The upper and lower arms are also the same length, and when the arms hang down, the tip of the fingers should come to the middle of the thigh and the elbows slightly above the waist.

The fingers and the shape of the feet differ widely according to racial and cultural background as well as lifestyle; Japanese people tend to have wider feet, for example. I also recollect the hands of an Okinawan Karate master, who trained to break a wooden board 3cm thick with his fingers extended straight: all his four fingers were the same length, making a perfectly straight line from the index finger to the little finger – though this anatomy must be unique.

The best way to learn proportions and so enhance your drawing skills, is through life drawing. However, it might be difficult to get a model, so in this instance it is acceptable to resort to photos and magazines. These are points you need to check before you buy them:

- the bodyline must be clearly visible (the model should not be wearing baggy clothes);
- all, or most of the body must be revealed;
- the picture should not be taken from an acute angle;
- the figure must not have a contorted posture.
- The models don't have to be naked: the whole point of life drawing is to learn how body parts relate to each other, and how they are proportioned, without being obscured by clothing, so a swimming costume or clothing that reveals the bodyline is perfectly acceptable.

PERSPECTIVE

You will not draw all your scenes in the story only from a side view. By changing the viewpoint, you can create drama and give various messages to the reader. You need to think and observe how each part is elongated, shortened, hidden and changed according to the angle of view. Another aspect of perspective is the character's relation to the background; in Anime, this is called 'Pa'a-su', from 'perspective'. If your character is not standing with the correct angle to the background, he looks as if he is recreating Michael Jackson's famous Smooth Criminal.

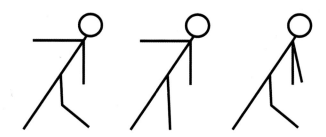

Matchstick men showing how to balance a figure.

FLEXIBILITY

Flexibility refers to how much each joint can move, and how a whole body is able to co-ordinate. Body movement is restricted not only by the limitations of its flexibility, but also by its costume and muscles. In turn, understanding how the body co-ordinates helps you to create the momentum and stability of an action. You might think it is easy, but once you start to draw complicated postures or a figure in action, you'll understand how important it is to have a knowledge of flexibility and body co-ordination in order to draw a credible figure.

BALANCE

If, when you draw, your figure appears to be collapsing on one side, or is unstable, this is because you have misplaced its centre of gravity. A human's centre of gravity is just behind the navel, and to draw a stable figure you need to place this point roughly at the mid point between his feet.

This often does not quite work, however, especially if you are drawing an action scene. Look at the matchstick man on the right in the illustration: he is almost the same as the matchstick man on the left, but he looks unstable. The cause of this instability is, as you can see, the arms, and the solution to this problem is to decide where the weight should be centred, and to distribute the weight on both sides. The left matchstick man's figure represents this, as his arm is stretched out to give weight to the left side of his body. The centre of weight can be any place between both feet. However, he appears most stable if it is placed at the mid point between the feet. This balancing action is part of body co-ordination. We unconsciously make this kind of counter-weighting and counter-movement to keep balance in almost every action.

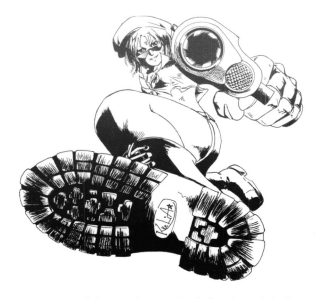

Every now and then you have to check that the body is drawn properly. With such acute angles, it is very easy to confuse the proportions of the body. It is challenging, but the result is satisfying if you take care.

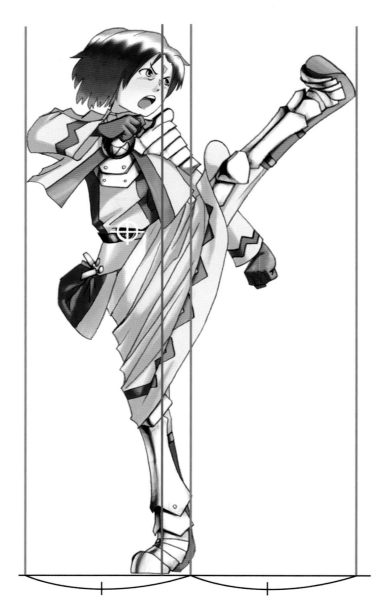

Balancing with one leg.

When a character is standing on one leg, this issue becomes more problematic, since you have to place the leg precisely at the centre of weight. The illustration shows this situation. The red lines indicate the outermost points of the body (the width of the figure), and the red line in the middle is the centre line, a rough indication of the centre of weight. The blue line is the actual centre of the weight and the place where the supporting leg should be placed. The body is not the only thing to be counted as weight: there are also objects (props), costumes and weapons. If your character is carrying heavy items, his centre of weight shifts accordingly. The white cross with a circle on the belt is the centre of gravity, although this point is not important in this situation.

CREATING MOVEMENT

Removing stability: Now you have learnt how to stabilize a figure. A stable figure, however, has one huge problem – it is almost impossible to use him to depict movement. Because a stable figure is so well balanced (and that's the whole point of it), any movement of the figure is neutralized by its stability. So, if stability neutralizes movement, removing stability would bring about movement – and the illustration shows this.

The left figure, the same one used to explain the balancing, is a balanced figure. The right figure is carrying out the same action but the centre of weight is shifting to the right – you can see the right figure looks as if she is moving to the right. We know by experience that if you posed like her, you'd fall to the right, and this assumption creates the illusion of movement (the

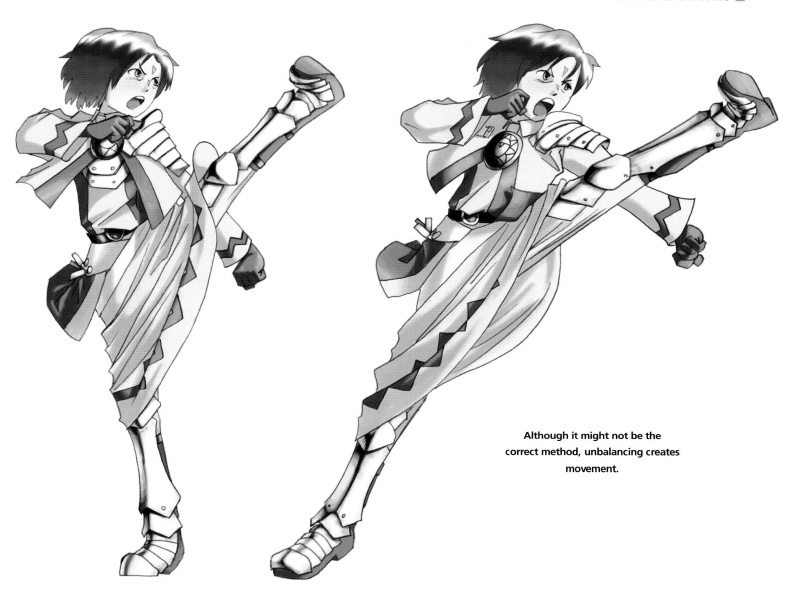

Although it might not be the correct method, unbalancing creates movement.

same thing happens when you step on to an escalator that has been stopped).

Exaggerated perspective: Another way to depict movement is to exaggerate the perspective. Although this only works when something, or someone, is zooming in or out, it does create a great sense of motion. Not only exaggerating the perspective, but also elongating a part of the body can be included in this technique.

Blurring: One of the most widely used techniques to depict movement is to blur a part, or all of the body. Quite often the blurring is accompanied by a trail, to further emphasize the speed as well as showing the course of the movement. You need to be careful, however, not to blur so much that the blurred part becomes unrecognizable.

Special Effects

'Special effects' in this book refers to a series of techniques that are characteristic to Manga/Anime to depict its drama. These work just like a pictogram, to evoke a certain emotion or atmosphere.

ICONS

Icons are the most obvious special effects that you'll find in Manga and Anime. You might have found them strange at first, but once you understand their meanings, you will realize how a single icon can enhance the drama of the scene. Most of these icons are the pictorial representation of a Japanese saying, which

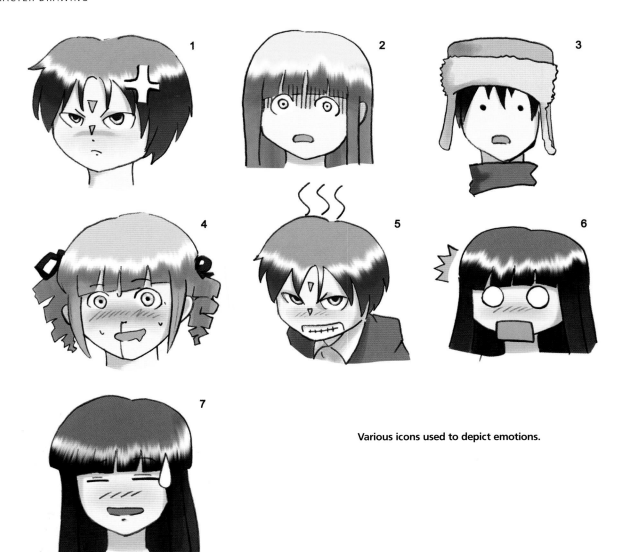

Various icons used to depict emotions.

is why they are so unfamiliar at first sight. Equally this means that you can create your own version of icons using English sayings. There are hundreds of these icons, and it is impossible to list every single one of them. I have picked seven that are widely used in Manga/Anime.

1. This '#'-like icon is a stylized blood vessel and represents anger. The original Japanese saying is 'stands blue lines (or showing blood vessels)'. When you are angry, the heart pumps a lot of blood to your head, and as a result, blood vessels appear on your forehead.

2. These vertical lines represent 'paleness'. The Japanese equivalent of 'turning pale' is 'turning blue', so in Manga/Anime the colour blue is used. Vertical lines represent blueness in a black-and-white media.

3. 'The eyes become dots' is a Japanese way of saying 'surprised' or 'gobsmacked'.

4. 'Getting (sexually) excited > blood pressure soars up > weak blood vessels rupture > bleeding from the nose' is the sequence of events that explains this strange icon. It is almost always employed in a comic situation, and both the quantity and the strength of the blood flow are quite often exaggerated.

5. Steaming from the head is another way to illustrate anger. Your head gets so hot that it starts steaming. Although it illustrates anger (as above), this is used to depict a much calmer anger. Another use of this icon is to express embarrassment, though in this case make sure the character's face is sufficiently red so that the reader can recognize that he is embarrassed, and not angered.

6. 'Having round eyes' is a Japanese saying used to express surprise. Another expression to depict the same situation is 'having a face like a pigeon getting hit by a pea (the pigeon's eyes are round)'. The mouth in the illustration is

**Shadow effects. It's often effective to add crosshatching to give
texture to shadows as in the right hand example.**

nothing more than a representation of a wide open mouth, but sometimes a very similar style of mouth is used to express something surprising. In this case, the mouth is the pictorial representation of the Japanese saying 'I can't close the open mouth', to represent the utmost surprise.

7. Sweat drop(s) are perhaps the best known Manga/Anime icon. They represent confusion, an inability to react to a situation. Despite its name, this icon cannot be used to express real sweat.

SHADOW EFFECTS

Since Manga is mostly printed in black and white and is trying to re-create the representational techniques of moving images, it is obvious that it has borrowed some techniques from film noir. Alfred Hitchcock's film *Psycho* reveals that drama can be created by the use of shadows. Casting shadow across the face makes the character sinister, or even terrifying; this is further emphasized by growing eyes. Shadows can also be used to create tension, but in this case you enhance the original shadow, not add another shadow.

BACKGROUND EFFECTS

Musashi Miyamoto, a famous swordmaster, wrote 'Since a Samurai carries two swords, he should master how to use these two swords.' The import of this saying is that you cannot create a Manga with figures alone, but must also consider the influence

of background and foreground, just like the Samurai's two swords. Thus background can be used not only to depict the kind of place where the scene is set, but also to depict and enhance the drama of the scene. Some examples of background effects are shown on page 78:

1. **Blank:** A blank background shows 'nothing', and this emptiness can be used to depict the 'blank state', such as being so surprised that the character cannot think of anything.

2. **Gradation:** A gradated background is useful when you feel the background is too empty, but you don't want it to appear too busy. The illustration shows two patterns of this effect: if the upper part is darker (as in illustration 2a), this gives a depressing feeling to the scene; when the bottom is darker (as in illustration 2b), the atmosphere of the scene is easier. This tendency is more pronounced in the black-and-white image. If you are creating a colour image, just as you can see in the examples, the colour of the gradation is the key to determining the atmosphere of the scene.

3. **Black background:** Sinking the scene into darkness creates two different impressions. One is stillness, and either this can represent that time has stopped physically, or that time within the character's mind has stopped (a state in which he is too shocked to react to a situation). This background effect also depicts his isolation from other characters.

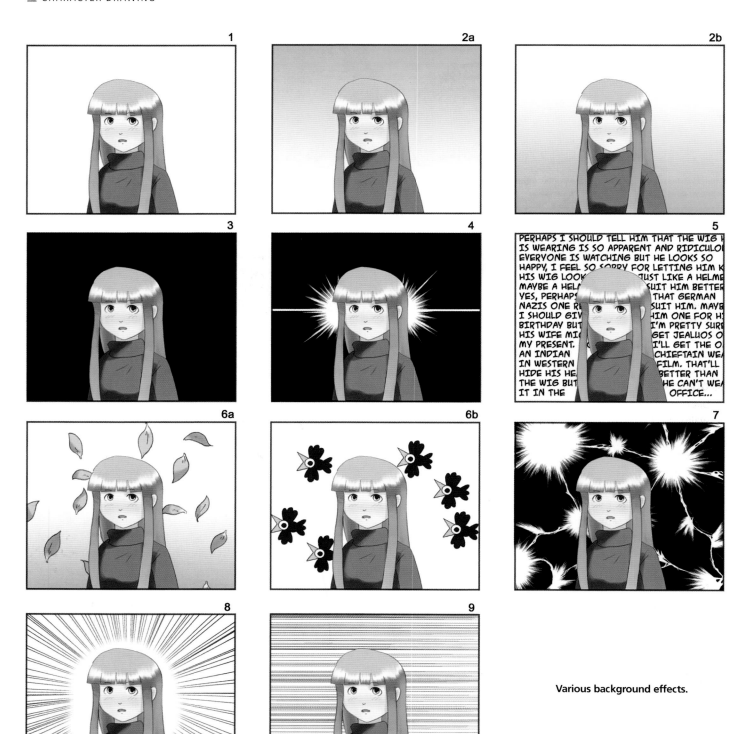

The text visible in panel 5:

PERHAPS I SHOULD TELL HIM THAT THE WIG H
IS WEARING IS SO APPARENT AND RIDICULOL
EVERYONE IS WATCHING BUT HE LOOKS SO
HAPPY, I FEEL SO SORRY FOR LETTING HIM K
HIS WIG LOOK... JUST LIKE A HELME
MAYBE A HEL... SUIT HIM BETTER
YES, PERHAPS... THAT GERMAN
NAZIS ONE R... SUIT HIM. MAYBE
I SHOULD GIV... HIM ONE FOR HI
BIRTHDAY BUT... I'M PRETTY SURE
HIS WIFE MIC... GET JEALUOS O
MY PRESENT.... I'LL GET THE O
AN INDIAN... CHIEFTAIN WEA
IN WESTERN... FILM. THAT'LL
HIDE HIS HE... BETTER THAN
THE WIG BUT... HE CAN'T WEA
IT IN THE... OFFICE...

Various background effects.

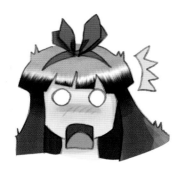

Showing how an item (in this case a ribbon) can support the depiction of emotion.

4. **Ping!:** This effect depicts divine inspiration, or realizing something very important. Sometimes the former expression is depicted by a light bulb floating above a character's head.

5. **Words:** Words used as a background show what the character is thinking or mumbling relentlessly. If the character in the scene is reading something, you can use this to show what he or she is reading.

6. **Objects:** Almost any objects can be used in the background to depict drama, in a fashion more like wallpaper than scenery. The overall effect of this expression varies with what you choose. Flower petals (often accompanied by a haze), as in illustration 6a, are used to create a romantic atmosphere, while the birds in illustration 6b make the scene silly and comical.

7. **Lightning:** A lightning flash is quite similar to 'ping', the fifth example. This represents surprise and shock.

8. **Concentration lines:** Concentration lines are essential when drawing action, and give the effect of zooming in and out. Also, as in this example, they can attract attention to the focal point, that is, someone/something you want to be the centre of attention. This effect is also used to single out a particular character from a crowd, just like pointing out Wally in the *Where's Wally?* series.

9. **Speed lines:** Speed lines create the movement horizontally, vertically and diagonally in a scene. This example suggests that the camera (or the reader's eye) is moving horizontally at a fast speed. When horizontal speed lines are used with several characters, they shift the attention of the reader from one character to the other in quick succession.

USING ITEMS

Look at a cat or a dog and you can see how they use their ears and tails to express their emotions. These gestures were adopted in Manga, with items to act as the ears and tails. Most of the items used in this technique are accessories and they must be in the same position as they would be found in their animal counterpart. And the shape is better if it looks similar, although this is not really necessary. The important point is that the reader must recognize the items' movements and relate them to the character's expressions. If the tone of the scene is very serious it would not be appropriate to employ this technique, and it would be best not to use it.

Chibi Characters

A Chibi character ('chibi' means 'small' or 'midget' in Japanese and is not really a polite word, so be careful) is the most stylized drawing style and one of the most unique features you'll find in

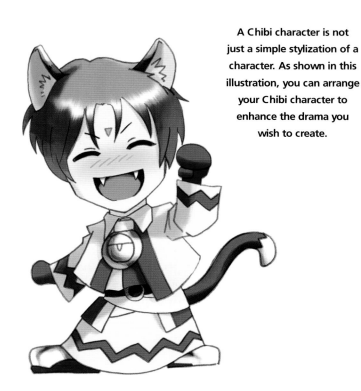

A Chibi character is not just a simple stylization of a character. As shown in this illustration, you can arrange your Chibi character to enhance the drama you wish to create.

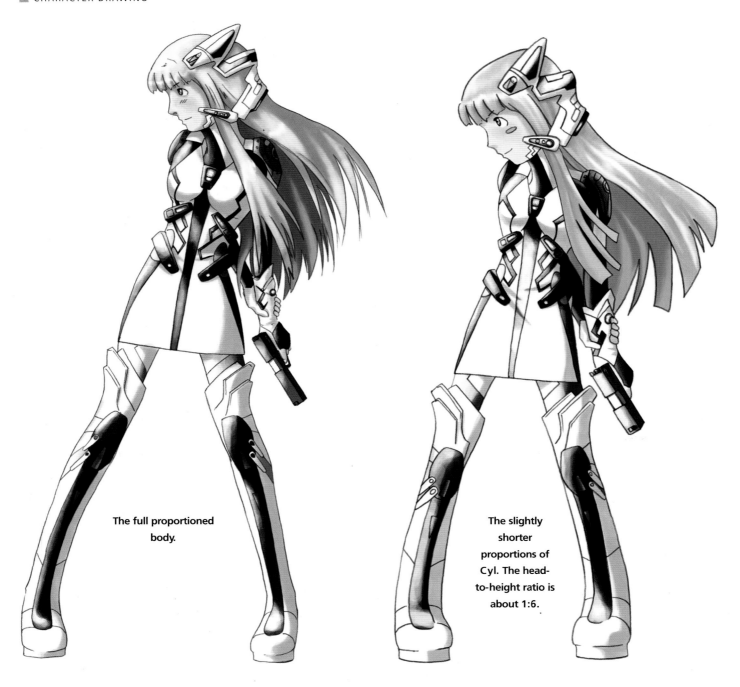

The full proportioned body.

The slightly shorter proportions of Cyl. The head-to-height ratio is about 1:6.

Manga/Anime. A Chibi character discards unnecessary parts of the original, and keeps and emphasizes those features that define him. In other words, how to pick up and emphasize these defining features is the key to successful Chibi characters.

Some artists use Chibi character as their standard style, although generally such figures are used for comical scenes. Chibi characters are effective in that they show the entire body while preserving some detail, which is why they are used in some illustrations. Every artist has his own way of stylizing these characters.

Stylizing

The most important part of a character is the head, and almost all characters can be recognized by their head alone – therefore this is the part that should be the largest proportionally. Rather than setting the head size to be one-eighth of the height, as discussed above (*see* page 72), Chibi characters reduce the 1:8 ratio to around 1:4 to 1:2. Legs and arms are less important, and they are often reduced to a simple protrusion sticking out of the body. Fingers are not usually drawn, or they are reduced in number. The least important features are contortions of the body,

These figures are somewhere between a normal character and a Chibi character. The approximate head-height ratios are, from the left; 1:5, 1:4.5 and 1:4.

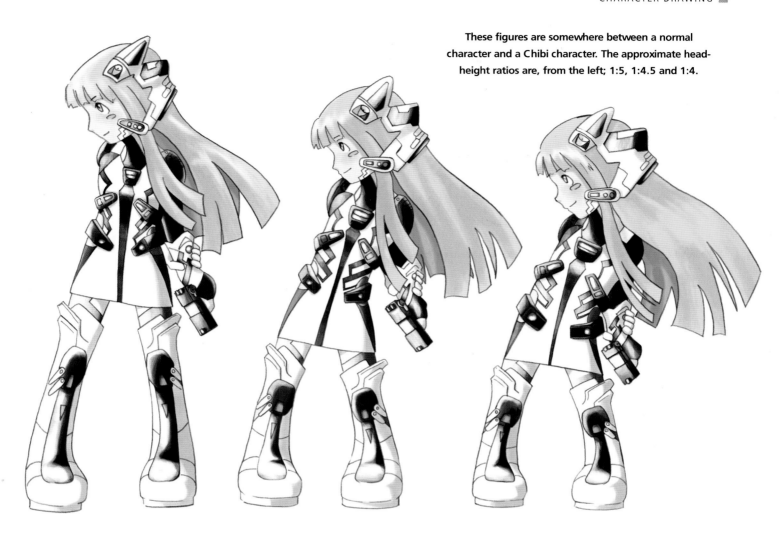

Chibi characters. The ratios are from the left; 1:3.5, 1:3 and 1:2.5. Note that some of the costume's details are now removed, especially those on the legs.

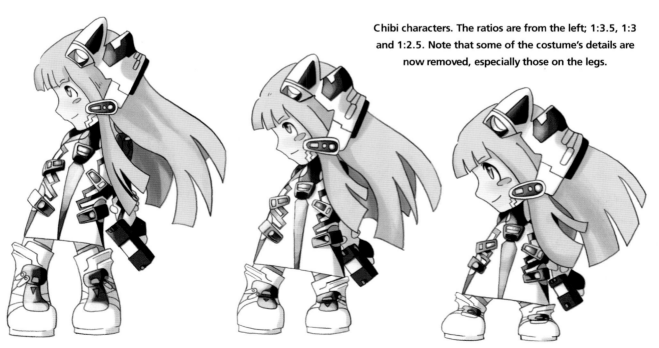

Darc's head before and after stylization. You can see the Chibi one looks younger and more feminine.

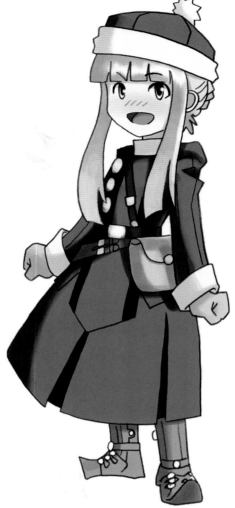

If you do not shorten the character much, the character retains most of its details.

breasts and hips, the most apparent female body features. The torso is generally drawn as a straight tube, and by doing this you get rid of gender differences from the Chibi character. In fact Chibi characters are drawn almost exactly the same way, and expressing gender difference is not considered at all important.

The Head and Facial Features

As discussed above, the basic facial parts are the eyes, mouth and eyebrows, and because a Chibi character should have only the most important parts depicted, all you need to draw are these three. The others (such as nose and wrinkles) can be

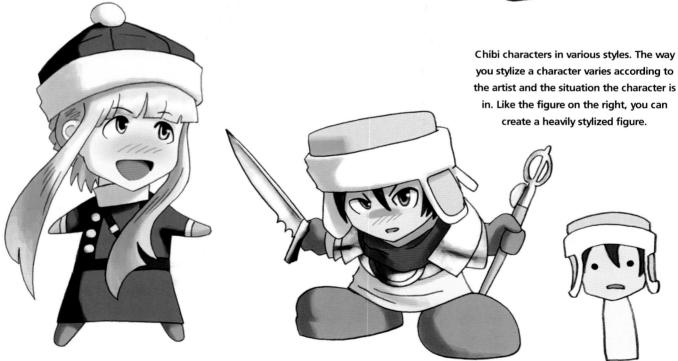

Chibi characters in various styles. The way you stylize a character varies according to the artist and the situation the character is in. Like the figure on the right, you can create a heavily stylized figure.

The Chibi character's emotions and actions are usually exaggerated and heavily stylized. Also the use of icons is the norm. The left-hand figure is full of icons and the right-hand is enlarged to give more presence. The right-hand figure is an example of a Chibi character in action. Here, I extended the legs to make the figure more natural.

removed unless you really need them; above all you should avoid drawing small parts. Chibi characters look most effective with fewer lines that are thick and clear. Trying to depict too many facial details is one of the most common causes of unsuccessful Chibi characters.

The eyes are the most important part, and they are further emphasized in the Chibi character; usually they are drawn so large that irises often change their shape and become oval. Unfortunately, oval irises are hard to draw, and you must always check that you are drawing a balanced oval, or the eyes will look strange. Some Chibi characters have pink circles on their cheeks: this represents blushing.

The Chibi hairstyle is usually drawn as a solid area rather than a mass of hair. If your original drawing style is quite realistic, you need to think how to simplify the hairstyle while retaining the overall shape.

Lastly, the neck is reduced to a tube that connects head and body. You really don't need to think about anatomical accuracy: just place it in the centre.

The Chibi Body

How to deal with the body reveals the most about an artist's style. Some artists draw huge feet, some don't draw the limbs at all, and some retain most of the original shape. How much you shorten the character determines how much you need to stylize it. If the characters are not shortened much, the character retains more or less the same proportion as the original shape; if the character is shortened a lot, however, you have to stylize it heavily.

Items and Costume

It is important to consider how to stylize items and costume before you start drawing. In most cases these are made up of small parts, and it is a huge temptation to put in these details. Items (especially those you can hold, for instance weapons) should be drawn larger, thicker and shorter. Many parts are reduced to a simple circle and square, or not drawn at all.

For costumes, the principle is the same; often a costume has a focal point or points, and this is what should be emphasized. If the character is strongly stylized, it is often enough to draw these focal points only, and the rest of the costume becomes simply a pattern on the body.

Depicting Chibi Expressions and Actions

A Chibi character's actions are also heavily stylized and make full use of icons. Sometimes the part that shows the action or gesture is enlarged to attract the attention of the reader. Depicting Chibi actions is most challenging because the characters tend to have very short limbs, and they are often too short to bend at the joints, thus reducing the action effect. There are three solutions to this problem. The first is to extend the limbs so they are long enough to have joints. The second is to avoid situations that cause the characters to act in this way. The last is to modify the action slightly so that it doesn't look strange when the character carries it out.

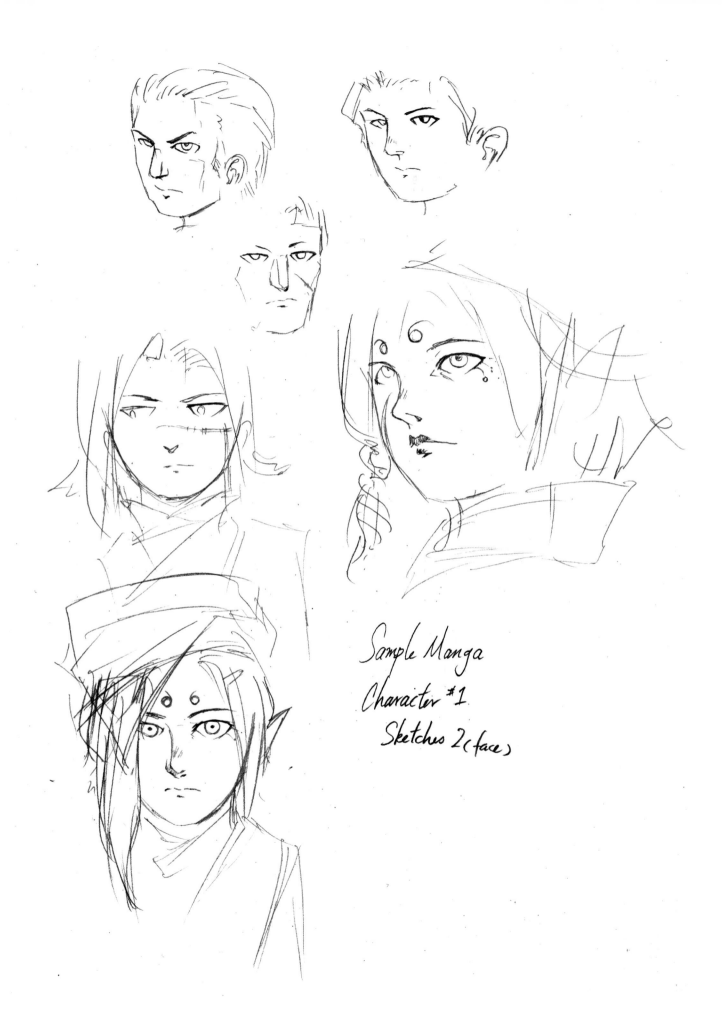

Sample Manga
Character #1
Sketches 2 (face)

SAMPLE CHARACTER DESIGN

By now you might feel you have understood how to design and draw characters, but there is still a lot to learn about what you have to prepare. The best way to understand and to learn is to do it yourself, and the second best way is to look at what others are doing. This section shows how the characters of the Sample Manga were designed, and how I prepared for them; it also describes the methods of some other artists.

Note that it is never too late to make changes, and I changed the story after finishing most of the character designs. For example, Cyl's family have become much less important and accordingly appear far less often, and the creature I prepared initially was replaced. The character that suffered most was Cyl's father: he was a key person in the first script, but in the final script he is just a background character.

The workflow for designing is as follows:

- Deciding the general direction ('brainstorming')
- Initial character design
- Rough design
- Final rough sketches
- Image sketches and facial expression studies

I usually finish the designing at this stage, but for this book, I included:

- Cleaned-up drawings
- Colour schemes
- Tone plans
- Items design
- Height reference

The last five are not really necessary but are useful as reference, and if you are working in a team, or need to show your designs to the client, it is often better to clarify the design. Don't expect them to have the same artistic sense or understanding as you!

Finally, this process is not a one-way street: if you have a problem, go back and re-do the procedure until you are satisfied.

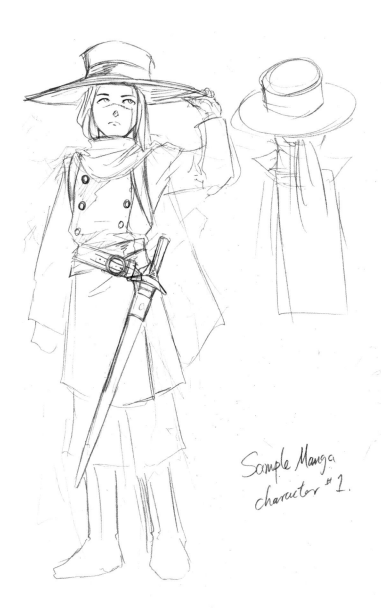

Sample Manga character #1.

The first rough drawing for Darc. You can see already that even at this early stage, most of his main features (the scarf and the box) have been designed.

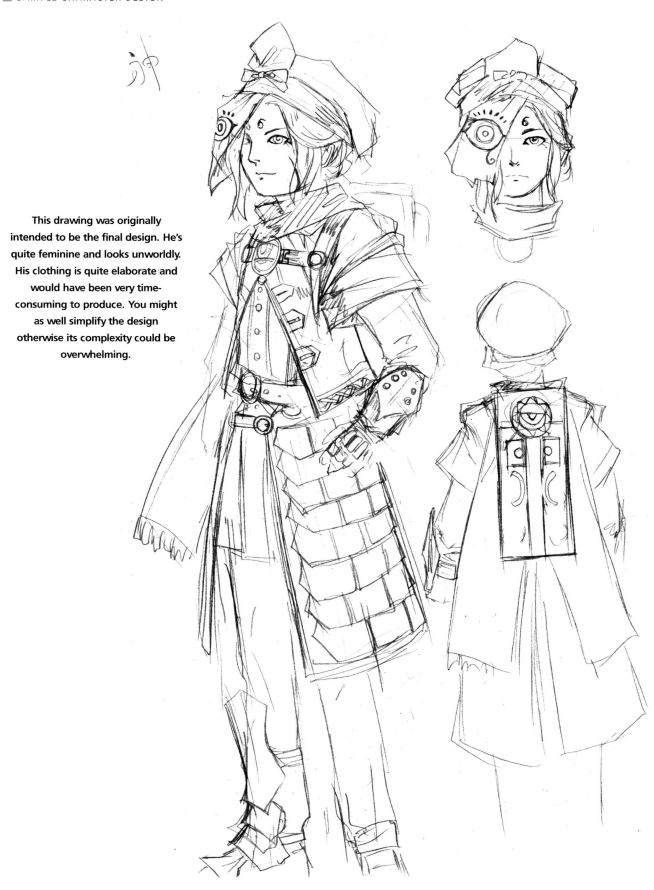

This drawing was originally intended to be the final design. He's quite feminine and looks unworldly. His clothing is quite elaborate and would have been very time-consuming to produce. You might as well simplify the design otherwise its complexity could be overwhelming.

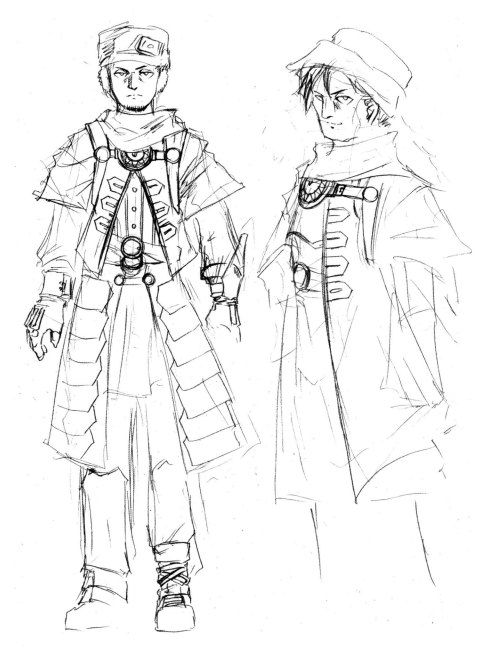

This is the first drawing after the design concept of the character is changed. Note that the costume itself hasn't changed much.

The General Design Direction ('Brainstorming')

First you have to decide the general design direction, which I call 'brainstorming'. It is important to make the most of the world and the characters' general settings as well as the story outline. I chose a fantasy world, with magic and imaginary creatures, because it is possible to use more special effects and techniques than in ordinary worlds. The setting is Eastern European, specifically a Russian forest, and the season is winter. The costumes reflect the climate, and are thick and heavy, and cover almost the entire body. The exception to this is Krelia's costume.

Initial Design Work
Darc (Sample Character 1)

At first I designed Darc as a mysterious conjurer who summons a fighter (Krelia), and as you can see in the first sketch, I tried several possibilities for the character. The first image I chose for him was someone quite young, mysterious, unworldly and feminine, but later I changed the concept and tried to age him; also this change got rid of his more mysterious aspects.

Darc's focal point is the red scarf and a plate with a strange symbol. The symbol can also be seen on Krelia, representing a kind of bond between them. This symbol is a reminder of his former incarnation as a mysterious conjurer.

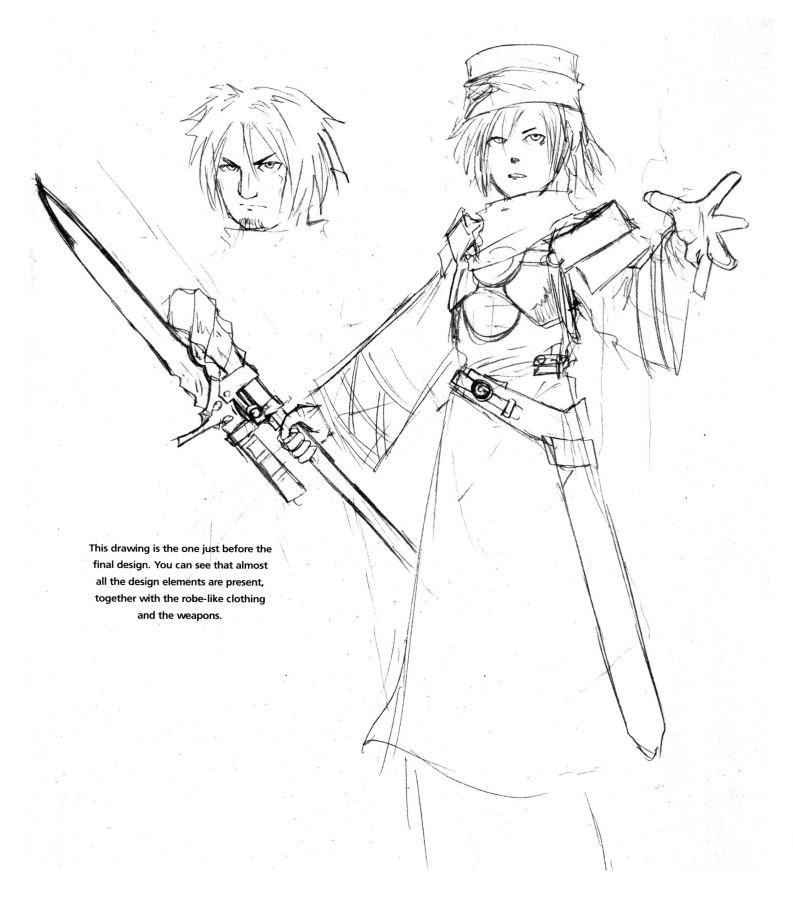

This drawing is the one just before the final design. You can see that almost all the design elements are present, together with the robe-like clothing and the weapons.

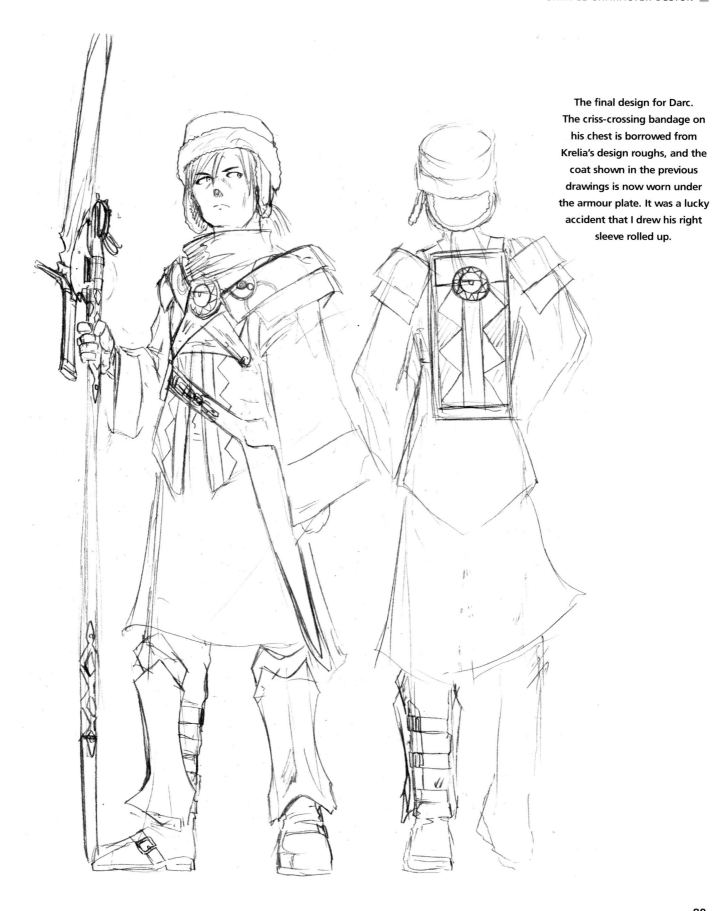

The final design for Darc. The criss-crossing bandage on his chest is borrowed from Krelia's design roughs, and the coat shown in the previous drawings is now worn under the armour plate. It was a lucky accident that I drew his right sleeve rolled up.

*Sample Manga
Character 2
(female)*

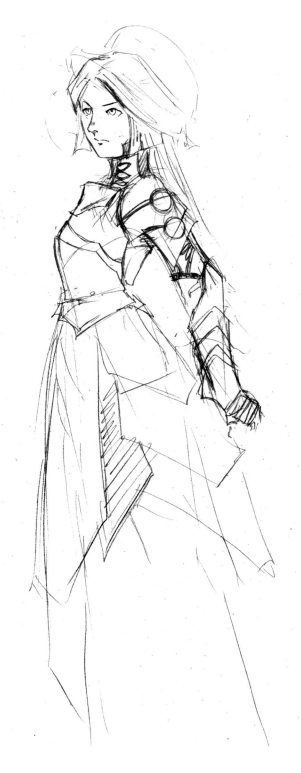

Krelia (Sample Character 2)

Krelia is a mysterious being, and she herself doesn't know what she really is. In the first script there was a scene where she told Cyl this. I didn't decide whether her personality should be 'strict and restrained' or 'outspoken and rough' until later in the design process. The first rough sketch shows I have explored several quite different options.

Her overall design is quite different from the others, to show that she is from a different background to the other characters. She is wearing much lighter clothes, and in her earlier design, her legs were exposed. Her weapon is large, to symbolize her superhuman strength.

Krelia's focal points are her face marks and the symbol on her chest. Her image colour is red.

LEFT: **The first study for Krelia. The symbol is already here. A short-haired girl from the second top is the basis for the final design. At this stage, no facial marks are introduced.**

ABOVE: **The first drawing of Krelia, as 'strict and restrained'. The basic design concept is 'heavily armoured fighter'. Also she looks much more mature than in the other designs.**

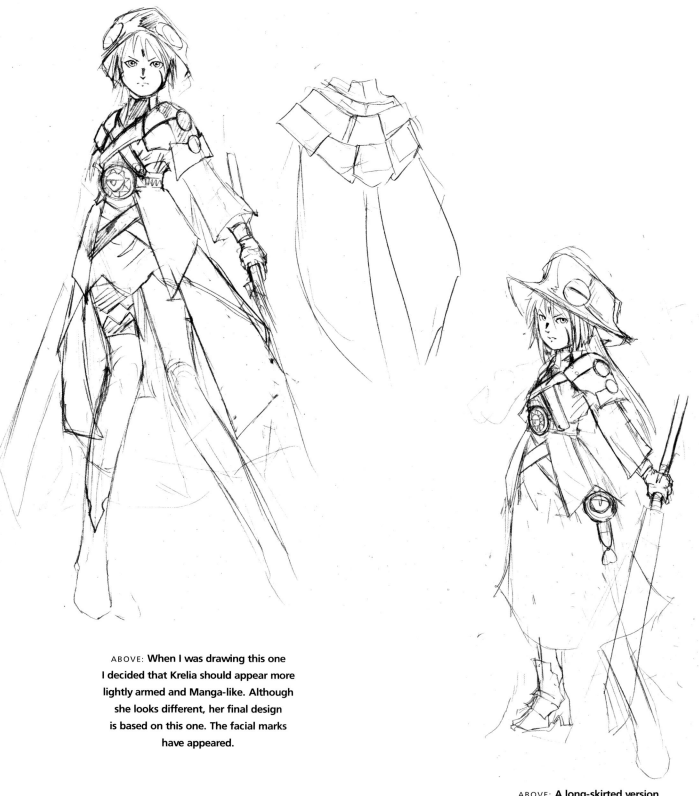

ABOVE: **When I was drawing this one I decided that Krelia should appear more lightly armed and Manga-like. Although she looks different, her final design is based on this one. The facial marks have appeared.**

ABOVE: **A long-skirted version of the previous drawing, to explore an alternative possibility.**

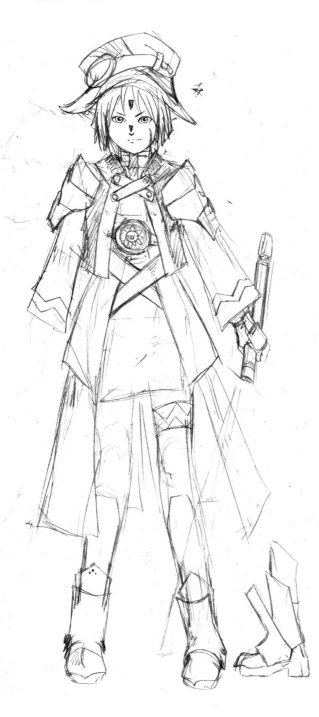

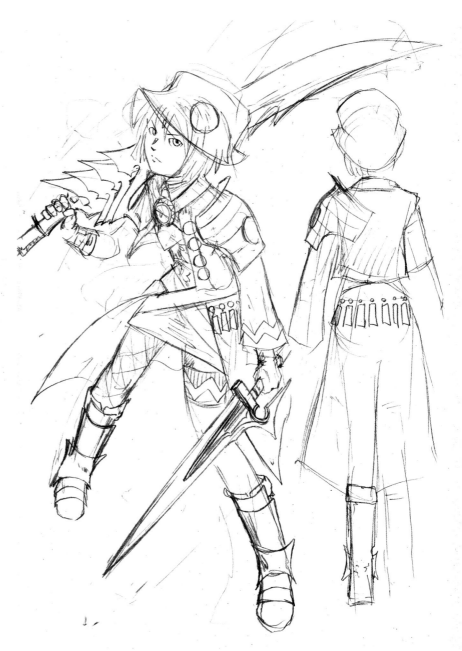

BELOW: **Krelia was first designed as a short girl, but later this change. In this drawing almost all her features are in place. The symbol is moved to the chest, the same place as Darc's; this is because putting a focal point on the stomach made her figure awkward. Possibly it is because some of the attention is directed to the stomach, while other focal points (the face marks and the bright red hair) draw attention to the face. Here, her right sleeve is shorter than her left. The hat, although it looked nice, didn't seem to suit her and is removed.**

ABOVE: **Krelia's hair is now short, and the criss-crossing bandage on her chest has been removed because although it looks nice, it makes her hard to draw. Another bandage on her hip is now very similar to the final one.**

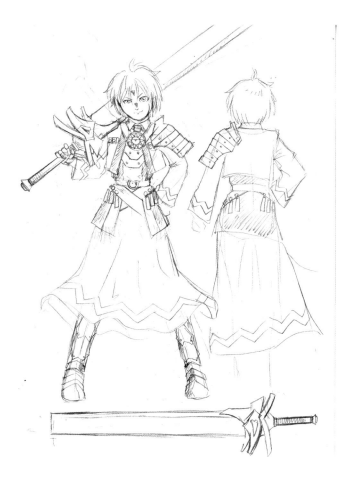

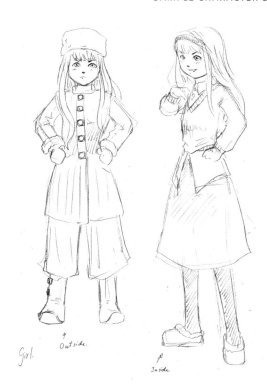

This shows Cyl living with her family. The figure on the left is her going out costume, and the one on the right is for indoors. It's a pity there's almost no place for these designs.

The final design. The costume is simplified and is now almost symmetric.

Cyl (Sample Character 3)

I found Cyl the easiest character to design, and came up with the final design in one go. The only difference after I altered the script is that her main costume changed from a cream-coloured coat to a dark blue battledress. I did not have the space in the Sample Manga to show that her cap is a memento of her father (you can see him wearing the cap in his design drawing and in the Sample Manga). Her blue cloth is inspired by a character from a game, and I added a hint of military uniform to it. Her costume is the most realistic of all of them. I liked her hairstyle, called corona, but am not sure if it works well with a cap.

Her personality is that of a strong-minded and somewhat stubborn girl.

Children

The children were first designed as samples to show characters with different personalities. Starting from the left in these

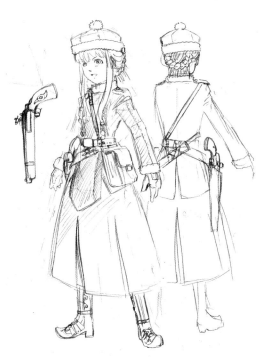

At first, this costume was intended to appear only in the last few pages of the Sample Manga. However, when the script changed this became her main costume. She has almost no focal point – streaks of hairs on the side of her face and colour combinations are possibly the only ones.

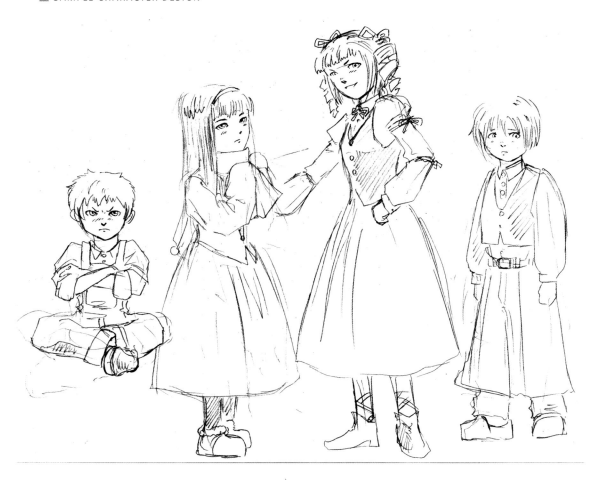

A rough sketch of the children in their indoor costumes.

Children in outdoors costumes.

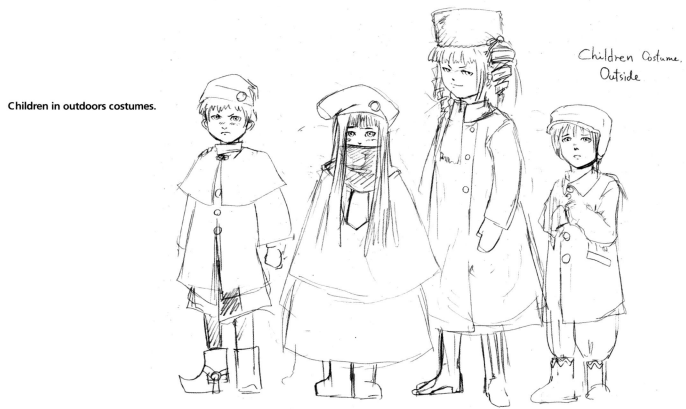

Children Costume.
Outside

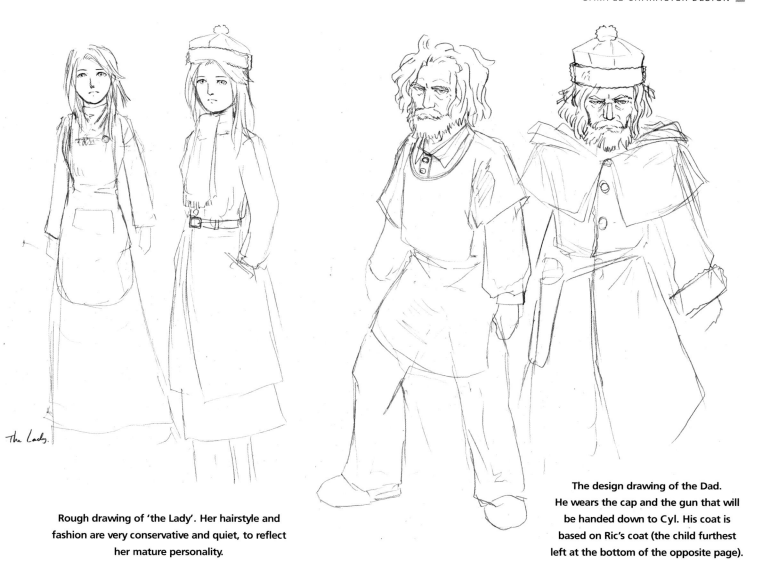

Rough drawing of 'the Lady'. Her hairstyle and fashion are very conservative and quiet, to reflect her mature personality.

The design drawing of the Dad. He wears the cap and the gun that will be handed down to Cyl. His coat is based on Ric's coat (the child furthest left at the bottom of the opposite page).

illustrations they represent 'rough, vivid and rebellious', 'quiet, shy and well-mannered', 'arrogant, clever and somewhat nasty' and 'introverted and weak' (I removed these settings altogether in the final work). Their hairstyles also reflect their personalities. Ric's (the boy on the left) short hair shows that he's active and sporty, while Pim's (the boy on the right) long hair gives the impression that he's quiet and not sporty. Sanah's (the girl on the left) long, straight hair represents quietness and conservativeness. Ren's (the girl on the right) hairstyle, called twin drills, suggests how much time she devotes to her appearance.

Father (Dad)

At first I planned a woman for this role. However, I thought I had enough female characters and wanted a sample character of an elderly person. As I wrote previously, in the first script he was a key character, but in the final script he makes virtually no appearance. His focal point is his wrinkles and his beard. This is also the point that differentiates him from other characters.

Creatures

I scrapped the original creatures when I changed the script. The first creature is a huge dragon and the final ones are inspired by insects. When you draw a creature or object, it is a good idea to place something in it to suggest the size. In this case, as in the dragon-like creatures' drawings, I used a human as the scale.

The first drawing of the 'creature'.

Small insect (left) and middle insect (right).

The second drawing of the 'creature'.
Still dragon-like, but more 'fishy'.
It 'swims' in the air.

BELOW: **Mother in her first form. Her image is that of a queen ant and a cocoon.**

Mother 1st form.
魏蟲 第一形態

Mother 2nd form
親蟲 第二形態

ABOVE: **Mother in her second form.**

House.
Outside.
Sketch.

Architecture and Scenery

When you're planning a Manga, you're not only going to design characters but also buildings, sceneries, objects and items. These things are, in some cases, almost as important as the characters. Generally speaking, designing such objects usually involves no more than researching and choosing what is appropriate. However, if your story features some unusual place such as a spaceship, you need to design the structure in detail. It is also useful to write down floor plans for the structure. You can easily work out the sequence of the scenes and viewpoints.

Image Sketches

Image sketches are rough sketches of your characters in a scene from your story. I use them to check the following points:

1. Are the characters' designs suitable for the action intended?
2. Does each character fit together well with the others?

The house, which was the main place in the first script. Also the floor plans of the house, to work out how the scenes would be carried out.

3. Do the characters' designs give the impression you intended?

These points are difficult to resolve with only design drawings, and it often happens that you run up against such problems when you start drawing your Manga. For example, I found that Sanah's long sleeves didn't look good when I was drawing the image sketches. You might not like to scrap the characters you have spent time developing, but the courage to do so is sometimes necessary to create a good piece of work.

There's another purpose to these sketches: they are helpful in convincing your client (and your team) that your characters are designed appropriately for the project. Since design drawings are intended to show how the characters are designed, they are motionless and emotionless. Most people, and that includes

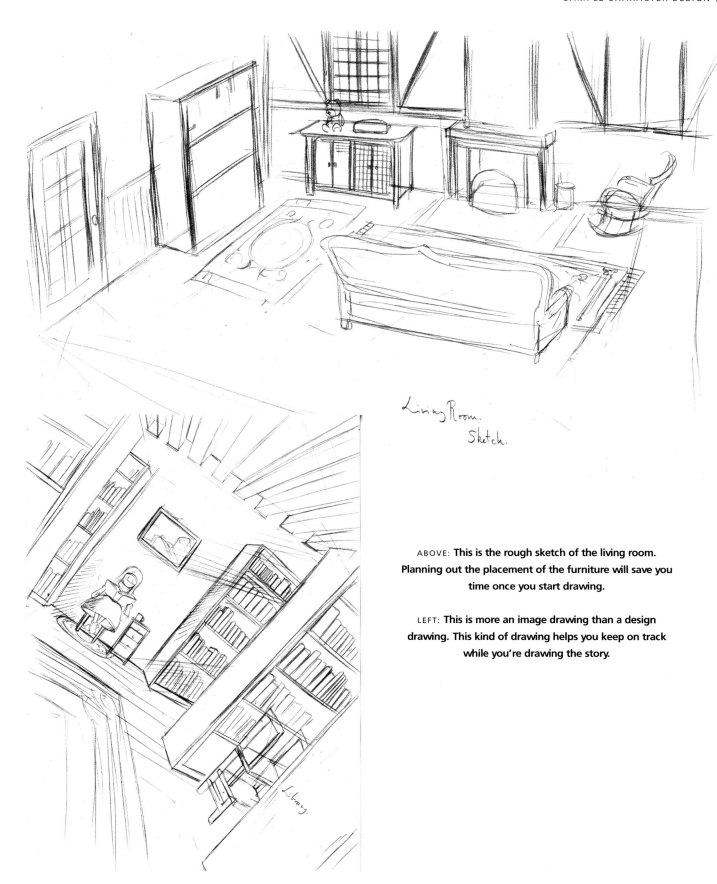

Living Room.
Sketch.

Library.

ABOVE: **This is the rough sketch of the living room. Planning out the placement of the furniture will save you time once you start drawing.**

LEFT: **This is more an image drawing than a design drawing. This kind of drawing helps you keep on track while you're drawing the story.**

Another image sketch showing Father (Dad) carrying food and Cyl talking with Krelia in the box.

The top image shows Darc talking to Cyl in a forest, and the bottom one shows the children playing. These drawings reveal the personality of the characters. It is difficult to see, but the bottom drawing depicts the living room, viewed from the armchair near the mantelpiece.

your client and your teammates, cannot see more than what you've put down on paper. Therefore, making image sketches helps them understand how you're intending to use these characters.

Facial Expression Studies

This study is a method used by many Manga artists. Its purpose is more or less the same as the image sketch, but it usually shows how the characters would behave.

RIGHT: This sketch shows the characters in action, but it is also used to check the design of the 'creature'.

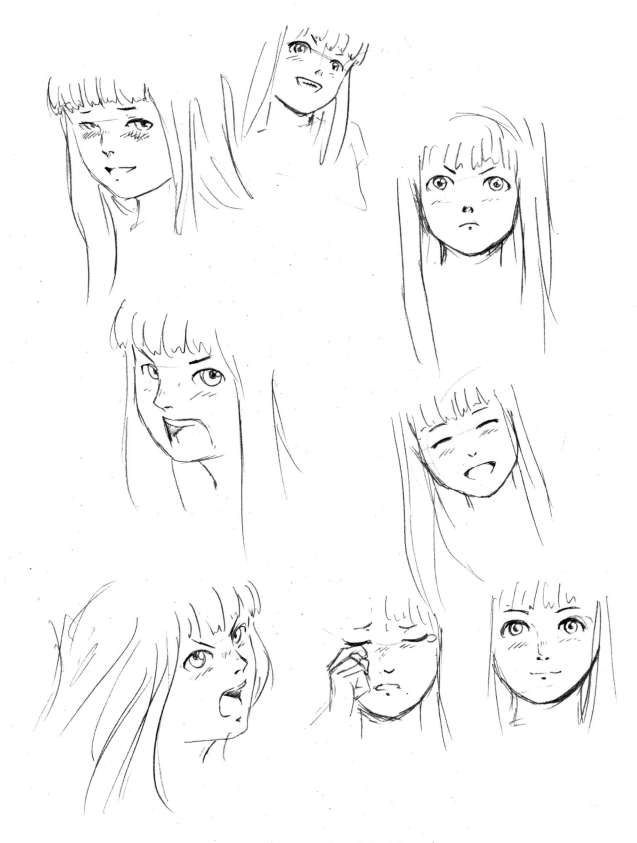

This is a sample study for Cyl.

Final Design Work
Cleaned-up drawings

Cleaned-up drawings are the best way to show the details of the characters in clear images. You don't have to draw such finely finished drawings (I don't) if you are doing the project on your own. If you're working with a team, however, it is necessary to draw them so that all artists have the definitive references.

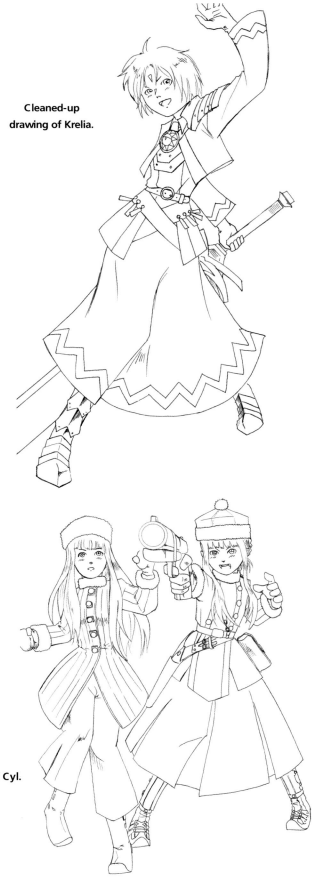

Cleaned-up drawing of Krelia.

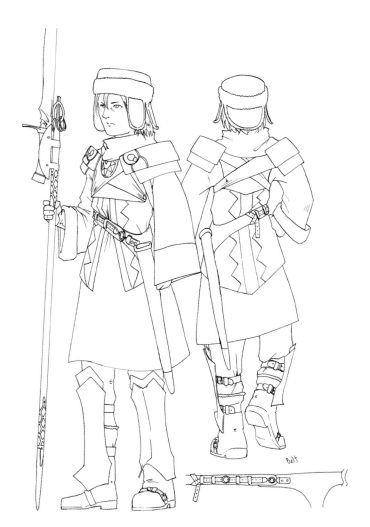

ABOVE: **Cleaned-up drawing of Darc. Also showing how his belt is fastened.**

RIGHT: **Cleaned-up drawing of Cyl.**

Colour Schemes

This drawing is to show the basic colour map of the characters. You don't need to put special effects. Just add basic colour and, if you feel like it, include a note about the colour components.

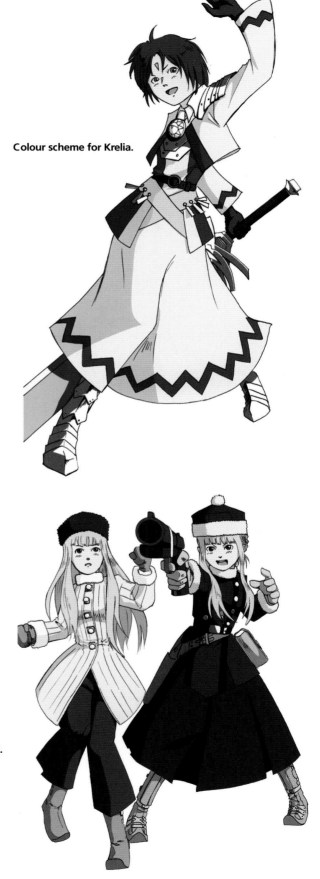

Colour scheme for Krelia.

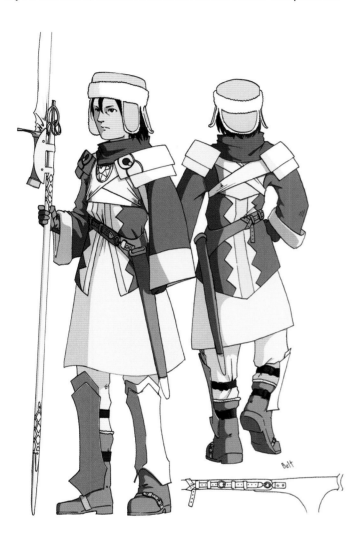

Colour scheme for Darc.

Colour scheme for Cyl.

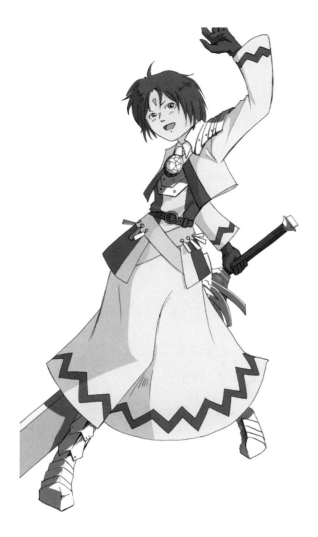

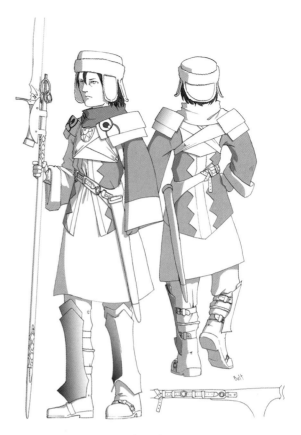

A tone plan of Darc.

This was the result when the coloured illustration of Krelia converted to a greyscale image.

Tone Plans

Despite the name, I created greyscale images for this. This is because I first created greyscale images and converted them to black-and-white images (I'll explain this later). You might think you can create the tone plans by simply converting the colour images, but as you can see in the illustration, this doesn't work.

Deciding where and what tone you use determines the appearance of the final work, so you need to think about it carefully.

A tone plan of Krelia. Compare with the greyed version of Krelia (opposite left) and see how her colouring is adapted to a black-and-white image.

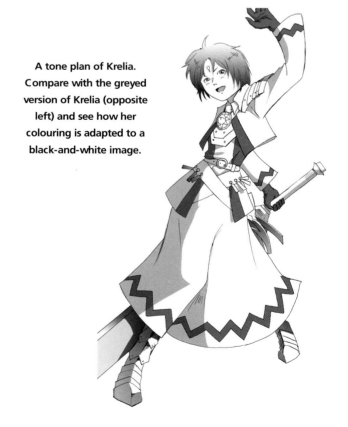

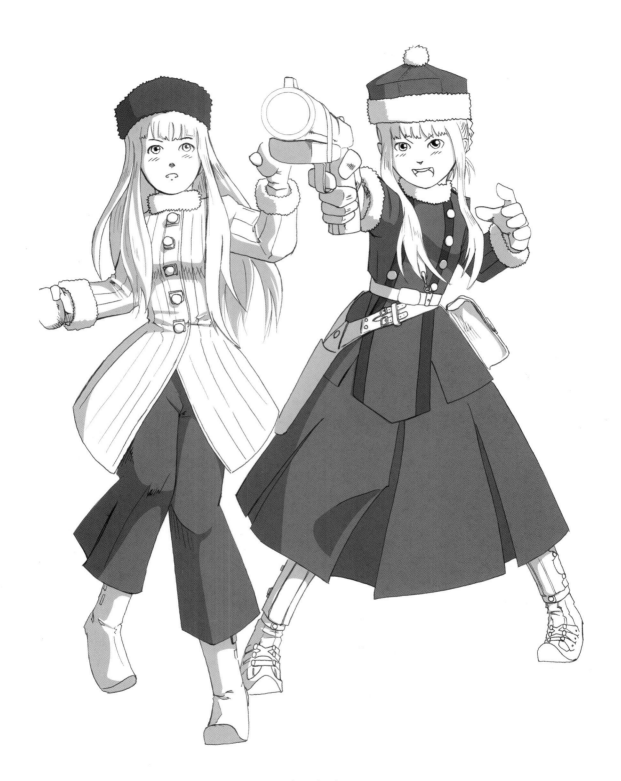

A tone plan of Cyl.

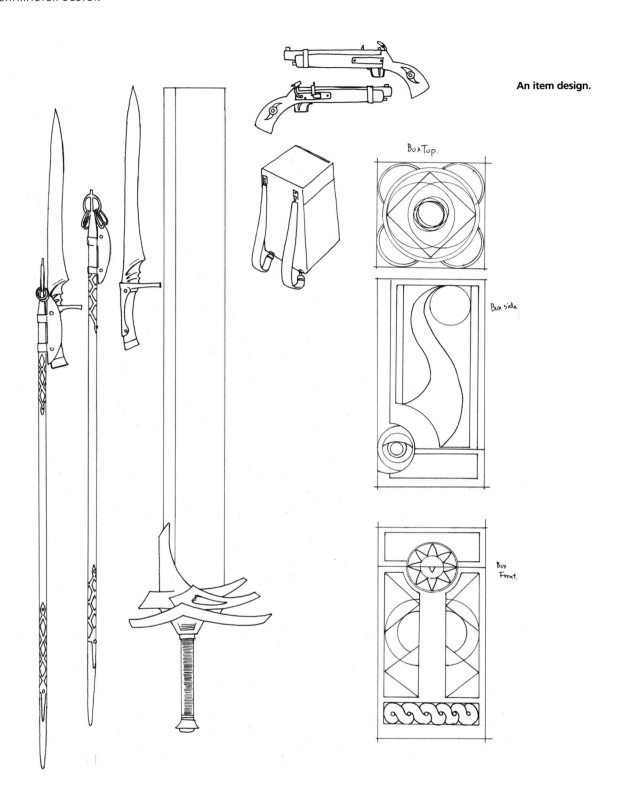

An item design.

Item Design

It often happens that character design drawings don't give enough detail concerning items. Creating detailed references for the items is a solution to this problem. You might want to put not only the design but also how the item moves. Some Manga artists go further and make small 3D models to check the movement.

Height reference of the characters. Behind them, the middle insect and the Mother
in her first form are drawn as shadows (they are too large to fit in this drawing).

Height Reference

In Anime, this is one of the essential drawings. It is often quite troublesome to see if a character looks tall at one time and small at another time. This also gives an idea of how one character would react to the other. Look at the illustration. If Pim and Darc are engaging in some activity (talking or fighting, for example), you can see that the difference in their height makes it hard for them to interact with each other.

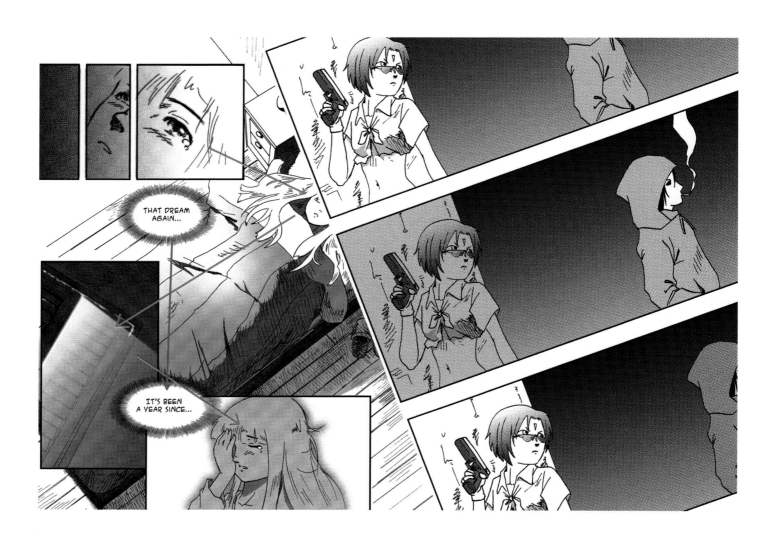

THAT DREAM AGAIN...

IT'S BEEN A YEAR SINCE...

CREATING MANGA

Before starting to draw, there are some rules of layout and composition that must be considered in order to create a drama. When you finish designing, you'll feel you have done a great amount of work. However, you're just at the starting line, and you still have a long way to go. Now you need to think about strategy so that you can finish the race a winner. If you don't, your talent and effort will be wasted.

Be warned that there are no definite 'rules' or 'methods' as regards creating Manga, since both theories and methods are evolving rapidly. Try experimenting in every possible way, learn from other artists' works, and most importantly, be critical of yourself. That's the only way you can improve.

Tools

Tools are important because they determine the final appearance of your work. Try to get the best you can buy; in most cases, the best are Japanese. Try buying them on line, and if possible, by going to Japan.

Here, tools are discussed in three sections according to their importance – though of course the importance of the tool differs according to the person: for example, if you draw on a computer, you don't need a pen.

Essential Tools

PENS
Almost all Manga artists in Japan use dip pens for their work, the most popular being the G-pen, originally used for English writing. This pen can control the thickness of the line, it holds a reasonable amount of ink and is easy to draw with. Another popular type is the Maru pen: it holds less ink, but can draw a very fine line; it resembles a calligraphy pen but is made from harder material. I have never seen them sold in the UK so they need to be ordered abroad.

I use G-pens by Tachikawa and by Nikko (though mainly Tachikawa), and a Maru-pen from Tachikawa. The Sample Manga is written with the G-pen only.

Dip pens. The top one is 'G-Pen' and the lower one is the Maru pen.

FELT-TIPS AND FINE-LINER
These types of pen are used to draw fine lines, mainly frame lines and objects (especially in the background). Larger ones are used to paint black areas. Although convenient, they are not recommended for use for the main figure.

RULERS
A ruler is one of the most essential tools. If possible, buy a transparent one so that you can see the line beneath.

ERASERS
To make a clean job of erasing pencil lines and other unnecessary lines be sure to use a high quality, preferably soft eraser.

PAPER
You need two different types of paper: ordinary paper for drafts and other tasks, and heavy paper to draw the actual artworks.

I used 160g/m2 card for an inkjet printer. Japanese artists use heavy paper and specialized Manga paper; the latter has all the necessary grids and measurements printed on it. Choose paper with a smooth surface.

INK

Buy black ink. The quality of ink does affect the line you draw. Inks sold in the UK are usually of acceptable quality.

PENCIL

Use soft lead for drawing. Avoid lead that is harder than HB.

Very Important Tools

The tools listed in this category can be very useful but are not always strictly necessary to create Manga.

Scalpel: Can be used to cut out and scrape screen tones.
Lightbox: Quite useful in many ways. Some artists use this to trace over a photo or image they made for a background.
Computer and scanner: Although most artists create their works manually, the computer is changing the way they produce Manga. Some artists use 3D modelling programs to create scenery for their works. *Negima!* uses objects created by LightWave, a 3D modelling and animation software, for the background.
Templates: Very useful to draw a certain shape quickly. I use a circle template and an oval template.
Compasses: Check if your compasses can hold felt-tips.
Tones: Many people might associate these tools with Manga. Tones can create almost infinite effects. However, they are possibly the most expensive tools you need to use for Manga.
French curves and setsquare: French curves are useful to draw a beautiful curve, and a setsquare to draw parallel lines.
Camera: Used for reference.
Sketchbook: It is nice to have a book where you can put down your sketches and ideas.

Useful Tools

The following are useful, possibly essential tools for creating Manga manually. However, if you are working on the computer, you might not need them at all.

Copying machine: Recent computer developments have made this machine fairly obsolete, but it's still useful.

Hair dryer: Used to dry inks and paints.
Brushes: Used to paint black (and white) areas, and to create splatters.
Tooth brush: Used to create fine splatters.
Acrylic white: Mainly used to correct mistakes and draw white lines. It is also used to create white splatters.

Workflow

This workflow shows how an artist works to create Manga. Unlike most comics' artists, Manga artists themselves write the storylines, which is why many How to Create Manga books have a chapter devoted to developing a story.

Basic storyline: The first thing you need to do is make a rough note for the story. It involves what you're going to put on a certain page and how a story would develop.
Script: Consult the basic storyline note, and write the script. Every artist has his or her own style. Often they write as a script, though some artists (or writers) write just like a novel. You need to think hard about what to put in your script. It's very easy to put too many words and actions on one page.
Draft (*Ne'e'mu*): *Ne'e'mu*, pronounced 'name', is a Japanese word used to describe drafts. Here, you draw how you lay out the pages. This is perhaps the most important element in creating Manga.
Creating Manga: Drawing and creating Manga artwork.
Finishing and printing: This involves laying down the words, doing the final checking and carrying out the printing process.

Layout

Layout is a crucial factor that determines the readability and overall impression of the story. You might not notice how important layout is until you start creating your own Manga.

Manga consists of a series of panels with drawings and speeches. These panels are laid out in such way that they create a sequence of an event. These sequences lead us along the path the artist has created for us. Every artist has his or her own style of layout, and there is no one 'right' layout. But one thing is sure – a good layout is invisible, and if the reader starts noticing it, this means it is not a good one.

The basic layout of a page. In this book, the pink areas are called 'panels'. The blue and orange areas are 'frame' and the orange area is also called 'margin'. The green area is a panel without a frame. These names are my originals and may differ according to other artists.

The reading direction. The red arrows indicate how the reader reads through the page. The green area shows vertical columns.

Basic Layout

Manga has frames around the panels. These frames divide the page into multiple panels. The outermost frame consists of margins, the space between the edge of the page and the printing area (or text-safe area). Recent Manga tends to have fewer margins to have more space for drawings and openness.

The size and placement of the panels is important. The size of a panel directly relates to the importance of the scene depicted in it, therefore if you want to emphasize a scene, make the panel bigger. Also the regularity of the layout affects the flow of time (*see* page 114).

When you read, you read from left to right. Your Manga is also read in the same direction. In Japan, most Manga is read from right to left (some Manga is read from left to right; for example

Madara by Shou Tajima is one of those Manga that is translated in English). However, the principle is the same, in that a single page is divided into several horizontal columns, and these columns are further divided into panels. When you lay out panels, it is easy to create panels as a block of horizontal columns.

Narrative Direction

It is natural to place the speech balloons as you write – from left to right. The difference is that you need to make it clear who is talking. It is much more difficult in English than in Japanese. The Japanese language is very flexible and you can make out who is talking by reading the speech. But since you are creating Manga in English, you need to think about the position of the speech

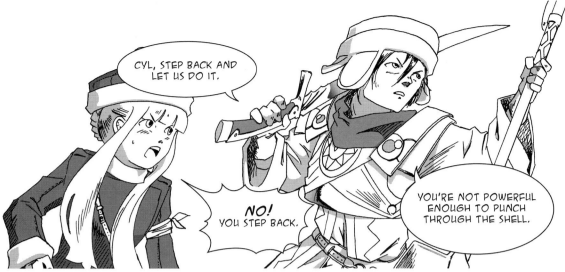

LEFT: The characters and speech balloons are laid in the reading direction.

BELOW: A scene from the Sample Manga reversed. Without considering the characters' places and the order of dialogue, the result is a confusing scene. You can barely make out what order they are speaking in and where to look.

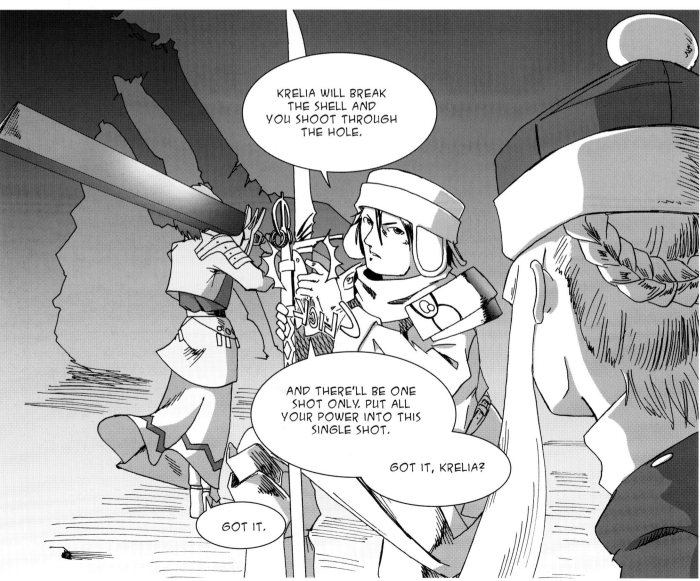

balloons and the characters to avoid confusion. If one of your characters has a speech mannerism, this will help to distinguish his or her speech from others.

Ideally, speech balloons should line up in one single line. I find diagonally placed speech balloons, from top left to right bottom, are the easiest to read through. This is because the next speech balloon is placed right next to the end of the words of the first speech balloons.

Paging

When you plan a Manga, make sure that you get the paging right. For example, when I was making *Othello* I made a mistake with the paging and as a result, a double-page spread was messed up. It was eventually resolved, but I wasted a great deal of time.

Paging also has an important role in creating drama and tension. A book is made up of a series of double-page spreads, and the important implication of this for the reader is that they cannot see what follows on the next spread until they turn the page. As an example of this, take a look at the following script:

Detective: The mysteries are all solved.
I know who the murderer is.
Male 1: Tell me who the killer is!
Male 2: Impossible! I left no evi…. Evian.
Detective: The murderer is….
Males 1 & 2: Is….
Detective: Me!
Males 1 & 2: ….

To maximize drama and tension, at which line would you want to cut and send the rest to the next double-page spread? The obvious answer is between lines 5 and 6, just before the detective reveals he's an idiot. The script is also written to drag the reader's attention to this point. So you should send the revelation to the next page to keep the answer as long as possible.

Another possibility is to cut the scene after line 3. Here, the reader might expect the detective to pick up on the name that Male 2 has let drop, but doesn't. In this case you should add something after line 3 to emphasize how the detective missed his chance.

Turning over a page also breaks the flow of the story and introduces the reader to new pages. Therefore bring the first page of the new scene to the even-numbered pages.

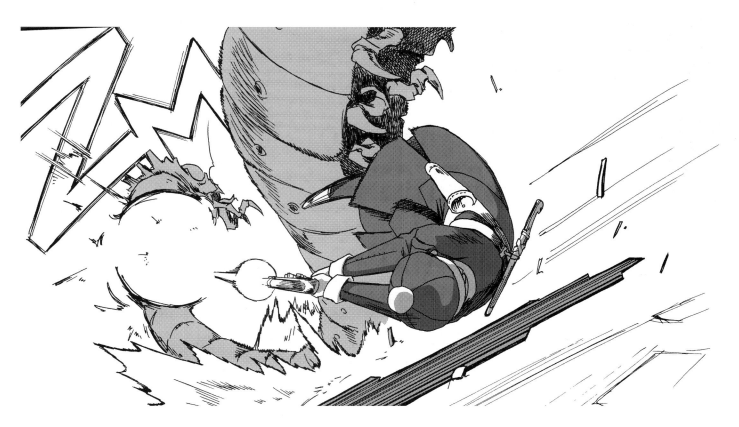

This scene without speed lines slows down or even stops the time within the scene. This is an equivalent to the slow-motion effect in film.

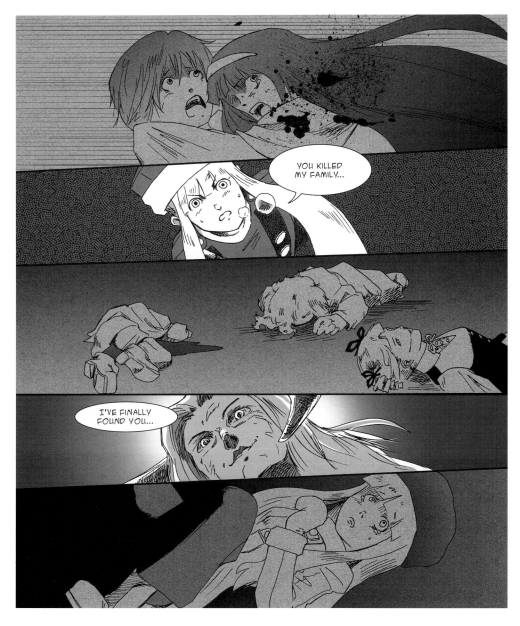

A page from the Sample Manga. The speech in this page regulates the passage of time of the page. The existence of speech implies to the readers that the time passing is just as long as the word is spoken.

Composition

It is important not only to know how to compose a panel, but also how to organize a page. Most of the things in this section you will know instinctively, but you will notice a great difference if you use them consciously.

Controlling Time

Manga creates a sense of time by placing a series of drawings in a sequence, but the speed of time that flows can be changed slightly by many factors. However, please bear in mind that the time described in this section is more a mental timescale than a physical one. In many Manga, time literally slows down and speeds up according to the character's situation. This is very similar to the way a film controls time in order to create a drama.

The layout creates the base rhythm of time. A regular layout, such as is often seen in American comics, creates a steady flow of time. An irregular layout disturbs it, and as a result, you feel that the time flow speeds up, or slows down.

Action is another element. Action, including conversation, supports the flow determined by the layout. If the action in a panel is energetic and busy, you feel that time speeds up. When there is not much action, time slows down accordingly.

You might also notice that time cannot slow down infinitely (although you can stop it). If you want to slow it down beyond the limit, you need to insert a panel or two to break the flow.

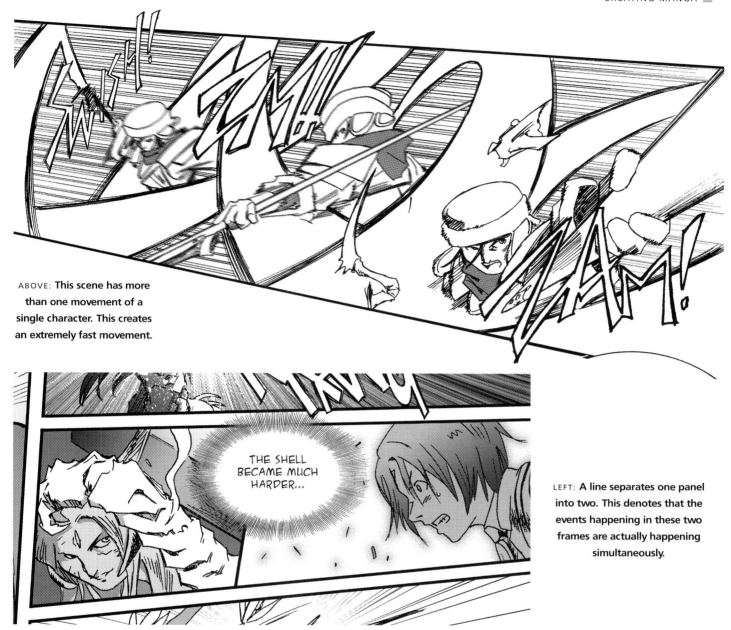

ABOVE: **This scene has more than one movement of a single character. This creates an extremely fast movement.**

THE SHELL BECAME MUCH HARDER...

LEFT: **A line separates one panel into two. This denotes that the events happening in these two frames are actually happening simultaneously.**

This might be most apparent in conversation. If you put a lot of speeches in one panel, it looks busy and hurried, whereas placing the speeches in many panels slows them down.

Similarly putting a number of actions in one single panel speeds up the action; to slow it down you can break up a single action into several panels. This works exactly like a fast-forward and slow-motion effect.

You have two solutions if you want to show several different actions taking place at the same moment. One is to insert a small panel in a larger panel; the other is to replace the frame that divides two (or more) panels with a single line. This method merges multiple panels into one.

Scenes Outside the Main Timeline

From time to time you need to draw a scene that is outside the main timeline, for example a character recalling an event. It is natural to depict the past event rather than to show the character recalling it. However, this often confuses the reader, and to prevent this from happening, you need to make it clear that the scene is not in the present. One solution is to put a tone on a panel. Tones darken the panel and push the panel back, implying that it doesn't belong to the main story's timeline.

Another solution is to change the shape of the panel, and the colour of the frame. However, with this method the reader needs to know what these changes mean, so you need to introduce some way of pointing out what it means the first time it

Another example, where the left panel has a small panel inserted into a scene that is happening at the same moment. The right panel is also tied to the left panel by the speech balloons. The balloon indicates that these two panels depict events that are happening almost at the same moment.

occurs. With this technique, you can create a sense of depth in drawing: the illustration shows this technique applied to a scene. Adding tone, or shade, on to part of an image creates the illusion of depth. Also this is useful to distinguish an important object from other unimportant objects.

Controlling the Viewpoint

Controlling the viewpoint is an important skill not only for Manga but also for television drama and movies. A carefully worked out viewpoint enhances the drama and emphasizes what you want the reader to see. Manga borrows many techniques used in films, though since it is motionless, you need to

adapt these techniques. For example, use concentration lines to simulate a zooming effect, and make lines hazy to create soft focus effects. And if you want to emphasize the size of the object, look up at it from a lower viewpoint; looking down at it from above will exaggerate its smallness, both mentally and physically.

From time to time you will want to depict a scene from multiple viewpoints. The methods that were explained in 'Controlling Time' (see page 114) are quite similar to this technique. Look at the illustration: it is from the Sample Manga on page 31. Here I wanted to show the Mother's entire body and her face, but she is so huge that you cannot see her face in detail. The solution is to place her face as a cut-in.

Separating the main figures from the background. This illustration shows the line drawing from the first page of the Sample Manga. In this scene, the main figures are buried in the background and hard to see.

Adding tone on the background clarifies the main figures.

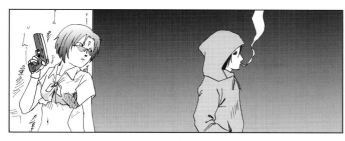

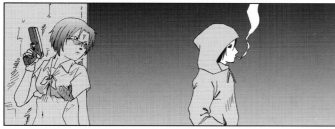

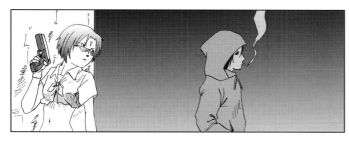

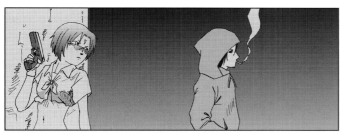

The same scene with different tonings. These four illustrations demonstrate how toning creates different impressions.

The top one, without tone on both figures, makes the image look flat. It looks as if there is no depth in this scene.

The second scene from the top shows tone onthe left-hand figure, making her less important than the one on the right.

The third from top scene has a tone on the right.
This creates a sense of depth.

The bottom one, with tone on both people, darkens the image.
It might indicate the darkness of the scene, or that this scene itself is not on the main story line.

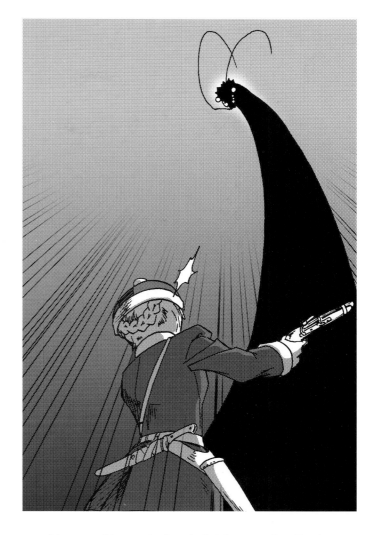

This composition emphasizes the height. Here, the effect has greater emphasis because of concentration lines that create the zooming movement.

Placing Characters

In general, place characters in the order they speak, because this keeps the location of the speech balloon easy to read. Also be careful about the location of the characters.

When you plan a panel, it is important to keep the consistency of the relative locations of the character. The illustration overleaf shows an example. In the first panel of pages 27 and 28, I placed Darc on the right-hand side of the panel and Cyl on the left. These placements of the characters in relation to the panel are consistent throughout the scene. If you changed the viewpoint (or camera) and shifted their relative placements, your reader would be confused by the sudden change.

The same can be said for a panel that has only one character. Try to keep the character facing in the same direction.

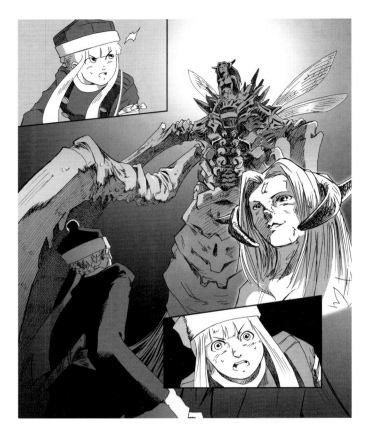

LEFT: **This scene is similar to the previous illustration, with one difference. It is intended to show the overpowering presence of the Mother. To achieve this, the size and height of the Mother are exaggerated, and the placements of the two characters are made unrealistic.**

BELOW: **These extracts from the Sample Manga show how the placement of the character from the point of view of the reader is unchanged. The dialogues are placed so as not to disturb the order in which the characters are placed.**

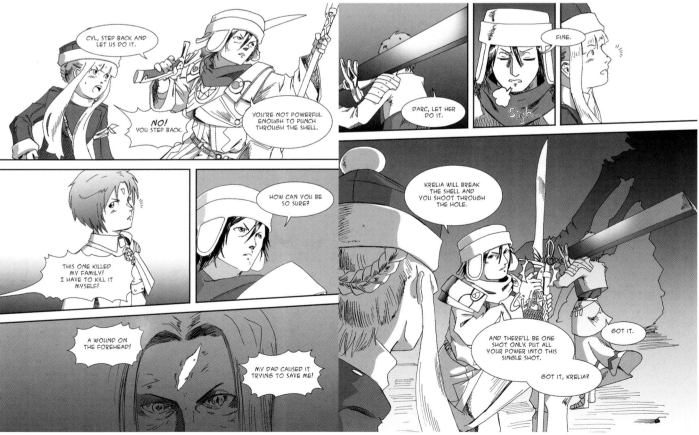

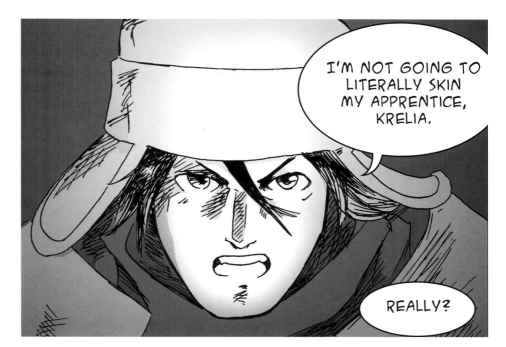

This is what you need to be careful about when you draw a double-page spread image. Here is Darc. The centre line of his face is on the centre line of the page. This is how you see the pages when you are drawing.

However, this is the result when the pages are printed and bound. The middle part of his face has disappeared in the crease and his face is distorted.

Double-page Spreads

The image in a double-page spread is used to create the utmost drama in a scene. You can do whatever you want for your image making, but there are a few rules:

Firstly, do not place important objects and characters too close to the middle.

Secondly, if you want to show the frontal figure, do not place the centre line of the figure in the centre of the pages.

Thirdly, place speech balloons on the same side of the page as the characters talking.

These rules are all due to how a book is printed and bound. No matter how you try, it is inevitable that your final product will have a crease, and the middle section will be virtually unseen.

To create a double-page spread is very easy: stick two sheets of paper together and draw your creation.

OPPOSITE TOP: **This illustration uses light to indicate the character's attention. In this case, Cyl has just recognized an insect attacking her from behind. The toning suggests that the light is showing from behind her, from the same direction the insect is attacking. This, with concentration lines, expresses her sudden realization that something is attacking her from behind.**

OPPOSITE BELOW: **This is similar to the 'pushing back' effect. Toning is used to indicate something important in the scene – in this illustration, the sword. This works as a spotlight, pointing the reader where he or she needs to look.**

Lighting

Manga does not simply depict the reality: everything is used to create drama, even natural phenomena – for example, lightning is used to create a dramatic moment, such as surprise. Lighting is the same. Thus you can suggest that an object is important by literally casting light on it. It can also be used to symbolize the character's attention: in this case the shadowed part is 'pushed back', and the lightened object is pulled out.

The most famous (and perhaps the earliest) example of this is Caravaggio's *Supper at Emmaus* in the National Gallery, London. In this painting, the face of Jesus is lit up to make clear he is an important figure; in real life, his face would be hidden by the servant's shadow.

Page-by-Page Notes to the Sample Manga

Many of the methods and techniques presented in this book are exemplified in the Sample Manga, and explained below in the page-by-page notes. Where things have not worked particularly well I have also added my criticisms. This is because no work has ever been perfect, and even though you may have created your Manga story, it still won't be finished: you need to look at your work carefully and criticize it, and you will be amazed at the flaws and mistakes you may find. Nevertheless, looking for them and their solutions is the best way to improve your skills.

There are many places in the Sample Manga I could still improve, but I've left them as they are. One reason is, you'll never finish redoing a Manga if you keep actually making these improvements to your work; the other is to demonstrate why they aren't good by revealing the flawed parts.

Overall Notes

This Sample Manga is created to demonstrate as many effects and techniques as possible, and for that reason it is successful. On the down side, it is also virtually the first action-oriented Manga, and I still need to pay more attention to the layout, especially in terms of how to break down an action and develop the parts into a fluid sequence. On a technical level, I changed my drawing style slightly. If you have my *Othello*, you will notice that the drawings in the Sample Manga have more crosshatching.

These are the points I have to improve:

1. The way to introduce a new scene. I have used too many fade-in and fade-out methods, and these are not very effective.
2. Effects for action.
3. Layout.
4. Breaking down an action and laying it out to create a sense of speed.

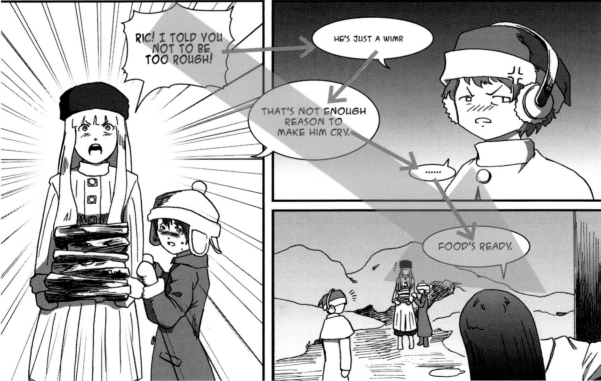

Page 0 (*see* Page 10)

The first panel of the story is traditionally used to introduce the world to the readers. Here it is a snowy winter scene, suggesting that the story is set in a countryside.

The layout of the lower part is quite useful, except for one restriction. Since you read diagonally from the top left to the bottom right, you cannot place speech balloons on the bottom of the second panel. If you do, readers will it find awkward or they might even miss them. Red arrows show how the speeches are read; the green arrow shows the general direction of the reading.

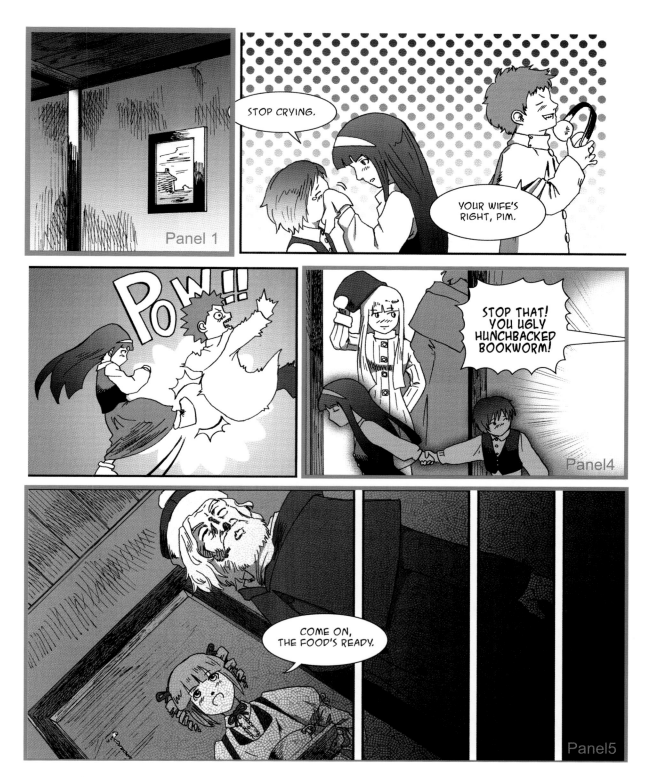

Page 1 (see Page 11)

Panel 1 is a small panel indicating that the scene has changed. The reader would be confused if you changed the scene without any indication.

A flash of light in panel 4 suggests action, usually something violent and loud; in this case it is shouting. I used a flash of light but you can use short concentration lines.

Panel 5 shows the effect of fade-out. This panel links with the first panel of the next page.

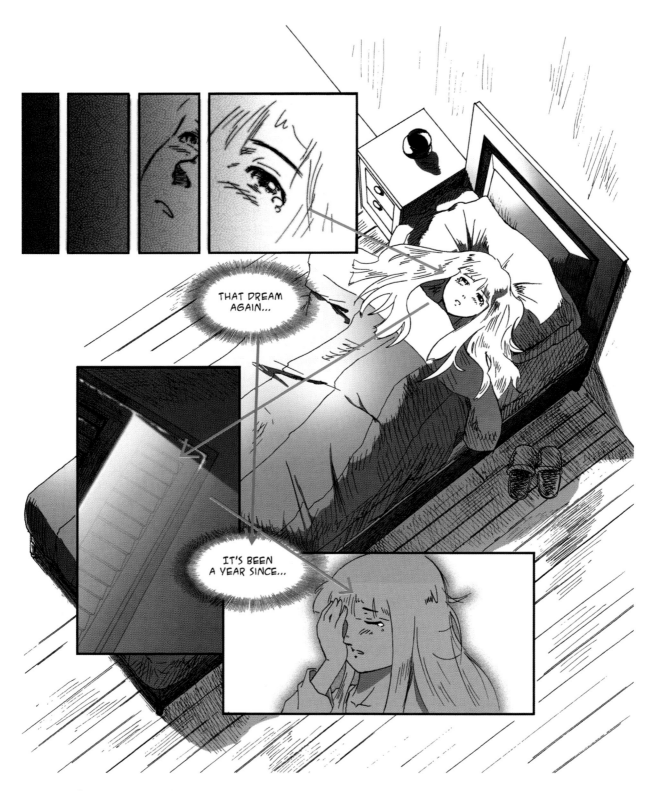

THAT DREAM
AGAIN...

IT'S BEEN
A YEAR SINCE...

Page 2 (see Page 12)

This page establishes the scene. The arrows show how I structured the layout: the red arrows show my intention of the order of how the images should be seen; a blue arrow is the line of speech. These arrows form a diagonal line, from top left to bottom right.

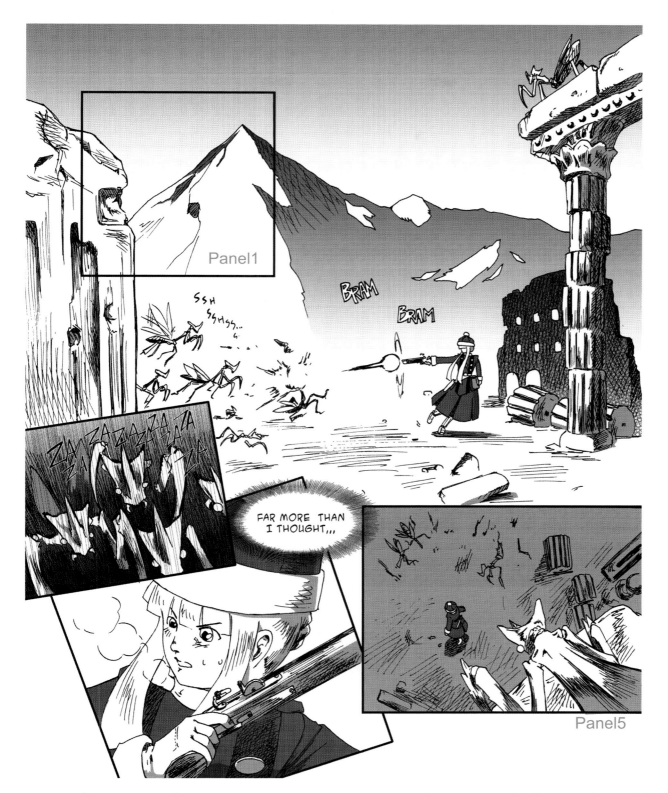

Page 3 (*see* Page 13)

The frame in panel 1 might not be needed. This panel was originally intended to cut a part of the scenery to create an introductory panel.

Panel 5 is an example of tone used to push back a part of a scene. You can see that the small insect on the pillar looks closer.

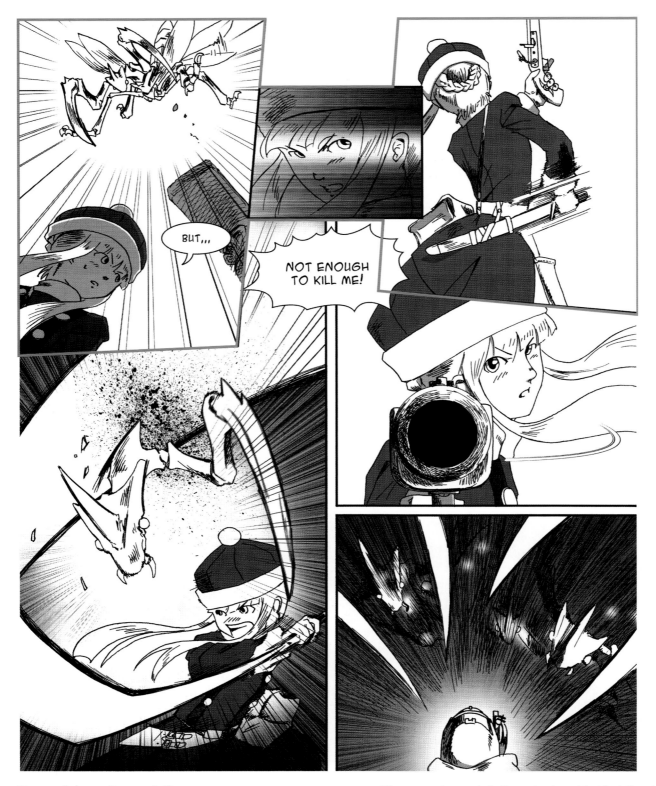

Page 4 (see Page 14)

I used an irregular framework on this page. This is to increase the movement and drama of the scene. However, this might confuse the reader, especially the top part.

The second speech balloon is placed behind the drawing of a small insect. This creates depth to the image.

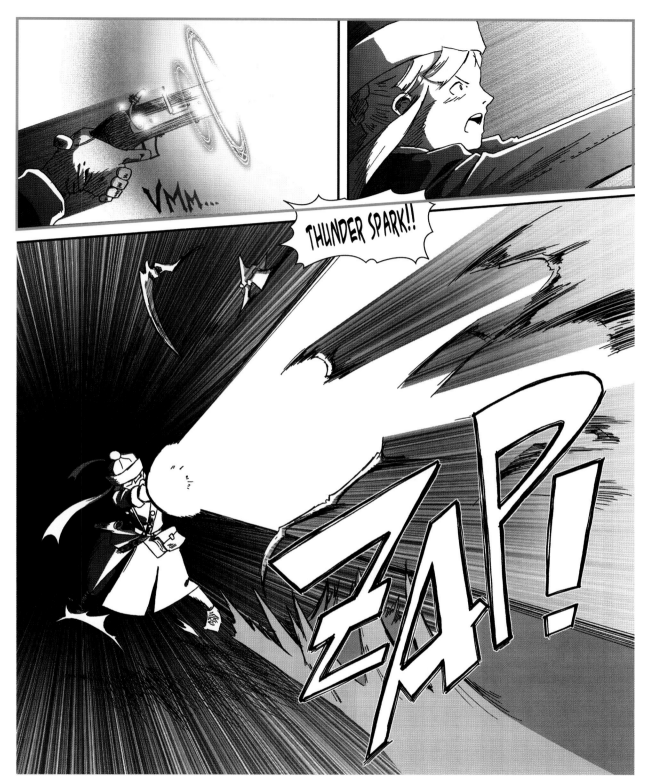

Page 5 (*see* Page 15)

The top two panels look as if they are both depicting the same moment from different viewpoints, and an action in a short timescale. This is because Cyl is making the same action in both panels. The speech balloon that overlaps the three panels also gives the impression that the three panels are all executed while the word is being spoken.

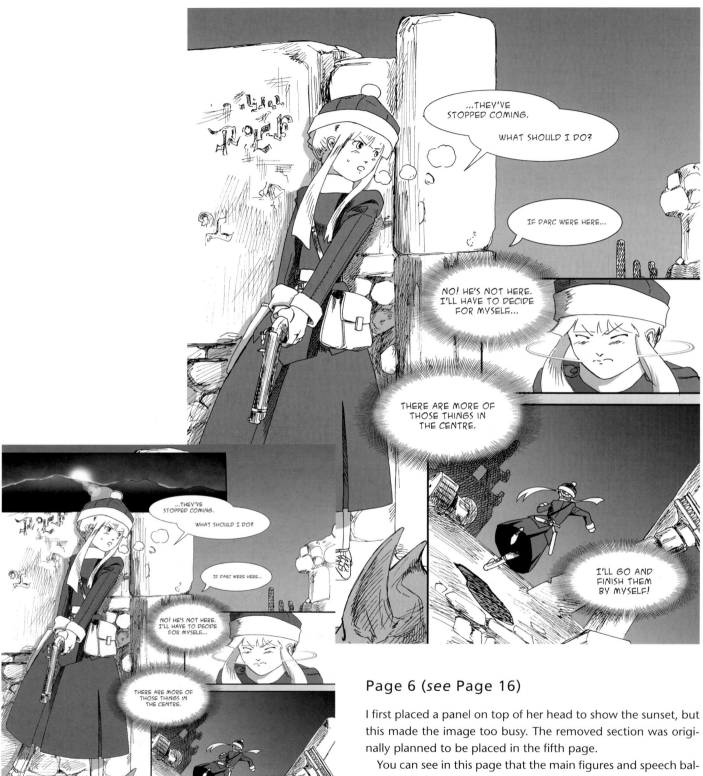

Page 6 (*see* Page 16)

I first placed a panel on top of her head to show the sunset, but this made the image too busy. The removed section was originally planned to be placed in the fifth page.

You can see in this page that the main figures and speech balloons are placed to form a diagonal line.

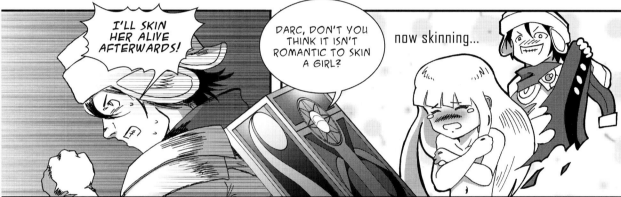

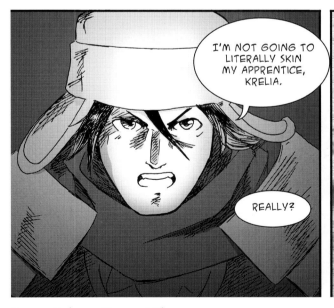

Page 7 (*see* Page 17)

The third and fourth panel act as a flip-board. The third panel depicts this actual world, and the fourth panel illustrates what Krelia is saying.

The fifth panel shows scenery. Shifting the image from figures to scenery distances the reader from what is happening and helps to switch the scene.

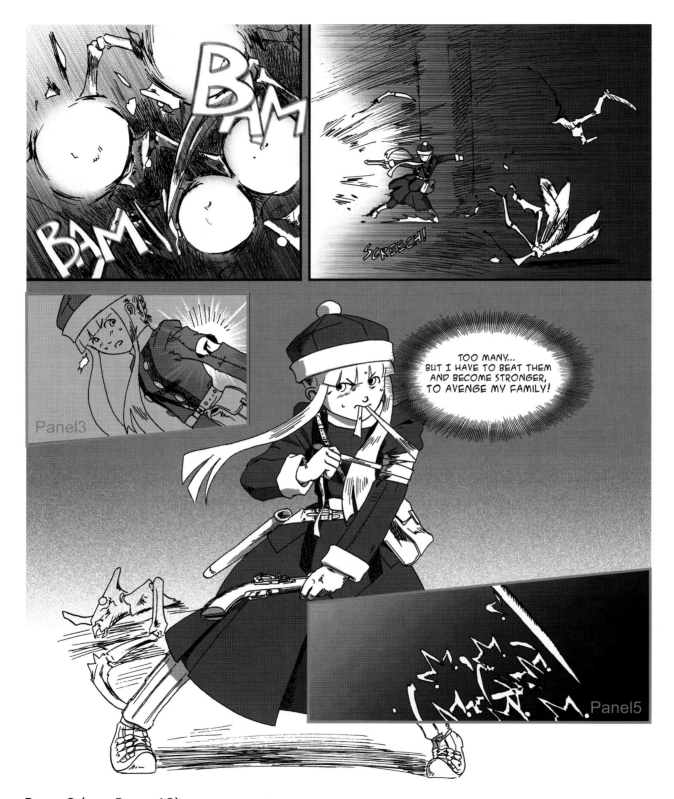

Page 8 (*see* Page 18)

In panel 3, the tone is used to illuminate the wound. This panel should be a separate panel, rather than an insertion. Panel 5 shows insects creeping up, but it is not as obvious as I intended.

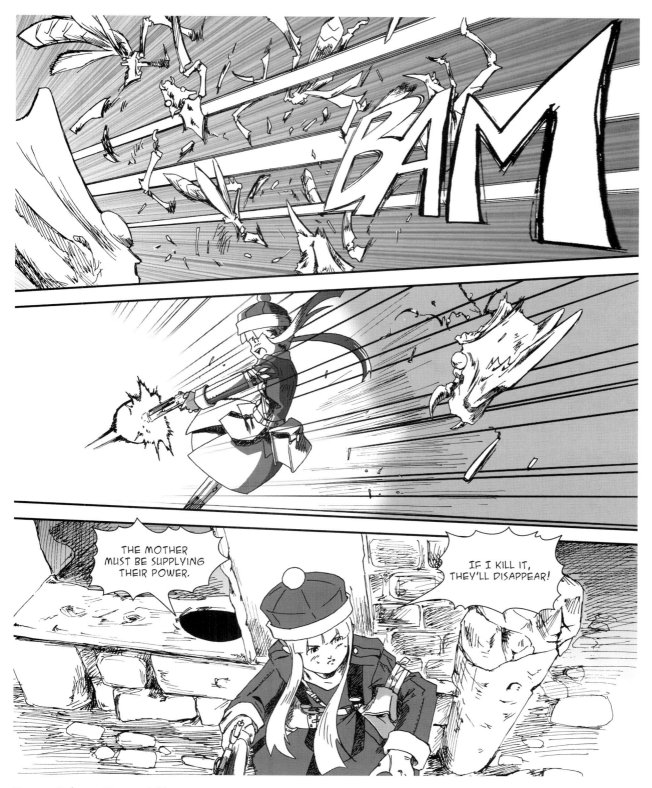

Page 9 (*see* Page 19)

The bullets in the first panel should have been thicker. It would
look better if the trails had some effects.

Page 10 (*see* Page 20)

When I finished this page, the action looked a bit jumpy. This is because originally the third panel showed Cyl shooting the head of the middle-sized insect, and in the fourth panel she dodged a falling insect and shot again. I had assumed that the reader would make out what was going on, but actually the original didn't really make sense. So I replaced the third panel with the image that bridges the second and the fourth panels.

The last panel uses almost no speed lines, creating the impression that time has stopped. This effect is equivalent to slow motion in film.

Page 11 (*see* Page 21)

Placing the Moon behind an object (here, the Mother) is a classic technique used to enhance the atmosphere and clarify the object's silhouette. This is also used to hide the character's face. To enhance the height of the Mother, the characters' positions are not realistic. They are so close that Cyl would be simply crushed by her legs.

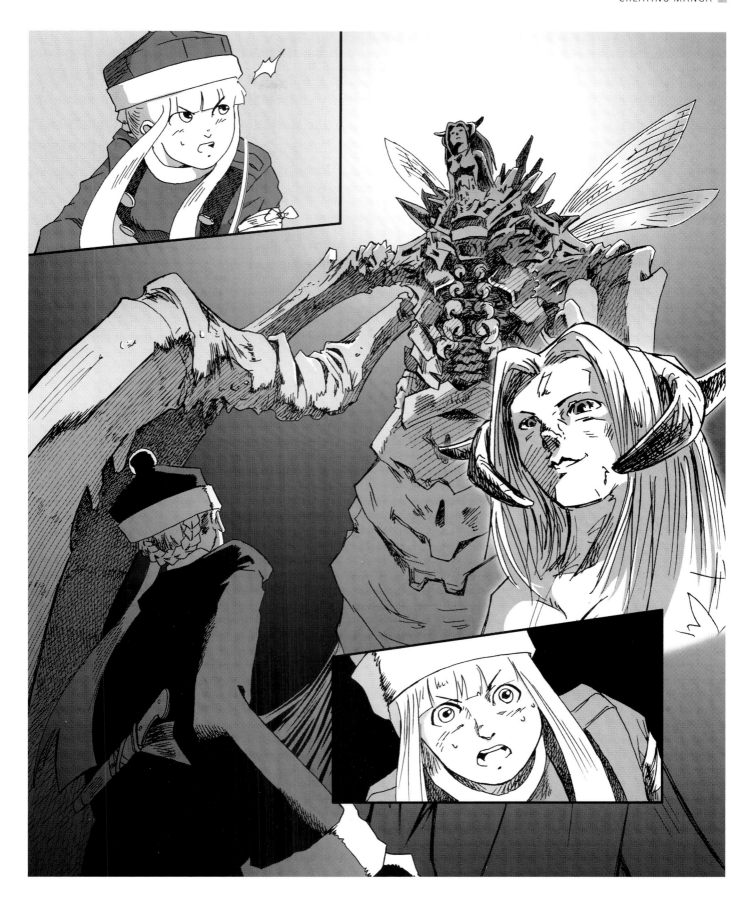

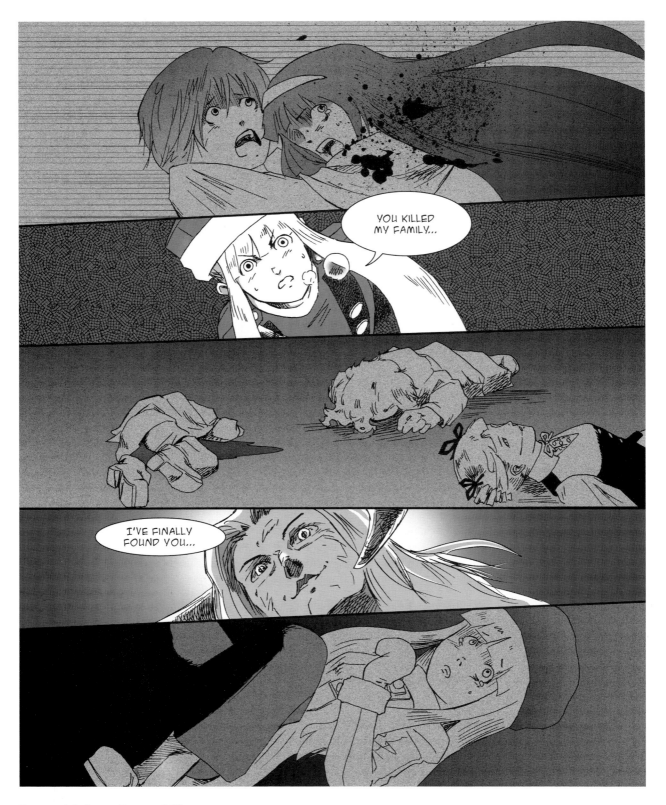

Page 12 (*see Page 22*)

This page shows Cyl's recollections. The past is illustrated with tones over the panels. The viewpoints of the second and fourth panel imply the power relation between the two characters: Cyl looks up and the Mother looks down, symbolizing the fact that the Mother is much more powerful than Cyl.

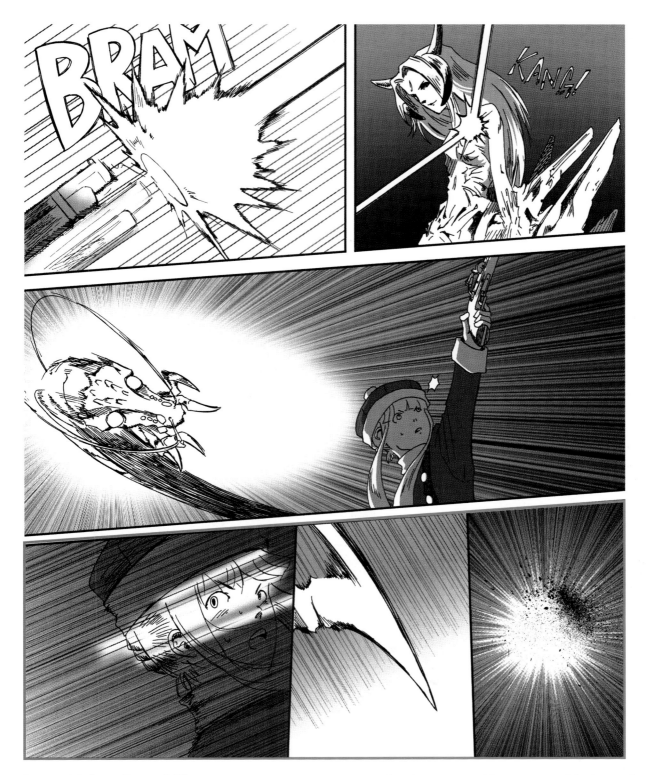

Page 13 (*see* Page 23)

The direction of the speed lines and light in the fourth panel is misleading. In the previous panel, the middle insect attacks her from above so the direction of the speed lines should be from the top left to the bottom right. The current lines make her look-

ing down, not up. The sequence of the lowest three panels is not clear, but I think this can be fixed by making the second panel clear that the image depicts a craw. Maybe it would work better to combine the left and middle panels to show both Cyl and the insect.

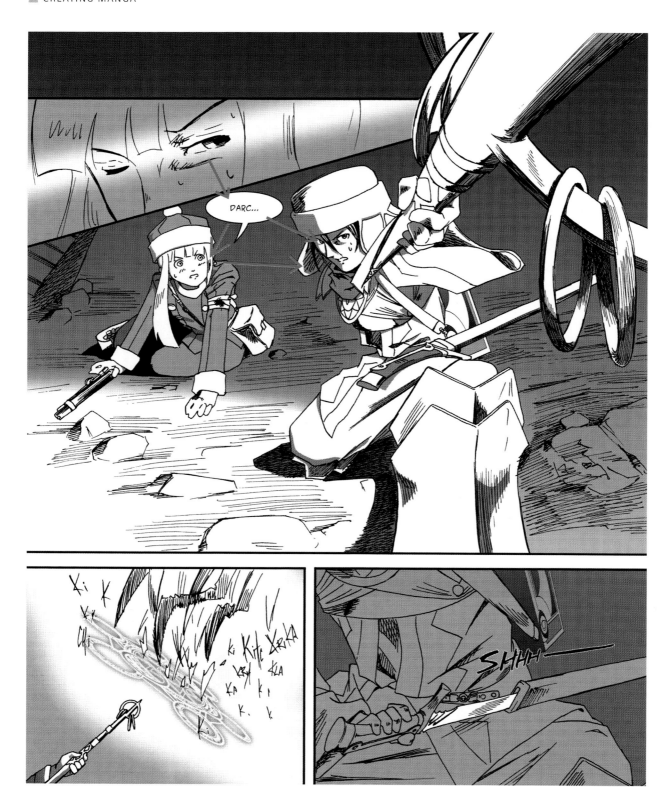

Page 14 (*see* Page 24)

The arrows show the order in which the reader would read the page. The figures are composed to form the diagonal lines roughly needed for easy reading.

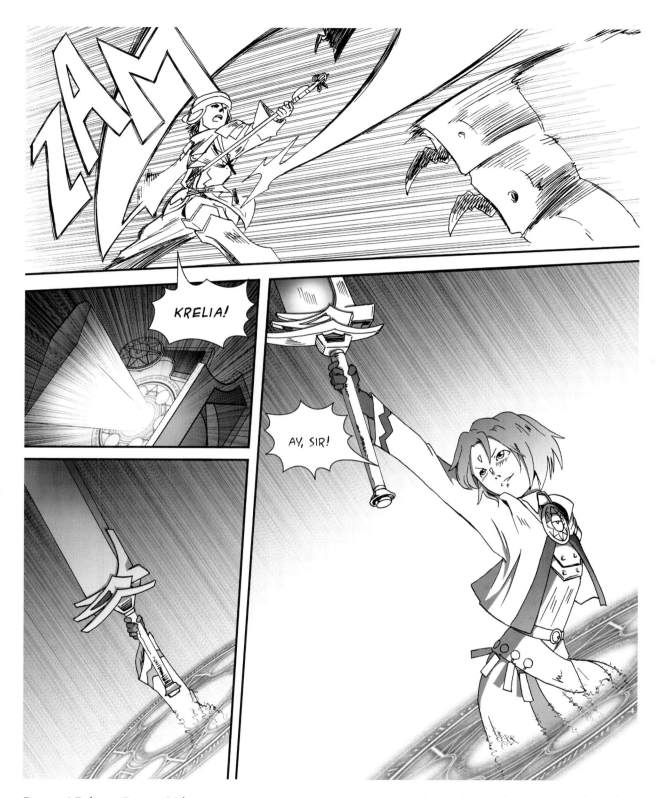

Page 15 (*see* Page 25)

The lower part of this page is completely rewritten: the original drawing was not clear as to what was going on because there were too few panels to illustrate the sequence where Krelia is appearing. It is very important to show the sequence of an action that readers are not familiar with. After the second time you can shorten the sequence.

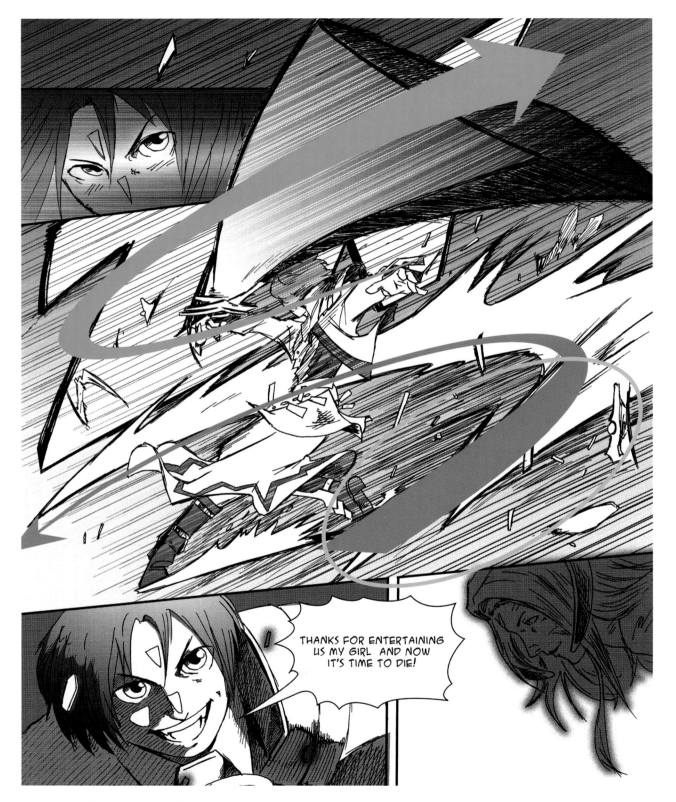

THANKS FOR ENTERTAINING US MY GIRL AND NOW IT'S TIME TO DIE!

Page 16 (*see* Page 26)

The top part of the page has a similar layout to page 14, but this page is more dynamic and has more action.

The direction of the blast (the area surrounded by a blue circle) should be reversed to make the swinging movement clearer. The red arrows indicate the movement of the blast effect, and the green one shows the movement of the sword.

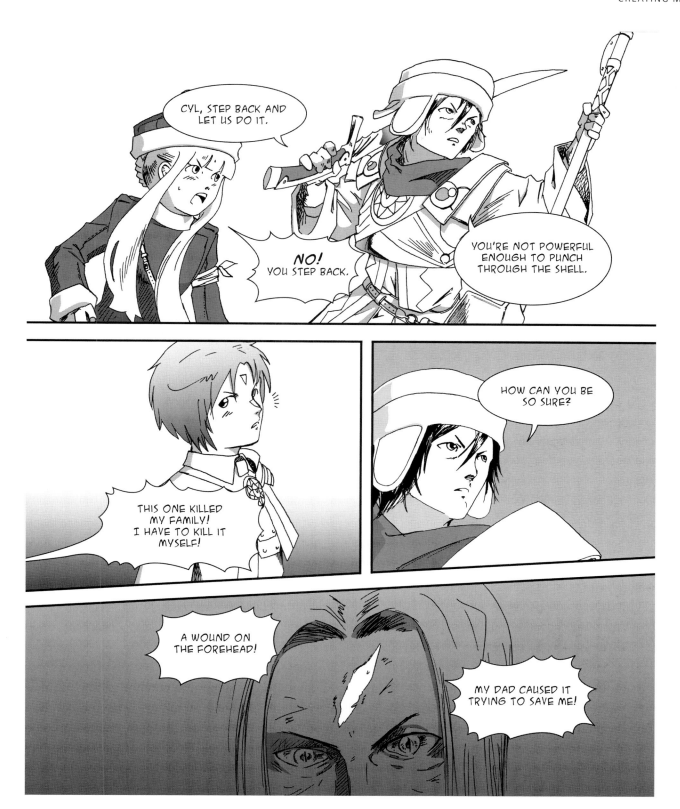

Page 17 (*see Page 27*)

This page is used as an example of characters' placement. The Mother is outside the page on the right-hand side. Three char-

acters, Darc, Cyl and Krelia, are facing her. Darc is alert, so he's keeping his eyes on the Mother all the time.

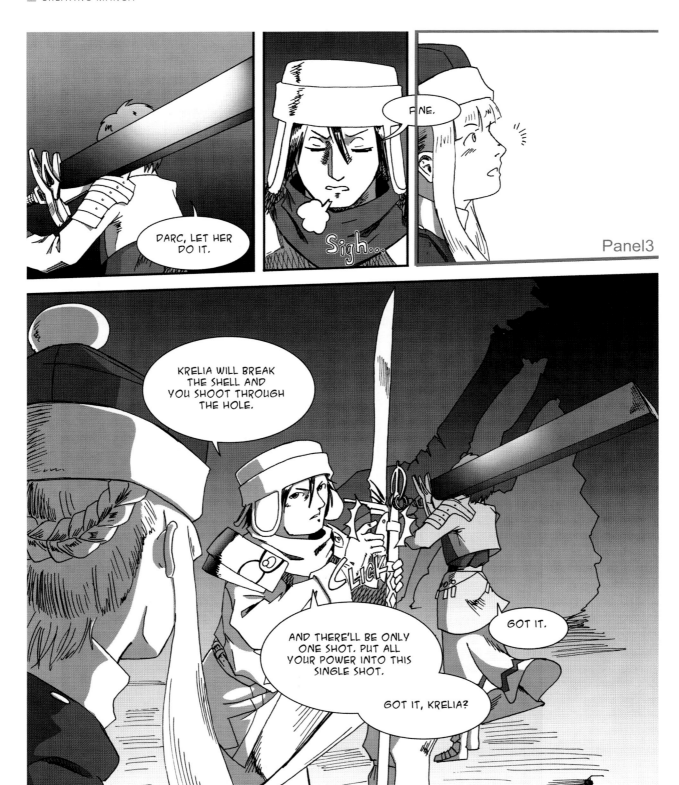

Panel3

DARC, LET HER DO IT.

FINE.

Sigh...

KRELIA WILL BREAK THE SHELL AND YOU SHOOT THROUGH THE HOLE.

CLICK

AND THERE'LL BE ONLY ONE SHOT. PUT ALL YOUR POWER INTO THIS SINGLE SHOT.

GOT IT.

GOT IT, KRELIA?

Page 18 (see Page 28)

The white background in the third panel lightens the atmosphere. In this panel, this background is used to depict her feelings. When you create a night scene, the atmosphere becomes depressing and heavy. In some cases, you'll find it hard to lift up the atmosphere during a night scene.

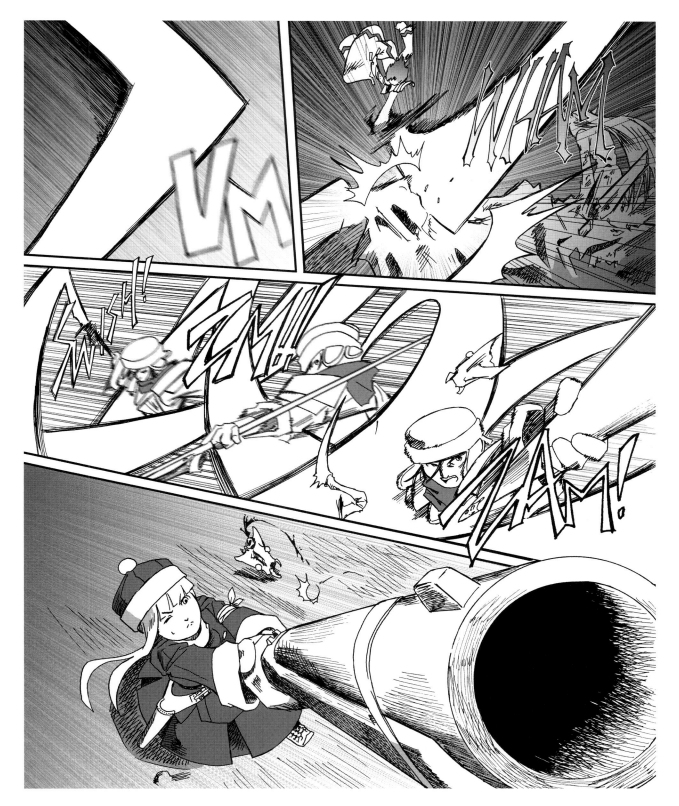

Page 19 (*see* Page 29)

The first panel is supposed to be the sword. It might be more recognizable on the next page, but it needs to be made more obvious. The third panel is an example of fast movement. These three figures are drawn on the same sheet of paper. I copied the lines and blurred accordingly, using Motion blur filter. It would look better if the insects were blurred, too.

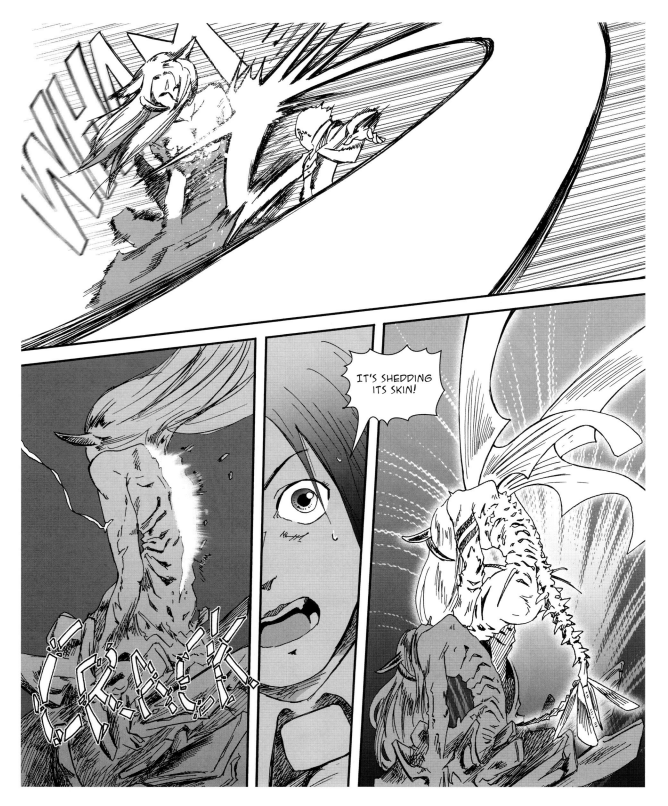

Page 20 (*see* Page 30)

White in panels 2 and 4 indicates to the reader the important parts in these panels. Using tone and white, the unnecessary parts are pushed back, and the readers' attention is drawn to white areas. A white splatter on the first panel depicts a spark. As on the next panel, adding white splatter creates a sense of power in the scene.

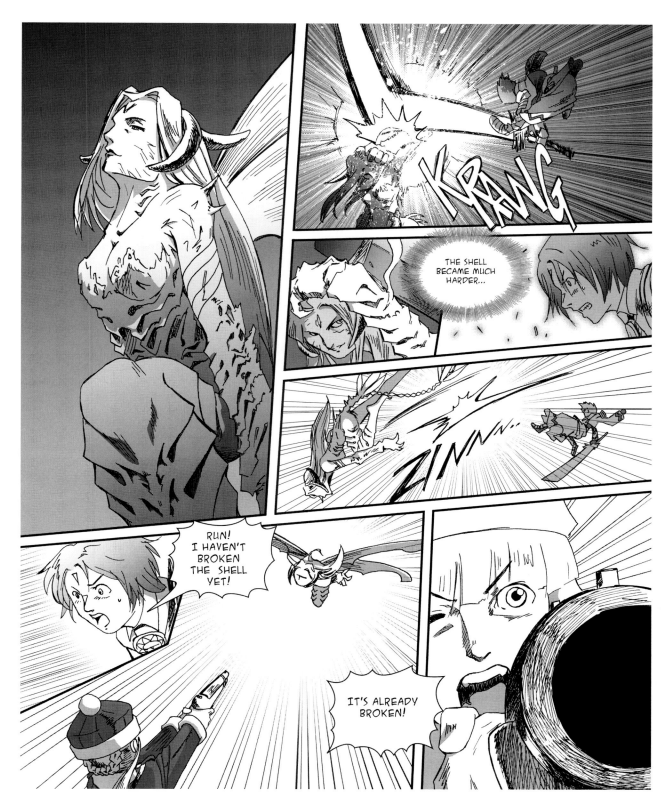

Page 21 (*see* Page 31)

The layout of the top part of the page is basically a reversal of the lower part of page 0. The first panel's image is not really nec-

essary for the story. This drawing is to show the whole body of the Mother in the second form.

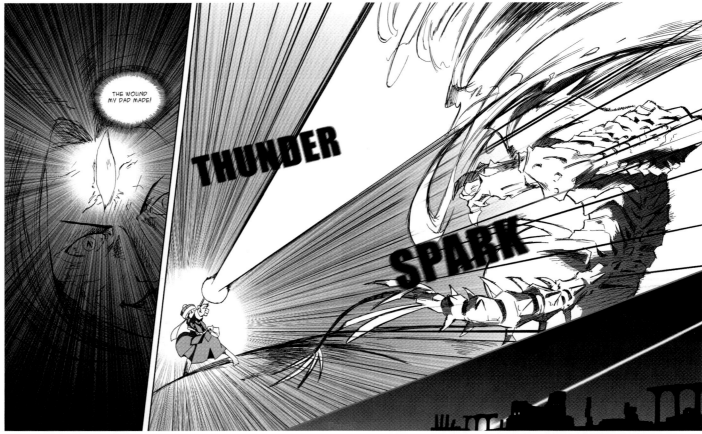

Pages 22–23 (*see* Page 32–33)

The third panel is intended to show the ruin seen from a distance. The light beaming from the ruin is Cyl's bullet. The scene also works to create a sense of time between the previous panel and the next page. Unfortunately that image doesn't indicate clearly enough what's going on; adding sound effects might work better.

Page 24 (*see* Page 34)

This page has very few actions. A withdrawn viewpoint in the first panel creates a detached feeling. It also depicts stillness and quietness.

Page 25 (*see* Page 35)

The drawing in the second panel has a blurred outline on the original outline. This will create a soft-focus effect. This tech-

nique is also used to depict over-exposure, emphasizing the brightness.

Page 26 (*see* Page 36)

The middle part of the page originally had the legs below the third panel. I removed them when I was inking to make the page clearer. It is effective because the reader would recognize the lower margin as a blank part, not as part of the middle section.

Page 27 (*see* Page 37)

Krelia's shoulder guard is misplaced in the fourth panel.

Page 28 (*see* Page 38)

Krelia's figure, circled with red, is a method used to depict a large figure. This is a kind of multi-viewpoint method, and it does not separate the figure from other panels.

Page 29 (*see* Page 39)

The last panel concludes the story.

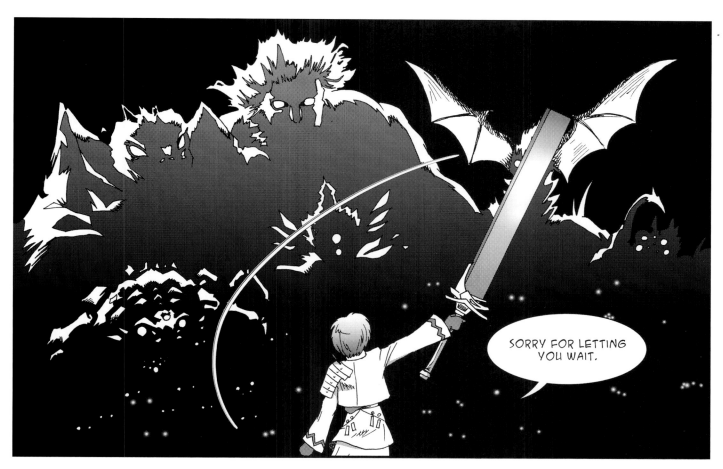

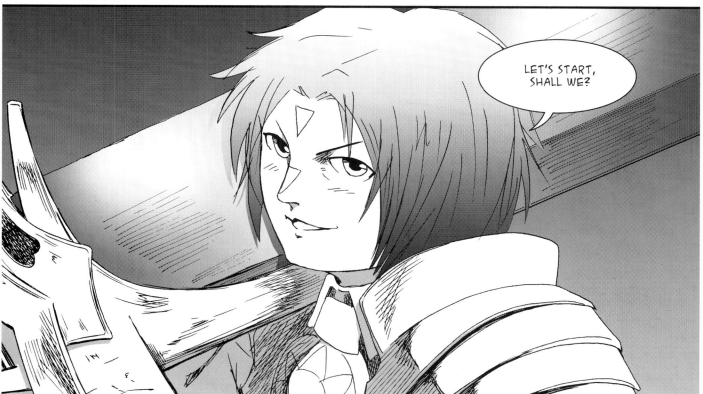

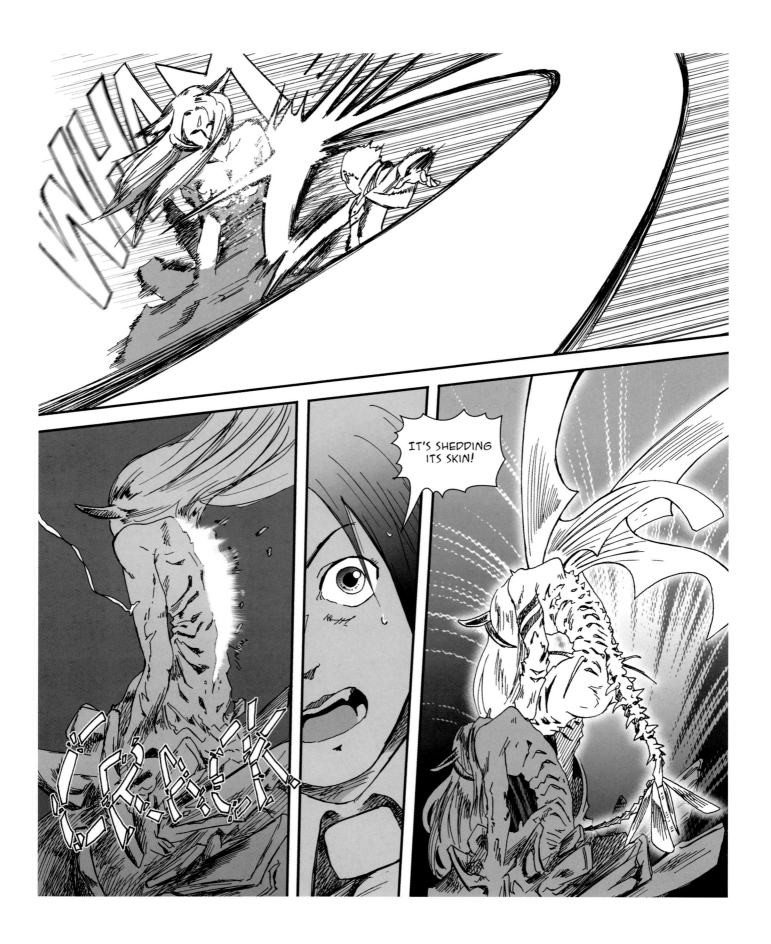

MANGA TECHNIQUES

You have designed your characters and laid out the pages; now you can start creating your piece of work.

Recent developments in computer graphics have had a huge impact on the methods needed to create Manga. The programs I use are Adobe Photoshop, Illustrator and Manga Studio (called 'Comic Studio' in Japan). Even if you are not using these programs, understanding how these techniques are used will help you to use your accustomed programs.

This chapter focuses mainly on digital Manga creation, explains how a page is made, and shows the whole process of creating a page from the Sample Manga.

Page Structure

The illustration shows the structure of page 20 of the Sample Manga (*see* page 30), divided into layers. A layer works like a transparent film sheet on which a certain image is stuck; a graphic image is made of these layers stuck in a certain order. When we see the final image, we're looking down on this pile of sheets from above. Understanding and managing these layers is crucial to successful work.

The illustration shows a typical layer set of a page. These layers are, from the top: texts, speech balloons, sound effect 1, frame, white, line drawing, sound effect 2 and tone.

Texts: The layer for the texts almost always comes top. It is better to leave this layer separate and editable.
Speech balloons: The layer below the text layer is for speech balloons. I often place the balloons over frames, so this layer goes above the frame layer.
Sound Effect 1: In most cases, sound is placed over drawings and other effects.
Frame: The fourth layer is for frames. It is best to have a separate layer with a frame, so as to ease the work when putting in tones and other effects. This layer masks the lines and tones that bleed out of the original frame on the line-drawing layer.

Layers that create the page.

White: This layer is for the white overlay of the page. These overlays are mostly lights and splash. If you have a layer for glowing effects, it should come somewhere around here.
Line drawings: The main part of the artwork is placed on this layer. I have extracted the line for this layer but you can place the original file with the transparent mode set as 'multiply'.
Sound Effect 2: This layer is for anything that you want to place behind the line drawings.
Tones: The tones come on this layer, and it is best to place the layer at the bottom. Although it is fine to place the tone layer on the line-drawing layer, placing it at the bottom prevents you from merging it with others by mistake.

Text layer. Unless you are doing all the processes on your own, it is better to keep the text layer and artwork layer separate when you flatten the layers.

Speech balloon layer.

Sound effect layer 1. This layer is the part that goes over the line drawings' layer and the frame layer.

Frame layer. This layer also works as a mask for the layer below.

White layer. White is a term for correction, drawing and other effects using white paint.

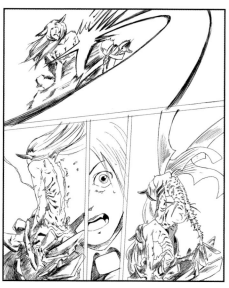

Line drawings layer.

Sound effect layer 2. This layer is for the parts that would go behind the line drawings.

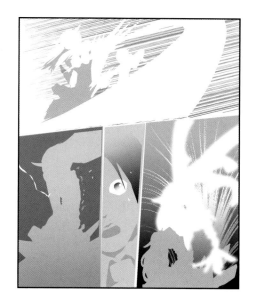

Tone layer.

Techniques
Selection Tools

Creating selection areas is the most important aspect of creating an image on the computer. Fortunately, Photoshop has various tools and techniques to do this.

Magic wand tool.

Rectangular marquee tool.

Lasso tool.

Quick Mask Mode. This shows a square selection in the Quick Mask mode. In this mode, the selection is represented without a mask.

Magic Wand Tool (shortcut 'W'): This tool is the quickest if you have an image with a closed outline. If, however, you are working on a greyscale (or colour) file, the tool won't select the image with less than 50 per cent transparency. Also, be careful that 50 per cent transparency is not 50 per cent opacity. You can still select the lines even if the layer's opacity is set at less than 50 per cent. This transparency is the darkness of the image on a layer.

Rectangular Marquee Tool (shortcut 'M'): This tool creates a rectangular selection. It is useful for selecting a panel.

Lasso Tool (shortcut 'L'): This tool enables you to create a selection freehand. I use it to select speech balloons.

Quick Mask Mode (shortcut 'Q'): Quick Mask is a very powerful tool. It visualizes the selection area and enables you to manipulate it, just like painting. You can apply almost all kinds of image-making techniques in this mode. This is ideal to fine-tune the selection you have created with a Magic Wand Tool. The illustration shows a rectangular selection area in Quick Mask Mode; it is shown with no mask applied.

Selection Techniques

ADDING AND REMOVING PART OF A SELECTED AREA

With most tools, pressing the 'shift' key or clicking the second right icon in the menu bar changes the mode to 'Adding New Selection' mode. In this mode, you can add the newly created selection area to the existing ones. The mode can be recognized by the pointer. In this mode, the '+' mark appears next to the tool pointer.

To remove part of an area from a selection area, use the tool while pressing the 'Alt' key. The same can be done by clicking the second left icon in the menu bar. This 'Removing New Selected Area' is recognized by the '−' mark next to the pointer.

Clicking this button before creating any selection makes the mode you set the default.

Adding a square selection on to another square selection using the Rectangular Marquee Tool.

Subtracting a selection from another selection. The tool is the Lasso Tool.

Sometimes you will want to set an 'Adding Selection' or 'Removing New Selected Part' mode as default, so that you can add or remove the part in succession. You can do this by clicking the icon you want for default in the menu bar.

The pen tool can be used to create a selection. Draw an image and right click on the page window, then select the 'Make Selection' in the pop-up menu. Set the Feather to 0, then click OK to create a selection. Another method is to click a layer icon in the Layer Tab while pressing down the 'Ctrl' key. You can rasterize the vector image and use the Magic Wand Tool to make the same effect.

This technique works in almost all situations, and I used it extensively while creating the Sample Manga. Its one drawback is that it is time-consuming.

Use the pop-up menu when you convert a vector mask created by Pen Tool to a pixel image. Feather blurs the edge of the converted selection. Set this to '0' to get sharp edges.

You can create a selection using a channel. Go to the Channel Tab in the Layer Tab, and click on the 'Load Channel as Selection' button. Dragging the appropriate channel on to the button can do the same. You need to be careful that this selection, created like this, is inversed. This technique is used to extract lines.

In order to inverse the selection, go Selection > Inverse (shortcut 'Shift + Ctrl + I').

Going to Select > Modify allows you to open a window to modify the selection. 'Expand' will enlarge the selection, and 'Contract' makes it small. You can expand or contract the image up to thirteen pixels. If you want to modify the area more than thirteen pixels, you need to repeat the process.

This 'Load Channel' button is a useful tool. Clicking this button selects the area of a channel (in greyscale mode, you can select only grey, or the black part of the image).

Creating Lines

Manga and comics use lines to denote various effects of movement, the most notable being speed lines and concentration lines. These lines can be created on a computer.

Most artists, however, still create lines manually, and dip pens and fine tip pens are used for this purpose. The dip pen is the most popular tool, but you need skill to draw a line. When you draw, use a plastic ruler with a sloped side, and flip it so that the ink does not go down the ruler and smear the paper. To create concentration lines, stick a pushpin at the centre and pivot the ruler along it.

CREATING SPEED LINES 1

Open a new document in Photoshop, preferably square in shape. Making the document square helps when you create Concentration Lines 1 from this file.

Opening a document.

Inverting the selection comes in very handy when you're putting in tones. It is also indispensable when extracting lines.

Fill a part of the canvas with black.

Filling part of a document with black.

Expanding a selection.

Go Filter > Stylize > Wind.

Wind Filter.

155

In the pop-up menu, set the mode as 'Wind' and the direction to 'from Left'.

Pop-up menu of Wind Filter.

You'll see the edge between two colours change slightly. This shows that the wind effect is applied.

When the filter is applied once.

Repeat the same process five to six times. The illustration shows how it looks when the effect is applied six times.

The effect is applied, but the changed area is just a tiny por-

When the filter is applied six times. If you apply it more than five to six times, the effect starts to look jagged.

This is how it looks in its actual size.

Select the grey part.

tion of the whole image. Now we're going to enlarge the area. Use the Rectangular Marquee Tool to select the affected area, and copy + paste the area.

Go to Edit > Free Transform (shortcut 'Ctrl + T'), and stretch the area horizontally.

Stretching the selected part.

You might not be able to see it, but a part of the image will be sticking out of the document. You have to cut this part. Choose Crop Tool (shortcut 'C') from the tool bar and select the entire image, then crop it. This will remove the part outside the document. Delete the original layer, and you have new speed lines.

Cropping the area outside the document. This technique comes in handy when removing parts that are out of the page.

CREATING CONCENTRATION LINES 1

Open up a file with Speed Lines 1. Make sure the shape of the document is square. If it is not, use Crop Tool or go to Image > Image size to change it.

Open the file.

Rotate the canvas to bring the brighter side to the top.

Rotate the canvas.

Go to Filter > Distort > Polar Coordination.

Polar Coordination filter.

Select 'Rectangular to Polar' in the pop-up menu.

Pop-up menu of the filter.

This is the result. If the original document isn't square, you'll have distorted concentration lines.

Finished speed lines. You can manipulate this to create various special concentration lines.

CREATING SPEED LINES 2

The speed lines created by this technique are more like the traditional hand-drawn style than the previous ones.

Open a new document in Illustrator. You can take any size and shape you want.

Choose Ellipse Tool from the menu bar (shortcut 'L'). Set the colour as black for Fill, and none for Stroke.

Ellipse Tool button and the colour setting.

Draw an oval. This oval will be the basis of the lines.

Draw an oval. Draw it larger than you intended the line to be.

Choose the Convert Anchor Point Tool from the menu bar (shortcut 'Shift + C'). Click on the anchor points on the side of the oval. This clicking makes the curve into a sharp point.

Convert Anchor Point Tool.

Click left Anchor Point with the tool.

Make both right and left Anchor Points sharp.

Choose the Selection Tool (shortcut 'V'), and shift the anchor points to narrow the line.

Narrowing the line.

When you're satisfied, copy and paste the line to multiply it. Repeat this copy-and-paste process to create a group of speed lines.

**Copy and paste
the lines.**

When you do, alter the thickness and length of the line. This will prevent the lines from looking uniform and artificial. The example uses three different thicknesses.

**The detail of the lines.
With more variety of
lines, they look more
natural.**

Save the file in .ai format and open it in Photoshop. Choose the mode as greyscale to reduce the file size.

**Open the file in
Photoshop.
The resolution should
not be lower than the
pages you're going to
create.**

The illustration shows the details of the file. If you're successful, the image should consist only of the lines. Save the file in Photoshop format to finish it.

**In Photoshop, the white
background of the
Illustrator document
doesn't show up. This
really saves time when
you create some images
in Illustrator.**

CREATING CONCENTRATION LINES 2

Open the file with Speed Lines 2, the one you created with Illustrator. Copy and paste the lines in Illustrator. You need to have a good number of lines for this operation.

**You need a lot of lines for this
technique. The lines here are
multiplied three times.**

Choose all the lines and when they are selected, open up the option panel of Brush tab and choose 'New Brush'.

Select all lines.

Select the 'New Brush' option.

Select the brush type as 'New Art Brush'.

Select the 'New Art Brush' option.

In the pop-up screen, change the direction to 'vertical' and click OK.

**Option panel of the 'New Art
Brush' option.**

You don't have to think about other options because you can change them later.

If successful, the speed lines are stored in the Brush tab as a brush stroke.

The barcode-like icon in the Brush Tab is the newly created Art Brush. This will become the concentration lines.

Draw a circle with the Ellipse Tool. Make sure the Fill and Stroke of the circle is set to none.

Draw a circle.　　　　**Ellipse Tool button and colour mode.**

When the new circle is selected, click on the added Art Brush (this looks like a barcode); if successful, the lines are lined up along the circle. The result is concentration lines. Save the file and open it in Photoshop, then save it again to be ready to use in Photoshop.

This illustration shows how a concentration line would look

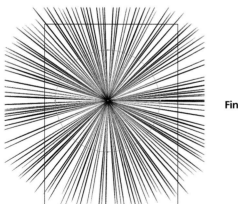

Finished concentration lines.

when it is created using Polar Coordination. The lines thicken as they move away from the centre, and there is also a strange change of thickness; these discrepancies make the lines difficult to use.

Concentration lines using Polar Coordination Filter in Photoshop.

CREATING SWISH LINES

Swish lines are used to describe sweeping movements. They are very hard to draw well manually. However, new developments in technology mean that you can draw them on the computer.

The program you need to use is Illustrator. Open a new document, then place the scanned pencil drawing by going to File > Place. This pencil drawing will be your guide.

The pencil drawings of swish lines.

Lock the layers and create a new layer on top of it. This layer is used to create base lines. Create lines with the same procedure as 'Creating Speed Lines 2' (see above). Then tweak the line appropriately.

Create lines just like the speed lines 2. The ends of the lower lines are moved slightly upwards. When applied, the upper part will come inside the curves.

Lines are made. The next task is to create a white area underneath the lines, which will block off images beneath them when placed. Deselect all and set the colour as Fill > White and Stroke > None. Pick the Pen Tool (shortcut 'P') and trace the outmost lines.

Drawing the white part.

When you have finished, bring the sub layer of the white part to the bottom. Select all and press 'Ctrl + G' to group them. This will ease their management.

Grouped and the lines are ready to use. I placed them on a red background to show the overall image.

Register the line as an Art Brush.

The next step is the same as when creating 'Concentration Lines 2'. Select the lines and click the 'New Brush' from the options in Brush Pallet. Select the 'New Art Brush' in the pop-up menu and click 'OK'.

The pop-up menu.

Make sure that all preparation is finished. Lock all the layers and create a new layer. Pick the pen tool and make sure the Fill and Stroke is set as 'none'. Trace the pencil lines.

Trace the pencil lines.

While the new line is selected, click the lines you have registered as an Art Brush from the Brush Pallet. The line will appear as a swish line.

Apply the Art Brush on the line.

However, in this example I wanted to flip the lines so that the side with two lines goes to the outside of the curve. In order to do so, select the line and click 'Options of Selected Object' button from the Brush Pallet.

Set the options as you please. 'Flip Across' is checked in this example.

When you're satisfied, make the layer no longer needed invisi-

Click the option button to change the direction and other settings of the Art Brush.

Pop-up menu of option.

Line images created in Illustrator. The image is first drawn by hand, then traced using the Pen Tool.

ble, and save the file. When you open the file in Photoshop, you can see the lines are ready to use.

How to Apply Patterns

Finished lines.

The image with a white background.

When you are drawing, you often have to draw the same repeated pattern. Many examples are found on buildings.

Create a pattern and open it in Photoshop. This example shows Darc's box created in Illustrator. As you can see, the image has some white parts and some transparent parts.

The first thing you need to do is to enlarge the canvas. Go to Image > Canvas Size and enlarge the canvas. Create a new layer and fill it in with white. When this is done, bring the white layer behind the original layer.

You don't have to extract lines, but keep the white part so that the pattern masks the lines underneath when it is applied.

Merge the two layers together. Select the outside of the pattern with Magic Wand Tool (shortcut 'W'); this will select the whole document minus patterns.

Invert the selection by choosing Select > Inverse (shortcut 'Ctrl + Shift + I'). This will make the patterns the selected areas. Using your favourite tools, deselect the unnecessary part.

161

Select the outside of the document with the Magic Wand Tool.

This shows a side panel of the box that was selected in the Quick Mask mode.

Drag the pattern on to the page window using Move Tool (shortcut 'V').

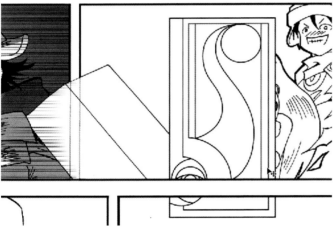

Drag and drop the image on to the page.

Go to Edit > Transform > Distort to reshape the pattern as appropriate.

Distort the image.

Remove the unnecessary parts. The images are placed in front of the frame layer. The tone layer for this part will be created on top of this layer.

You can also do the same operation in Free Transform mode. While you're in the Free Transform mode, click and drag the corner points while pressing the 'Ctrl' key.

When you're satisfied, remove the unnecessary parts.

Repeat the same process and you have patterns on all sides of the box. However, I need to place an eye on it. To do this, the method is the same as the previous one, though this time, the patterns are hand-drawn. When you create a hand-drawn image that will be cut and pasted, make sure the outlines are closed, otherwise you can't use the Magic Wand Tool.

The eye drawn on a sheet of paper.

The eye is distorted and applied to the box.

Click the option menu in the Layer Palette and select Merge (shortcut 'Ctrl + E'). This makes the selected layer merge with the layer below. However, you cannot merge a layer on to a Vector Mask Layer (the layer created by the Pen Tool). When you

merge a Vector Mask Layer on to another layer, the Vector Mask will be rasterized to create a pixel image.

When you put in tones, create a layer on top of the image layer. Be careful not to merge the tone layer on to the image layer by mistake.

How to Apply Magic Circles

This technique is used to create glowing patterns, such as magic circles, neon signs, computer messages, hologram images and lightning.

Firstly, create a pattern in Illustrator. You can, of course, create the image by hand. This example uses two images.

Two magic circles were created in Illustrator and imported to Photoshop.

Drop the images on to the page file and resize them into an appropriate size.

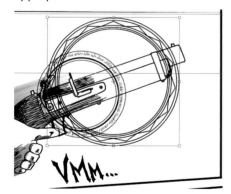

Two circles were moved and resized.

Link the two layers (in this case, layers 2 and 3) and reshape them. Because I linked them, you can reshape the image at once.

Determine the shape and position of two circles. Then move these layers on top of the line layer.

There are two methods for creating glowing effects: using the layer option, and without the layer option. Be careful that these two methods are modified for a whiter background.

Linking multiple layers enables you to manipulate these layers simultaneously.

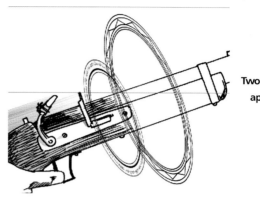

Two circles ready for applying effects.

USING THE LAYER OPTION
This method is the easiest one. I used this method on the left circle.

Invert the colour to white by going to Image > Adjustments > Invert (shortcut 'Ctrl + I'). Then double click the layer icon on the Layer Pallet to bring up the menu. Select 'Outer Glow'.

Layer Option pop-up window. This shows the default setting.

Change the Blend Mode to multiply, and colour to black. Play with the other parameters till you're satisfied.

The setting of the option for this example.

This is the result. It looks all right, but the white line is a bit too sharp.

The result.

Copy the layer and remove the effect. Then go to Filter > Gaussian Blur to blur the line. If you prefer, change the transparent mode to Dissolve. This would look better if it were printed as a black-and-white image.

Using Dissolve mode works better when the image is converted to a black-and-white bitmap image.

Erase the unnecessary lines to finish.

Finished image.

WITHOUT THE LAYER OPTION

This method is more complicated, but you can fine-tune the effect.

Duplicate the layer and go to Filter > Minimum to thicken the line. In contrast to their name, Minimum Filter thickens the lines, while Maximum thins them.

Thickening the line.

Next, go to Filter > Gaussian Blur to blur the lines. Reduce the opacity if you think the image is too dark. The illustration's opacity is set at 70 per cent.

Blurred line.

Choose another layer (the one you've been keeping in the original state) and make the line white. Duplicate the layer again. Put the Minimum filter and the Gaussian Blur filter to mask the middle part of the image. This will create a glowing effect.

Invert the colour of the lines.

Duplicate and blur
the lines.

**Backlight effect is
commonly used to
represent strong light.
In this example,
however, the effect is
used to soften the
image. Removing the
tones over the figures
create this effect.**

Merge all the layers and remove the unnecessary lines.

Fill in the desired area with 100 per cent black. This will be the base for the effect.

Finished magic circle.

**The opacity of the
black-filled part is
reduced to show the
lines of the figures.**

This is the final result. The image is slightly different from the ones in the Sample Manga because I redid the effect.

Duplicate the layer and go to Filter > Other > Minimum to enlarge the size of the image. In case you want to modify the effect, leave the original layer untouched.

**Comparing two circles
created by different
techniques. The left-
hand one is with the
Layer Option, and the
right-hand one is
without the Layer
Option.**

Using the Minimum filter to expand the black part.

Backlight Effect

The backlight effect is a Manga expression, which is not depicted in a realistic way. In real life, the light bleeds inside the figure's edge, while in Manga, the shadow bleeds out of the figure. I also use this to distinguish part of the image from the rest of it. If you use a white colour, you'll have a glowing effect, and this method can be applied to create a soft-focus effect.

Blur the image: go to Filter > Blur > Gaussian Blur to do this. At this stage, what you need to think about is the area of the blurring, not the shade. You can change the shade of black later on.

Duplicate the layer with a blurred image, and change the mode of the new layer to Dissolve. By adding the dissolved

Blurring the area.

Merging the dissolved layer on to another layer will reveal the actual dot resolution. Also, this merging makes the Opacity mode normal.

image, the blurred part becomes clearer when it is converted into a black-and-white image.

Lower the Opacity as you please. The illustration sets the Opacity at 20 per cent.

Change the opacity mode as Dissolve.

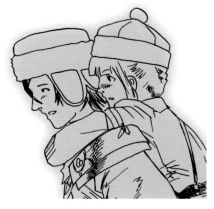

Lower the opacity of the layers.

If you think the shade is too pale, duplicate the layer. By placing multiple layers together, you can darken the shade.

You might want to drop the opacity of the Dissolved layer. However, as you can see, dropping the Opacity in Dissolve mode affects the inside of the image where you want it to remain solid black. To fix the problem, you need to set the mode not in Dissolve mode, so retaining the effect.

The solution is simple: create a new layer below the Dissolved layer and merge them together. This will make the layer with a Dissolved image in Normal mode.

You can finish the image as it is. But here, I want the image itself to remain white, and you might want to lighten the shade within the image. In this case, the original layer comes to life. Create the selection area by clicking on the layer icon of the original while pressing 'Ctrl' and deleting the effect.

Set the opacity at 100 per cent. This is what it looks like on display. The dotted area looks very coarse. This happens because the display automatically adapts the resolution of the dots.

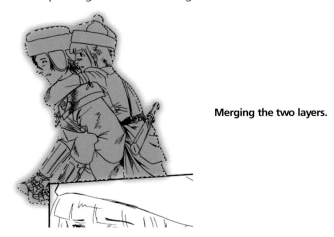

Merging the two layers.

The last thing you need to do is remove unnecessary parts. You need to be careful when the effect is created in this method, that the area of the effect does not spread beyond the frame and invade the other panel.

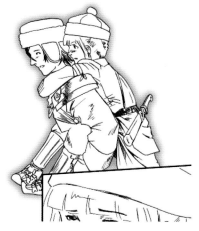

Remove the unnecessary parts – in this case, the inside of the drawing and the part that bled into the next panel.

Sound Effects

Sound effects are used extensively in Manga. The Japanese language has a vast library of onomatopoeias, and many of them are impossible to translate in English. Even the same onomatopoeia has different nuances in Hiragana and Katakana (Japanese alphabets: in general, Katakana gives a strong, hard impression while the Hiragana impression is softer). When I started to create Manga in English, this was the greatest problem I encountered – and these onomatopoeias are being created on a daily basis, their size, shape and colour determining the overall effect.

I usually draw the sound effect on a separate sheet of paper, but in some cases I do them directly on the drawing. Below is an example of how to create the sound effect on a computer.

The sound effect.

Open the file that contains the sound effects in Photoshop.

Using the Magic Wand Tool (shortcut 'W'), click on the outside of the sound effect to select the area.

Then go Select > Inverse (shortcut 'Ctrl + Shift + I') to reverse the selection. If you have more than one sound effect (and other parts), delete the unnecessary selections. Drag and drop the selected sound effect on to the page file. Rename the layer appropriately. Change the size and shape.

The next thing is to add a white area around the sound effect

Select the outside of the effect with the Magic Wand Tool.

Inverse the selection. This is how it looks in the Quick Mask Mode. Unless you feel otherwise, you don't have to think about fine-tuning the selected area as in placing tones.

Drag and dropped on to the page.

Resized.

to make it clear. Click on the layer icon in the layer pallet while pressing the 'Ctrl' key. You can see the sound effect's area has been selected. While the selection is working, create a new layer and fill it with white. For this illustration, I filled the selection with black to show how large the white part would be, and later inverted the colour to white.

Move the white layer behind the sound effect. Then go to Filter > Other > Minimum to expand the white image.

Image part filled with black.

You can have the same result by expanding the selection. Select the sound effect area and go to Select > Modify > Expand to expand the selection area. Then fill it with white.

Using the Minimum filter.

The finished image on a black background.

Splatters

Splatters are used for several effects. Black splatters are usually used for blood; white ones are for stars and sparks. Note that you don't have to create both black and white splatters separately: once you have made them, you can invert the image colour on the computer.

There are two different methods that create different types of splatter: coarse splatters with a brush, and fine ones with a toothbrush.

COARSE SPLATTERS

Coarse splatters.

Coarse splatters are used for blood splatters and sparks, as these need bigger drops of ink. You need a brush, ink and paper. Dip the brush into the ink, then blow the brush sharply on to the paper. This will produce a coarse splatter.

FINE SPLATTERS

Fine splatters.

Fine splatter is used to depict stars and to add a texture to a flat surface. You need a toothbrush in place of the brush: dip it in ink and flick its bristles with your finger.

Tones

Tones are perhaps the most characteristic tool employed in Manga. Using tones, you can quickly create a series of designs and patterns that are hard or even impossible to draw by hand.

Putting in tones by hand has always been quite time-consuming; moreover, they are very expensive. These problems are exacerbated as tone work techniques are developed and the

Dotted tones with various resolutions and greyness.

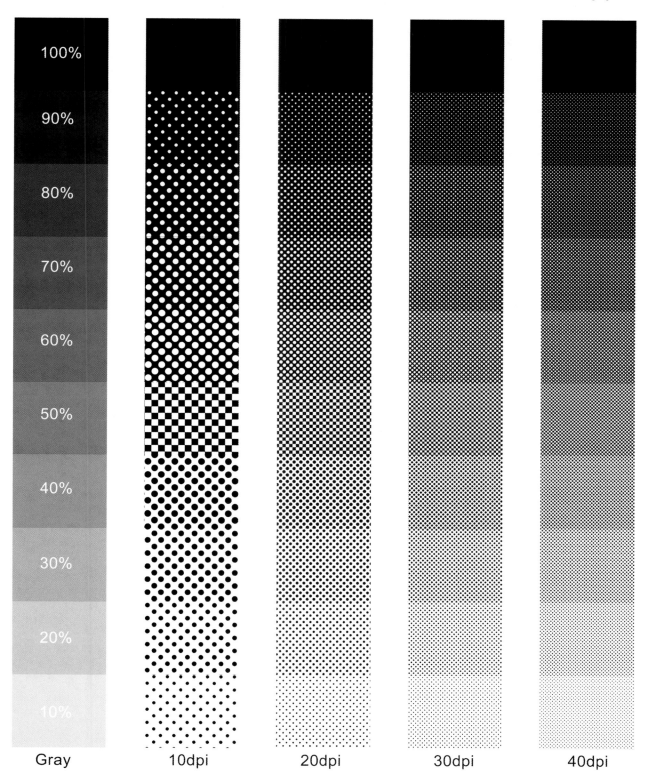

| Gray | 10dpi | 20dpi | 30dpi | 40dpi |

50dpi 60dpi 70dpi 80dpi

Dotted tones with various resolutions and greyness.

number of tones required increases. However, recent technological development enables you to create and use tones on the computer. Here, mainly digital tones are described.

Basic Knowledge

Tone is a sheet of plastic with glue on the back. Patterns and images are printed on to the surface of the sheet. When you use it, you need to cut it and stick it on the paper by rubbing it strongly. The patterns and images can be anything; the most popular ones are dot patterns. Magic circles and the patterns explained in the previous section can be described as tones.

Tones are very useful in creating repeated patterns and images that are too time-consuming to create by hand. However, they make the drawing flat and tasteless, and quite often they darken and depress the scene.

Tones are usually explained in a set of numbers, such as 40L30 per cent. The first set of numbers (40L, in this example) describes the fineness of the dots (lines). This example shows that this tone has the fineness of forty lines per inch (lpi) (by comparison, newspaper print is somewhere around 85lpi). The second set of numbers (30 per cent in this example) indicates the blackness, 100 per cent being solid black and 0 per cent white. The illustrations on pages 169 and 170 reveal the sample of greyscale and tones with various finenesses.

Moiré

Moiré is created when dots or other repeated patterns overlap with another pattern, and this is often a major problem when using tones. Applying more than one sheet of tone over another creates this moiré, and although this is generally something you must avoid as it distracts attention away from the main image, if used properly, moiré can create a beautiful effect.

Moiré is something you need to avoid when using tones. However, it is sometimes used to create special effects.

Hand-Applied and Digital Tones

Tones can be applied either manually or digitally, and there are advantages and disadvantages to both these methods.

Hand-applied tones are costly and time-consuming to create – cutting, sticking, scraping and removing them takes a lot of patience – and you need literally hundreds of them to start with. However, the good thing about hand-applying tones is that you can see the dots and lines of tone with your own eyes, and this really helps you work out which is the best tone to use. Furthermore some artists claim that hand-applying tone has more 'depth' and 'taste' than computerized tones.

Digital tones are applied as either pre-made tones or greyscale images converted into black-and-white images. They are much quicker to apply, a lot cheaper and you can customize them. You can reuse the tone again and again, and once you've had a bit of practice, you can apply them much faster than by hand. Furthermore the flexibility of digital tones is a very attractive factor. You can resize, distort and manipulate the opacity, and apply effects available to your graphic program.

However, there is one huge drawback: you can't see the dots in actual size. The display screen converts the dots on tones to fit the screen resolution, and in most cases, you can see moirés on them. This makes it very hard to judge whether your tone is the right one for the scene. And looking at dots on the computer screen quickly tires the eyes.

Broadly speaking, there are as many disadvantages as advantages between hand-applied tones and digital tones.

Applying Tones

The techniques explained in this section are for the Photoshop user. If you are using another image-making program, simply apply the technique to fit your own favourite programs.

The Pen Tool is the most effective for covering complicated areas where the Magic Wand Tool is ineffective.

USING PEN TOOL
The first technique is to use Pen Tool (shortcut 'P').

First of all, press 'D' to set the colour to default (black

foreground and white background). Select the Pen Tool, and trace over the area you want to use to apply tone.

If you want to apply more areas, click on 'Add to Shape Area' icon (shortcut '+').

Click this button to add new areas to the previously created areas.

Sometimes you need to remove some areas from the traced area. For example, let's remove tone from these icicles.

A shadow under the roof. However, the icicles are also covered by the shadow.

Click on 'Subtract from Shaped Area' icon (shortcut '–') and trace the icicles to remove the shadowed areas.

The 'Subtract from Shape Area' button.

It is tiresome to switch the 'Subtract' and 'Add' modes every time. Also, it often happens that you forget to switch to 'Add' mode after removing a part, and keep working (when you're in 'Subtract' mode, you cannot add any shapes). In order to prevent this from happening, use the following technique to switch automatically to 'Add' mode after you have finished subtracting an area.

To begin with, start tracing the area you want to subtract while in 'Add' mode.

Tracing the icicle. The mode is still in 'Add' mode.

Click on the 'Subtract from Shaped Area' icon (not shortcut) before closing the line. This switches the mode from 'Add' to 'Subtract' only once.

Clicking the 'Subtract' button anytime before closing the line and the mode changes only once. The mode goes back to the previously selected mode when the line is closed.

Close the line to create an area and the mode selected back to 'Add to Shape Area'. If you use a shortcut instead of clicking on the icon, the mode switches after you created the area.

Changing the mode of an already created area to another one is quite a useful technique. Look at this example. A shape is created on the stump in 'Subtract' mode. You can see the outline but there is no fill. This is because the area is created in 'Subtract' mode. Now, let's change the area to a normal one.

When you are working at a fast pace, you often create an area in the wrong mode. This example shows the area created in 'Subtract' mode. However, this area should have been created in 'Add' mode.

Select 'Direct Selection Tool' (Shortcut 'A') and click on the shape. Click one of the anchor points on the outline.

Select an anchor point and remove it.

When an anchor point is deleted, the program recognizes the shape as 'under construction' and enables you to modify it.

Close the line.

Press the Backspace key to delete the point. Go back to the Pen Tool and click on a point at the opening. Then, in the top menu bar, click on the icon to change the mode to 'Add'. Close the line, and the result is as illustrated.

APPLYING PRE-MADE TONES

When you apply a tone, make sure that the resolution of the tone is high enough. If your tone is low resolution, the image shows jagged pixels when enlarged. When you create a tone, it is recommended that you make it at 600ppi (pixels per inch) or at least 300ppi.

This example demonstrates how to apply a sky tone on the first page of the Sample Manga.

Open the page and tone files. The tone is taken from the Manga Studio.

Open the page file and the tone file. Using Move Tool (short-cut 'V'), drop the tone on to the page. The tone has white parts, and the layers beneath the tone do not show up.

Change the Opacity mode as Multiply. It is not necessary in this example, but if your document already has other layers underneath, it is necessary to change the Opacity mode. Decide the placement of the tone.

Create the selection. This selection is created by using the Pen Tool, and the area is converted to a selection area.

If you created the selection area before placing tones, go to Select > Save Selection to save the selection area, then delete the

Drag the sky on to the page. The mode is set as 'Normal' so the layer beneath the sky is blocked.

Changing the mode to 'Multiply' makes the layer behind transparent, so that you can see through the sky layer.

Selection shown in the Quick Mask mode.

The menu bar of the Gradation Tool. This is the setting used for this example.

original selection. Saved selection can be loaded by Select > Load Selection.

Invert the selection and press the Backspace key to delete the unnecessary tone. When you created the selection, the selected area is the part where the sky will be. Therefore, you need to invert the selection and remove a part other than the sky.

The selection is inverted and the unnecessary part is removed. The problem with using tone is that even though the scene in the tone is bright, the greyness of tone makes the whole scene dark and depressed.

The sky looks too dark and needs to be lightened up. Click on the tone's layer icon in the Layer Tab with the 'Ctrl' button pressed. This selects the tone.

Create a new layer, then choose the Gradient Tool (shortcut 'G'). Select the appropriate style. The style in this example is 'White to Transparent'.

Apply gradation on the selected part and when you are satisfied, delete the selection.

Select the tone area.

The impression is now much brighter after the white gradation is applied.

USING THE MAGIC WAND TOOL

The Magic Wand Tool is a very powerful tool in Photoshop. With the right preparation, you can create a selection with a single click. However, this tool has some limitations.

Select the area with the Magic Wand Tool (shortcut 'W'). This Quick Mask image reveals the selected part. Bear in mind, however, that when you are using the Magic Wand Tool, you need to create a perfectly closed area. If there is a gap even one pixel wide, the selection will flood out of the gap and you will have the tiring job of finding and plugging the holes by hand.

This looks fine. But if you enlarge it, you can see the tool has selected only to the edge of the grey part around the line.

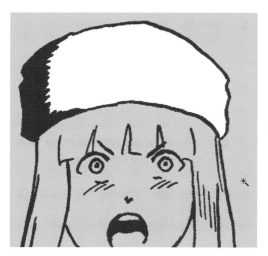

The area selected by the Magic Wand Tool in the Quick Mask mode.

A detail of the selected area. With the Magic Wand Tool, the selection ends with the edge of the grey part.

If you fill the selection area with tone, you'll have gaps between the lines and tone (although these gaps usually won't show up on the printed image). You need to enlarge the selection area. Go to Select > Modify > Expand and expand the selection by two pixels. Now you can see there are no gaps between the selection area and the lines.

After expanding the selection. Many 'How To' books recommend expanding only one pixel, but I often find that one pixel is not enough.

You still haven't finished, however. Small gaps and insertions, as in this illustration, are left unselected.

The circled areas are where you need to look carefully. The Magic Wand Tool cannot select these sharp and narrow gaps and insertions.

You need to add these parts to the selection. Here, Lasso Tool (shortcut 'L') is used, but you can also modify the selection in the Quick Mask mode.

Manually manipulated selection.

Now you're ready to apply the tones. When you fill them in, make sure you're not working on the line layer.

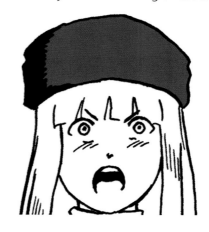

The selection with tone applied.

Adapting a Digital Tone

The Manga Studio has a vast library of tones. However, you cannot modify them in the Manga Studio as freely as you can in Photoshop. This section demonstrates how to adapt a Manga Studio tone to Photoshop format files.

To begin with, open the document in Manga Studio and place a tone on the document.

Export the file in .psd file and open it in Photoshop. The file is Photoshop ready but the image is still made of dots (lines). They are difficult to see on screen and if you reduce the size, the dots will congregate and become a messy mass of black when printed.

The file just exported from Manga Studio is in bitmap format that has only very limited tools available. The first thing to do is to change the mode to greyscale. Go to Image > Mode and choose Greyscale.

A picture tone opened in Manga Studio. This is a typical junior, or senior high school building.

The detail of the tone as it is.

Blurring will remove dots from the image. Be careful not to blur the detail out.

Changing the brightness and the contrast is a way to tighten up the blurred image and create another impression. I manipulated the image to remove various shades.

Then go to Filter > Blur > Gaussian Blur to blur the image. This will rub out the dots. From my experience, blurring the image by about five pixels works best.

Converting the file into a greyscale file enables you to modify the image; particularly important ones in this stage are brightness and contrast. The illustration had the brightness and contrast modified. You can now save the file and finish.

You can extract the black part, but bear in mind that once you have done so, you can no longer modify the brightness and contrast of the image.

Creating Tone

There are hundreds of different kinds of tone available, but sooner or later you'll find you are not satisfied with pre-made tones and will want to create your own. The tone I created is used as the background of an illustration in the second chapter.

Boot up Illustrator and create a new document. The size of document for this example is A4. Although you can choose any size you want, it is better to create a large size document.

Create a new document. Illustrator is very handy when creating a repeating pattern.

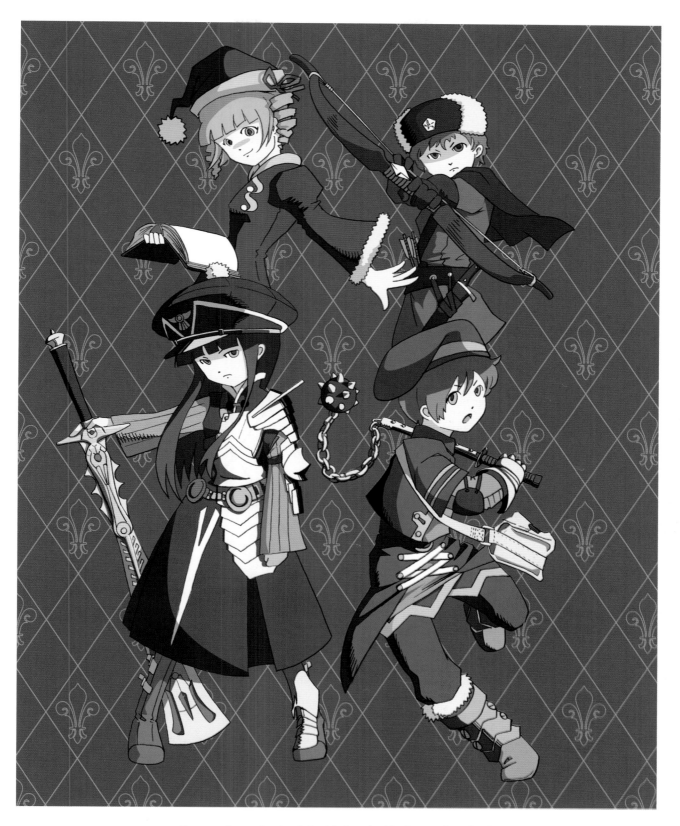

Tone can be used not only for black-and-white images, but also for
colour images. This is how the sample tone is applied on to a
coloured image.

Make a grid and
ruler visible.

Two lines finished.

Then, put in grid and rulers. These are the most important tools when creating a tone.

Draw a line. This line will be the basic line for the tone. The red line shows how the tilt of the line is determined.

Move the newer line to the left, to determine the size. Although you can resize the size of the finished tone, it's better to make the mesh of a smaller pattern. This tone has a cell of 20mm wide and 30mm long.

Draw the first line.

Detail of two lines crossing.

When you're satisfied, copy and paste the line on to another layer. This will prevent the confusion while making the base grid.

Copy and paste the lines. At this moment you don't need to place them at equal regular intervals, but make sure the copied lines don't go higher than the original line.

Reflect to create another
line with mirrored slope.
These two lines should be
in different layers otherwise
you would not be able to
select the desired lines out
of tens of lines.

Copying and
pasting the lines.

Reflect the new line with Reflect command.

This is how it looks when it's finished. Now move on to create the base grid.

When finished, select all the lines and click on the 'Vertical Align Top' icon. If you can't find it, go to Window > Align

(shortcut 'Shift + F7'). Now you have all lines aligned to the first line's height.

Aligning the lines. This Align and Pathfinder palette is extremely useful once you understand how they work.

Click the arrow in the circle to bring up the options. Enter the distance you want (in this example, 20mm). After entering the number, select the lines, click the leftmost line and click the second left button in the second column.

The options enable you to fine-tune the alignment and distribution.

This is the result. The lines are aligned at regular intervals. Now repeat the same process to the other set of lines.

The result. All lines are lined at equal intervals from each other.

When the grid is laid out, the document will look like this. The working area is much larger than the final size of the tone. You can remove these extra lines once you have finished, but equally you can leave them without any problem.

The image shows how the layers are organized. The lines are on two layers according to the direction of tilting. It is very important to keep your layers organized, especially in Illustrator.

Now let's create a main motif to put in the cells.

Finishing the grid.

How the layers are organized. In Illustrator, it is very easy to get lost in a sea of layers if you don't consciously organize them.

Create a new layer and place the image by File > Place. This example's drawing is different from the final motif. Lock the layer and create another new layer on top of it.

An imported drawing for the main motif.

Using the Pen Tool, draw lines over the original. At this stage you don't need to worry about the size.

Drawing with the Pen Tool.

In the final tone, the motif will be small enough to hide some flaws so you don't have to be precise. However, you need to think how it looks when it is made small. For example, very elaborate and detailed patterns often end up with unrecognizable black splatters, or the lines become too fine to see. When you're satisfied, proceed as follows:

Select all lines and go Object > Group (shortcut 'Ctrl + G') to group the lines into one object.

A half part of the motif finished.

Copy the group and paste it. Then choose Transform > Reflect > Reflect Vertically to make a mirrored image of the half. Now, put all of them together and group to create a motif.

Finished motif.

Place the motif in a desired position and modify the image. The stroke of the line is made as 0.75 points.

The motif in a grid.

Multiply the motif.

Copy and paste the motifs, and just like the grid lines, use Distribution to distribute the motifs regularly.

Group four motifs and repeat the same copy-paste-distribute process. This time, set the distance at 80mm: now we have a line of motifs. Group them together.

The motifs lined in two columns.

This image shows how the layers are organized.

Layers.

Repeat the same procedure again, this time sideways. Place the groups and align them to the left. Distribute them vertically by clicking the 'Vertical Distribute Centre' button. The distance is set to 60mm.

Vertical distribute Centre button distributes the selected images vertically, with the centre point of the group of images as the basic point.

The illustration shows how it should look:

The finished pattern.

Save the file and open it in Photoshop. This example's resolution is set at 600ppi.

Open the file in Photoshop.

The illustration shows what it looks like when it is first opened in Photoshop. There are many unnecessary parts.

It can be tidied up in the following way:

Create a white layer and fill it with white. Bring it behind the line layer so that you can see the patterns when you open the file later. Use the Crop Tool (shortcut 'C') to resize the document.

The whole view of the file. You can remove these unnecessary parts in Illustrator, but it is much easier and quicker in Photoshop.

Cropping.

This is the finished image, ready to use. Save the file with the appropriate name.

The finished pattern.

181

Speech Balloons

Speech balloons are used to insert texts and functions to indicate who speaks the text. There are many different types of speech balloon, and every artist has his or her own preference. The shapes of the balloons indicate the tones of voice. In general, round speech balloons are for a normal tone, and jagged, bursting balloons are for shouting or a loud voice. Balloons with broken lines are sometimes used to indicate whispering, and square balloons are usually reserved for narrations and insertions. Moreover, you can use specially shaped balloons to indicate a certain character's voice (for example, using square balloons to represent a mechanical voice).

There are many ways to create these balloons. Most artists draw them by hand, but there are templates available, and you can create them digitally.

Creating Speech Balloons

Start Illustrator and create a new document. Then, use File > Place to import a pencil drawing.

Lock the layer and create a new layer.

Create a new layer.

This layer will store the caption. Pick the Pen Tool and make the Fill blank. Now, trace the lines that separate the page.

Drawing lines to divide the document into sections.

I draw speech balloons on a separate sheet of paper. This is how they are drawn at first.

Number the page and balloons.

Using the Type Tool, type down the page number and the balloon numbers. Make sure not to type them in the balloons or to lose the balloons. Lock the layer.

The result.

I usually use three different types of speech balloon.

Create a new layer. The speech balloons will be created on this layer. You can see in the illustration that there are several different shapes of balloon. The bottom ones with many lines are for thinking balloons. Usually this shape of balloon is used to indicate monologues, but I use them to represent thinking.

Bring back the colour mode as default by pressing 'D'. Pick the Ellipse Tool and draw an oval shape.

A pencil drawing of a speech balloon.

3

Draw an oval on top of it. When you draw, press the 'alt' key while you are drawing. This will lock the centre point of the shape. This makes drawing easier.

It is advisable to create the circles slightly larger than the pencil drawing, to make sure the balloons are large enough to hold the text.

Select the Pen Tool and draw the tail.

Adding a tail.

Choose 'Add to Shape Area' to combine multiple shapes.

Select both the tail and circle. While they are still selected, click the 'Add to Shape Area' icon in the Pathfinder palette.

This will unite the two parts into one shape.

Burst balloons are slightly different to create. Check the colour mode is the default, and press '?' to make the Fill blank.

Make the colour of Fill blank.

You need to see the line beneath when you're drawing the line. Otherwise, you can lower the opacity of the balloons' layer, or bring the pencil layer on top of the balloons' layer and make the opacity mode as 'multiply'.

Trace the line with the Pen Tool. Make sure the tail is recognizable, and that the other points will not look like tails.

Tracing the line.

When you close the line, press 'D' to bring back the colour mode to default; the inside of the balloon is now filled with black.

Bring back the colour mode to default, and the shape is filled with white.

A balloon with a complicated shape is created just like the other balloons. Create each part separately and press the 'Add to Shape Area' button to unite these shapes.

This shows a speech balloon with two oval parts.

Merging simple shapes can create a complicated shape.

This is how it looks when it's finished. The balloons with a number inside are for thinking balloons.

Finished speech balloons file.

Make the original pencil-line layer invisible, and save the file as an .ai file. I name the speech-balloon file with a page number in order to avoid confusion.

Saving the file with page numbers helps you to avoid confusion.

Open the file in Photoshop. In this demonstration, the file is named 'word 0-1-2-3-4-5-6.ai'.

Open the file in Photoshop.

Make the resolution the same as the page document, 600dpi. If successful, the document looks like this. Save the file for later use.

That's how it looks if it is successful.

Applying Thinking Balloons

Applying speech balloons are more or less the same as applying sound effects or patterns. However, you need a different technique to apply thinking balloons.

Drag the balloon on to the page. This balloon, with a number written on it, will be the base.

Drag and drop the balloon bases on the page.

Open a file. I use Monologue balloons taken from Manga Studio (I extracted the lines from the original file). Select one balloon and drag it on to the page, and move it to its destination. Transform the balloon into an appropriate shape.

Select one circle from the file.

Place over the base.

Reshape it. Pressing the 'alt' key locks the centre of the shape.

Paint the base white, and it is now ready for the text.

THAT DREAM AGAIN...

Paint the base white and that's the final result.

The Creating Process

This section demonstrates how a page is created from start to finish; in this example it is page 5 of the Sample Manga (*see* page 15).

Drafting the Story

First, you need a script. There is no definite rule on script. Some write in a screenplay format, and some write just like a novel (in

some cases these 'script novels' are published as a proper novel, especially if a famous author wrote the script).

When you have finished writing script, you start visualizing the story. Drafting is very important since this determines the overall direction of the final work. I use A4 paper folded in two to represent a double-page spread.

Nee-mu (pronounced just as 'name') of the fourth and the fifth page.

To start creating Manga, I prepared a template with grids and measurements using Illustrator. The template is also the size of paper and the printing area. For the Sample Manga, this is 220 x 280mm, and the printing area is 185 x 234mm. The printing area is also called the 'text safe area'.

Template.

Going back to the manual process, the first thing to draw is the frame. I put the template beneath the sheet of paper and consulting the draft, drew the lines using the lightbox. I use A4

Frame lines drawn.

paper so the drawings would be enlarged. When I had decided on the frame, I traced the lines with a fine tip, 0.1mm pen.

Fitting the Text

Write down the texts and speech balloons. You need to write down all the words, no matter how tiring it is, because this will determine the size of the speech balloons. Consider how large the final speech balloons would be on the finished page. In most cases, the size of the final page would not be the same as the manuscript you are drawing.

Text and speech balloons drawn.

The speech balloons on a separate sheet of paper.

As already mentioned, this Sample Manga is written on an A4 sheet of paper and needs to be enlarged to fit 220 x 280mm. This means the speech balloons must also be enlarged, just like the drawing. You might find your speech balloons are too large for the text, though this won't be a problem in this example, and I did not resize the speech balloons for the Sample Manga. However, when the final printout is smaller than your document, this problem becomes a nightmare because the original speech balloon size would be too large for the page, and if you resized them, there would be no space for the text.

Try to keep the size of speech balloons slightly larger than the size of the text blocks.

Trace the balloons on to another sheet of paper. The illustration shows the traced speech balloons (from page 0 to page 6). Those with wavy lines are 'thinking balloons'. Number each balloon to keep track of them. When you do this, do not draw

balloons that belong to a single page on more than one sheet of paper, as this will lead to confusion.

Erase the original speech balloons from the manuscript and draw pencil drawings. In the first panel I drew the sound effect on the paper to save time – most of the time I draw them on a separate piece of paper. This part is the most time-consuming but the most enjoyable.

Inserting the Drawings

These illustrations are the 'parts' sheet and 'insertion' sheets. These parts and panels are later imported on to the appropriate page.

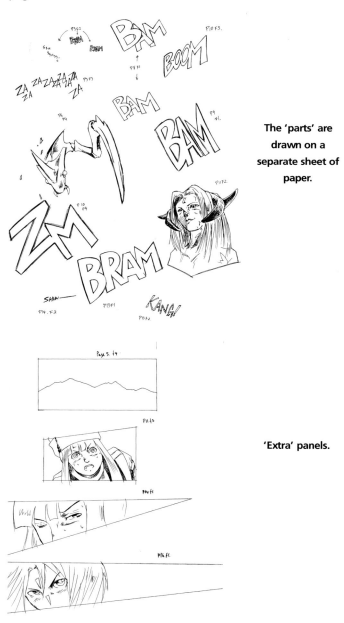

The 'parts' are drawn on a separate sheet of paper.

Pencil drawings.

'Extra' panels.

Ink the pencil drawings and erase the pencil lines. When you are inking make sure your drawings don't have openings so that you can save time when using Photoshop. The drawings in Sample Manga have a lot of cross-hatching that make the Magic Wand Tool ineffective. Therefore, I don't mind so much about the opening.

It is to be recommended that you check every time you move to the next process.

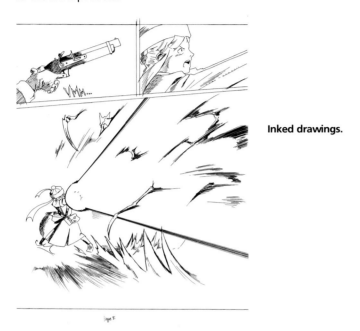

Inked drawings.

Scan the image. The mode is set as black and white, not greyscale or colour, and the resolution at 600dpi. Wipe the scanner and manuscript before scanning to reduce dust. Cleaning takes time, but the result is worthwhile.

Scanning the image.

REMOVING DUST

Even if you put maximum effort into removing dust, some small amounts will inevitably creep into the page. Save the page in Photoshop and start up Manga Studio, then create a new page as shown.

Document setting in Manga Studio. Maybe it is better to set the document size so that it is bigger than A4.

Go to File > Import > Photoshop File and you'll see a dialogue box. Click 'OK' to import the file.

Import the page file.

Go to Filter > Image Adjustments > Dust Cleaner, and remove small grains of dust. Set the size as 0.3mm. I found the default size of 0.2mm wasn't large enough to remove the dust effectively.

Using Dust Cleaner.

The setting of Dust Cleaner.

These illustrations show the 'before' and 'after' effect of applying the Dust Cleaner.

Before removing dust.

After removing dust.

Now we're finished with using Manga Studio. Export the file. The illustration shows my setting for exportation. Make sure you type the correct file name. To speed up the procedure, I recommend that you assign shortcuts for these actions, File > Shortcut Settings to assign shortcuts. My shortcuts are 'Ctrl + I' for Importing, 'Ctrl + =' for the Dust Cleaner > 'ctrl + =', and 'ctrl + \' for Exporting.

Exporting the file to Photoshop.

Go back to Photoshop to remove large grains of dust that were not removed by the Dust Cleaner. Set the zoom at 100 per cent.

When you're removing dust, don't forget the unnecessary lines and the parts that need correction. The process known as 'whiting' in Japanese is traditionally carried out using white acrylic paint and liquid paper. Using the computer has made the work easier, cleaner and quicker. Don't try removing dust and correcting lines at the same time.

Although you removed a small amount of dust, a good deal still remains.

Correcting the lines.

Lines trimmed and corrected.

Converting the Image

Convert the image to greyscale. The size ratio in the pop-up menu is set at 1.

The next thing to do is to paint the black area using the Paint Bucket Tool (shortcut 'G'). 'x' mark is a sign to indicate where to paint black.

Painting areas black.

'X' marks indicate these areas are to be painted black.

Extract the lines from the white background. Open the 'Channel' tab from the Layer Tab and drag the 'grey channel' icon to the 'Load Channel as Selection' button (the leftmost button on the bottom part of the tab). Or, while the 'grey channel' icon is selected, click the button. Now you'll see how the selection appeared around the lines.

Extract the lines.

Be aware that the selection area covers not the lines, but the area minus the lines. Go to Selection > Inverse (shortcut 'Shift + Ctrl +I') to inverse the selection.

Create a new layer. Using the Paint Bucket Tool, fill the selection in the new layer black. If it is successful, the lines are extracted on to the new layer.

Create a template for your page. Create a new page document with the size of the printing area (in this example, 185 x 234mm). Set the resolution at 600dpi, and make the mode greyscale.

Creating the template. Set the initial document size as the printing area.

Inverting the selection.

Reverse the foreground and background colours.

Expanding the canvas.

The result is this. The white part is the printing area (185 x 234mm), the black part is paper size plus bleeds (226 x 286mm).

Extracted lines.

Press 'x' to reverse the foreground and background colours. Black is now the background colour and white is the foreground colour. You can choose any colour.

Change the canvas size by going to Image > Canvas Size, and a pop-up window appears. Set the size as paper size + bleeds (usually 3mm to 6mm). Here, I added 3mm to all four sides.

Resizing the canvas resizes the canvas area without resizing the image itself. The newly created area is filled with the background colour.

Placing guides.

A template for a double-page spread.

Add the guides to the printing area. Zoom in as much as possible and place guides around the printing area.

Press 'X' again to reverse the foreground and background colours. Change the canvas size again, to enlarge the document so that you have free space around it. It is up to you how large the free space is. When it is finished, place guides around to mark the paper size.

Resizing the canvas again.

Line drawings dropped on to the page.

This is how it looks. When it's done, go to Edit > Fill to fill the entire canvas with white. Save the file as the template.

The resulting image.

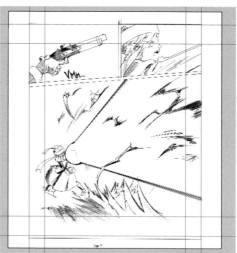

Line drawings enlarged to fit the page.

The illustration shows a template for the double-page spread. The centre column shows the border of the printing area. Try to

avoid putting texts and important figures within the column.

Open the template and image file. Drag the extracted lines on to the template. As you can see in the illustration, the drawings are smaller than the template.

Enlarge it to fit the size.

Drawing the Frames

The next thing to do is to draw the frames.

Create a new layer and name it appropriately. Using the brush tool, trace the frame lines. I usually use a 13pt round brush for this, but this time I used a 19pt one. Close the end of the frames outside the page.

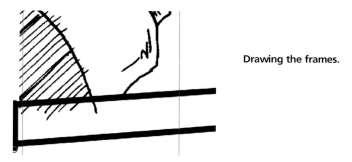

Drawing the frames.

Make the line layer invisible by clicking the eye icon, then erase the unnecessary frames.

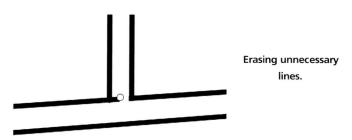

Erasing unnecessary lines.

When finished, fill the inside of the frames with the white using the Paint Bucket Tool.

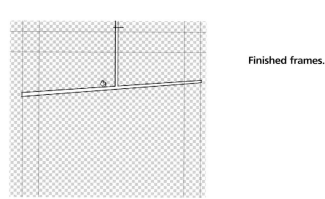

Finished frames.

Add extra parts – in this case, sound effects. To do this, refer to the 'Sound effect' part of the previous section.

Applying Tones

Tones can now be applied; I usually create a tone layer just above the background layer. This is to prevent accidentally merging the tone layer with another important layer beneath. I separate the tone and background layers, but it's perfectly all right to merge them. Refer to the 'applying tones' section above (*see* page 171).

When applying tones, it often happens that a part of the tones goes out of the document, as is shown in the illustration. Although it is not visible, these parts still exist and increase the size of the data. If you find some documents' file size is unnaturally large, these invisible parts are most likely the cause.

To remove these parts, pick the Crop Tool (shortcut 'C'). Zoom out to show the entire document, and the grey section that surrounds it. Click and drag outside the document, and the crop area will automatically be resized to the document size. Crop it, and the invisible parts outside the document will be deleted.

Now finish applying tones and special effects. The next thing is to add the white part. In this example, white is used to create a shining effect.

Tones and effects applied.

Adding Speech Balloons

Speech balloons can now be added. Open the file with the speech balloons and make sure the resolution of the file is the same as the page file. When an image is imported on to another page, it is resized according to the document resolution. For example, if you import an image that is 300ppi on to a file that is 600ppi, the image will shrink to a quarter of the original size.

Select the Lasso Tool (shortcut 'L') and draw a line around the balloon.

Then pick the Move Tool (shortcut 'V') to drag and drop the balloon on to the page and move it to the desired place.

Bring the layer with the balloon on top of the layer stack, and name it. I usually name the speech balloon file as 'words'.

The speech balloons layer opened.

The speech balloon placed on the page.

Applying text.

Although the text was fine as it was, I changed
the shape of the text. In order to do this, you first need
to rasterize the text.

Putting in the Text

If you're using a Word document for the script, you can copy and paste the texts on to the page. Then fine-tune the types.

Unlike the UK and American comics (and translated Manga), Manga uses various typefaces to create a drama. When a character is shouting, a thick and bold typeface is used. A weak voice is created by a typeface with thin lines. Quite often it will be used to indicate a characteristic voice (a digital voice, for example).

Now the page is almost done. Save the file and create a new folder that will store the finished files for printing.

The illustration shows how the layers are organized.

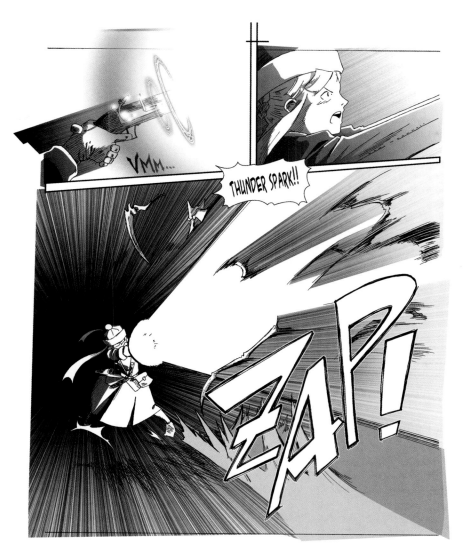

The page is almost finished.

The layers.

Rationalizing the Pages

The next thing to do is to trim and convert the pages into a black-and-white image.

First, flatten the page. To do this, click the arrow icon just under the close icon in the Layer Palette. Choose the Flatten Image option to flatten the layers into one single layer. Pick the Crop Tool and crop the file into the right page size.

Some publishers might want you to keep the words and images separate. In this case, make the text layers invisible and choose the Merge Visible Option, or put in words after flattening the page.

You may have finished creating the page but some publishers

LEFT: **Cropping the page. It is much faster to crop after merging the layers.**

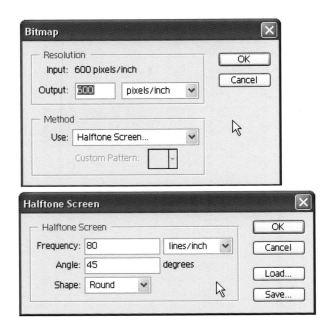

The pop-up menus of converting the image to a bitmap image.

The detail of the bitmapped image.

want the image as black and white, not as greyscale. Go to Image > Mode > Bitmap. Select the mode as Halftone Screen and output resolution as 600dpi. The frequency can be set as you wish. I chose 80dpi.

The result. The grey tone is now converted into a black-and-white bitmap image.

OPPOSITE: **The finished page.**

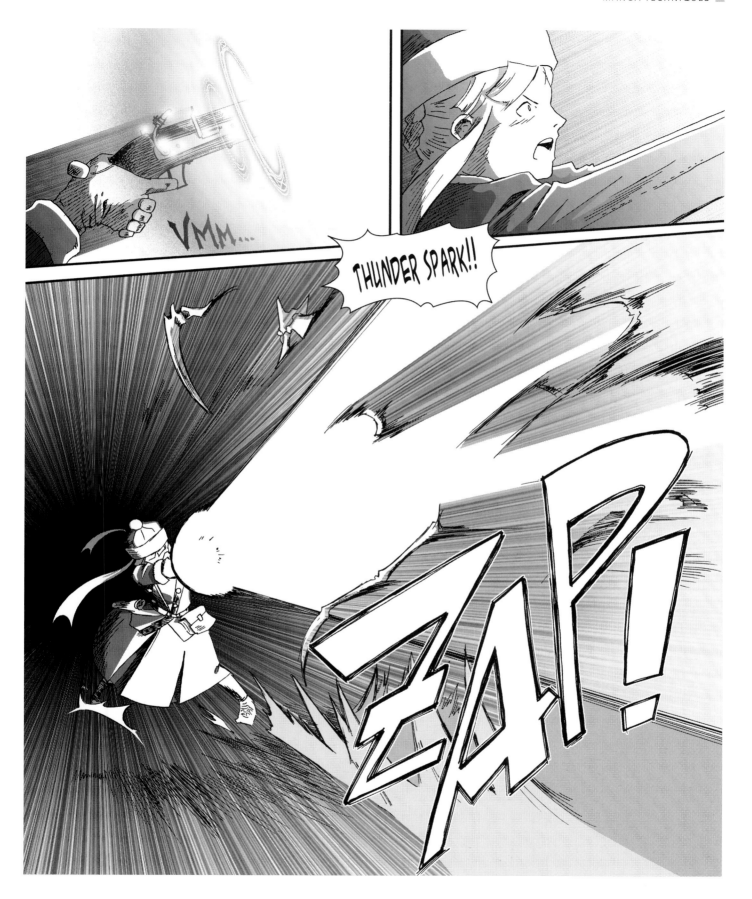

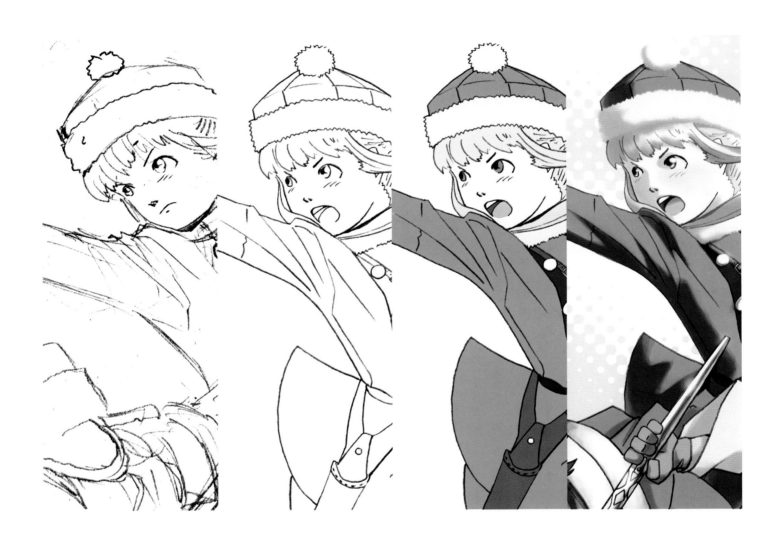

COLOURING

What we know as Manga-style colouring was developed from Anime and games. The style has now been accepted into various media because it works well with digital tools such as Photoshop and Illustrator.

At first glance, digital and manual colourings look completely different. However, their principles are basically the same, and the differences mostly relate to the media. Nevertheless digital colouring is quicker, cleaner, more forgiving and requires less space; what's more, you don't have to worry about quality loss when converting it to a digitalized format. On the other hand, digital colouring is limited by the power of your computer and its programs.

Manual colouring gives you better feedback and frees you from most digital troubles, but it is time-consuming and requires space. You have to prepare many tools and paints, and it is basically unforgiving. You also have to bear the quality loss when converting your work into digital media. I was taught that scanning an image would reduce its quality to around 70 per cent.

It is important that you weigh up the pros and cons of digital and manual colouring before you decide on a medium. Although this chapter explains how to colour on computer, you can also adapt the files to manual colouring.

The program used in this chapter is Photoshop; Painter and SAI are the other programs popular in Japan. I only use a mouse; however, with a tablet you can draw a wider variety of lines with more control – although there's no rule to say that you need to have one in order to create a good image. This is up to your skills and imagination.

Basic Knowledge

The process of creating colouring is more or less the same as creating Manga in black and white. Scan hand-drawn lines on to the computer and extract the lines (of course you can create everything on a computer, from the rough drawing). Colour layers are stuck beneath the line. And at the top of all layers comes the highlight. In other words, digital colouring is similar to oil and acrylic painting.

The most important aspect of digital colouring is how to organize the layers: creating and organizing the layers can determine the final image. A well organized layer helps you to colour effectively and quickly while keeping the file size small.

Generally speaking, a single figure is made up of twenty to forty layers, and one image is usually several hundred megabytes. If you were drawing a complex image, it would go over a gigabyte, with more than 200 layers. Therefore be careful when creating layers, and think how they overlap and stick.

Anime-e

In the UK most people would associate a coloured Manga and Anime image with blocks of solid colour. This style of colouring is called Anime-e (Anime painting). This is developed in the Anime industry for fast production and ease of animation. Most Anime has twenty-four to thirty frames per second, which means that a 26min episode requires 37,440–46,800 images. This technique is then adapted for more subtle images and is widely used for games. The title image of the Sample Manga and the illustration for the 'Fantasy' section in the first chapter are examples of Anime-e.

My style is something of an amalgamation of both Anime-e and a traditional colouring style: I am trying to express traditional painting tastes in a flat colour block of Anime-e.

Shadow 1, Shadow 2 and Highlight

To paint in an Anime style, 'shadow 1' and 'shadow 2' are the terms you need to know. Most people recognize that an Anime-e is made up of several blocks of colour. These blocks of colour are not laid out randomly, but in the following way:

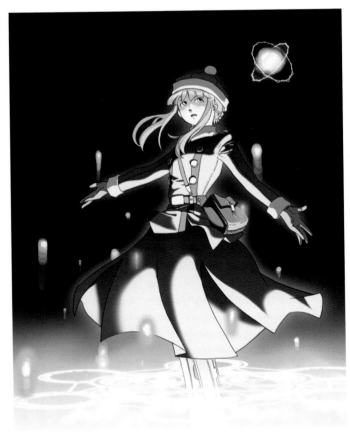

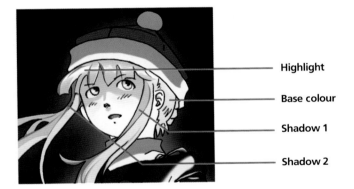

A detail of Anime-e, showing four elements: highlight, base, shadow 1 and shadow 2.

A sample of Anime-e. Anime-e is suited to creating a clean, flat colouring on a computer. With the aid of a computer, it can have effects that are impossible to achieve in hand-painted images. The major drawback of Anime-e is its flatness; many artists develop their own techniques to overcome this.

- Every part has a base colour.
- Shadow 1 is placed on top of it. This is used to create a sense of three-dimensional objects.
- Shadow 2 is a polar opposite of highlight and creates depth to the shadow. This is also used to depict a shadow cast by another object. Most Anime uses only shadow 1 for this purpose.
- Highlight adds a sense of light. You can create a shining and glowing effect.

These four elements – highlight, base colour, shadow 1 and shadow 2 – are what create a coloured image.

Shadows

A shadow is dark. When I see the works of many artists, I feel that quite a lot of them think like that and are satisfied by simply

Shadows can be rich in colour and light. This illustration demonstrates the reflection of light and bluish colour in the shadow.

painting shadows in black. In my opinion, however, this is a wrong conception, because a shadow is rich in colour, and sometimes even glowing. I believe that a shadow has a more complex colour scheme than the bright areas.

A dark shadow depresses the image and removes the liveliness from a picture.

Colouring Illustration

Every artist has their own methods and develops them to suit their own style and tools. Some artists create layers first and place colours on top of them; others create line drawings by hand and scan them to use them for colouring; yet others create their work entirely on a computer. However, the basic process remains the same. Create the line drawing, then layer and place the base colour, and paint and fine-tune the image to finish.

The important thing is to spend time creating the foundation before actually decorating your house.

A Coloured Image Step-By-Step

The program used for this process is Photoshop.

Creating Rough Drawings

First of all you need to create rough drawings. You don't have to create very detailed drawings (although this does help), they just have to be enough to make it clear how the compositions are laid out. It's a good idea to jot down a few notes (especially if you are planning to add effects that are impossible to depict

Cover illustration for this book.

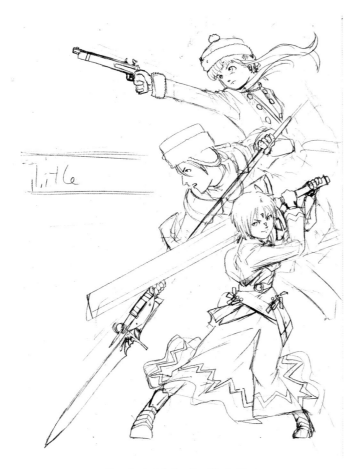

Rough sketch for the illustration.

by pencil lines). I drew several roughs before deciding on the final composition.

Draw pencil drawings and trace the lines on another sheet of paper using the lightbox. Before you finish, check the traced lines for missing parts and gaps. I drew the three figures on sep-

arate sheets of paper. Drawing figures (and part of an image) on a separate sheet of paper helps to fine-tune the composition. Also, if you are drawing the figures overlapping each other, drawing individual figures on different sheets of paper prevents missing parts.

Scanning the Drawings

Next you scan the drawings. The resolution is set to 600dpi with the greyscale mode. The reason for scanning with grey tone is to import the texture of the line.

Scanning in greyscale mode also picks up the texture of the paper. As they are, the lines are too pale for use: to remove grey parts and darken the lines, go to Image > Adjustment > Levels (shortcut 'Ctrl + L'), and slide the scale to tweak the drawings.

Save the file when you're satisfied.

Scanning the drawings.

Cleaned-up line drawing of Cyl. The three figures are drawn separately. When you draw a figure, try drawing larger than the final illustration would be.

When scanned, there are many grey parts that need to be erased.

Using the Level option is useful for removing these grey parts and tightening up the greyness of the lines.

Use the Lasso Tool to erase dust in large white areas.

You don't have to be exact to erase all the white area with the Lasso Tool.

Unfortunately you can't use Manga Studio this time to remove tiny grains of dust, you have to do it by hand. Check that the colour setting is the default (black for foreground and white for background), or press 'D' to restore it.

Pick Lasso Tool (shortcut 'L') and create a selection around the line. Because you're going to remove the dust by hand later, you don't have to create the selection precisely, just cover a large chunk of white space. Press the backspace key to erase the selected area. The erased area is filled with background colour automatically.

Zoom in. I zoom to 200 per cent, but 100 per cent or even 50 per cent is fine. Use the Erase Tool (shortcut 'E') to remove dust and unnecessary lines. Although it is tempting to correct the lines, try not to do so too much: these corrected lines tend to look artificial and tasteless. You can also over-erase the lines and end up ruining the whole drawing.

Erasing the dust and correcting the lines.

Extracting the Lines

Next, extract the lines. The procedure is the same as when extracting the lines for the Manga page. Although you don't really need to extract the lines when creating black and white Manga, this time you will have to extract them, otherwise you can't colour the line later on.

Press the 'Load Channels as Selection' button in Layer Palette. Create a layer, invert the selection and fill the line with black. Be careful that once you have extracted the line, you cannot change the contrast and darkness of the lines.

Repeat the same process for the other drawings.

Open the files and template. The template used here is the same as Manga, with inner guides removed. Refer to the previous chapter on how to create a template.

Extracted lines. It is essential to extract the lines for colouring.

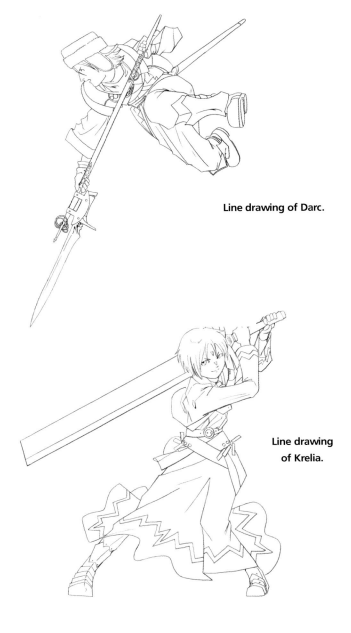

Line drawing of Darc.

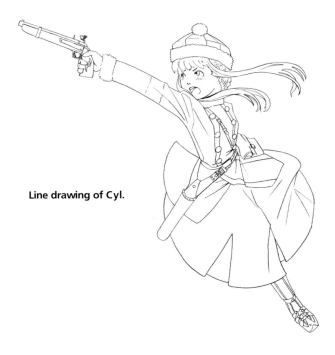

Line drawing of Cyl.

Line drawing of Krelia.

Drop the lines on to the template. The final image would be in CMYK colour, but at this stage, set the mode as RGB. An RGB file has smaller data size than CMYK and is lighter on the computer. Compose the image.

Managing the Layers and the Line Drawings

There are two ways to manage the layers and the line drawings. One is to erase the lines that go behind the figures and merge them into one single layer. The other is to keep the layers as they are. The first method is quicker, needs fewer layers and has a smaller file size. The latter requires more complicated layer

orders, is time-consuming and has a large file size, but you can change the composition at any time.

Creating a Layer Set makes your work a lot easier when working on a complex image.

Three drawings dropped on to the template.

Composed drawings.

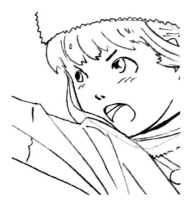

Create a base colour layer with the Pen Tool. You can also use other image-making techniques to create base layers, but I find this method is the fastest and the most accurate.

Click the 'Create a New Set' button in the Layer Palette to create a folder. Drag the lines on to the appropriately named folders. By doing this, you can distinguish which layer belongs to which figure.

Pick the Pen Tool (shortcut 'P') and referring to the colour sample, create the base colour layers.

When creating the layers, do it from the bottom in the layer order. In general, the layer that comes to the bottom is the skin layer. The area of the lower layer should extend beneath the other layers. For example, the skin layer's area extends under the hair and eyes layers to prevent the gap opening at the border.

At the same time you have to think about how to paint when laying the base colour area. For example, with Cyl's skirt and clothes, all are the same colour, and are organized into several separate layers.

Check the composition and colours again. The impression changes a great deal before and after the base colours are placed. The base colours, although they don't have the shadows and tints of the final image, give you a general impression of it.

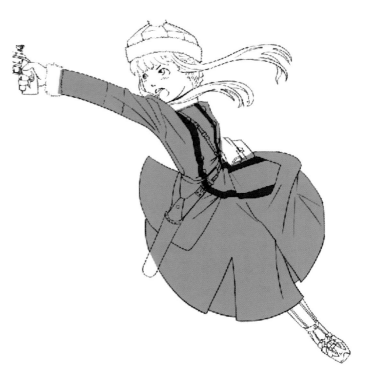

Cyl's jacket and skirt. This looks as if they are in one single layer.

Base colours are laid out. You can change the colour at any time so you don't need to be too exact when setting the base colours.

This is how the layers are laid out. Creating many layers with the same colour, as in this illustration, often leads you to forget, or to misplace some of the layers. To prevent this, you can create layers with different colours (just as in this illustration) and fill them with the base colour later.

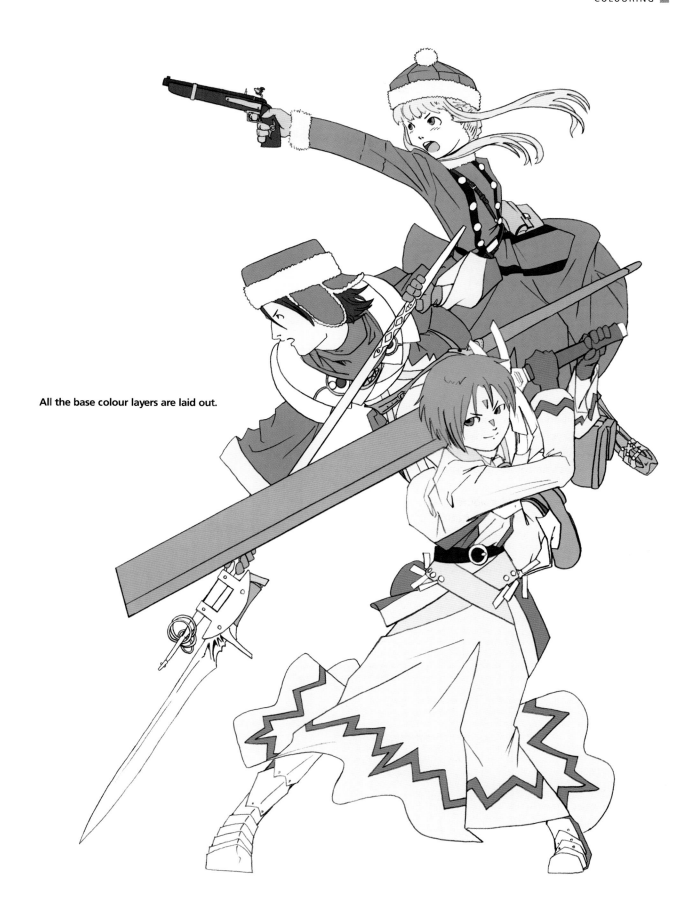

All the base colour layers are laid out.

Creating a layer with strong colours beneath the layers allows you to check the gaps.

If you are placing more than one figure, their colours might crush each other; if this happens, re-compose the image or change the colouring.

Create a layer with strong colours underneath, and check if there are any gaps between the layers.

As you check the colouring, create the background. I was thinking to make the background blank, so that there is not much change to the image. However, in most cases, the background image takes more time and effort than the main figure itself. Creating the background in another document can save time and the file size, but this method often discoordinates the figures and background. Choose what method suits you best before starting the process.

Now all the preparations are finished.

Most people create a colour palette when they are colouring. However, I often forget to switch the active layer, and then paint on the palette layer, so I no longer use it. Nevertheless, creating a palette is a good way to keep the image consistent.

Lock the transparent area of all layers by clicking on the 'Lock Transparent Pixels' button. This button prevents you from working on the areas that have no colour (image). In other words, you can now work only on the image area in this layer.

There is another method you can use to achieve the same result. Create a new layer and go to Layer > Group with Previous (shortcut 'ctrl + G') to group the active layer with the layer immediately below. The sub-layer's image is seen only when it overlaps with the mother layer. Grouping layers enables

This shows a grouped layer. A sub-layer 'Layer 2' is grouped with the 'skin' layer. Be careful that you group with only the layer immediately below the active layer.

Lock the transparency of the layer.

This shows how the grouping works. The illustration shows two layers. A layer with an orange mark is placed on top of the green layer.

This is how it looks when the orange layer is grouped with the green layer. The sub-layer (orange) can be shown only where it overlaps with the mother layer (green).

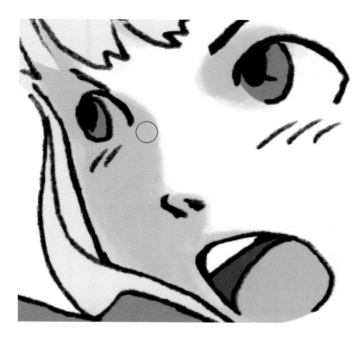

Painting with the Brush Tool.

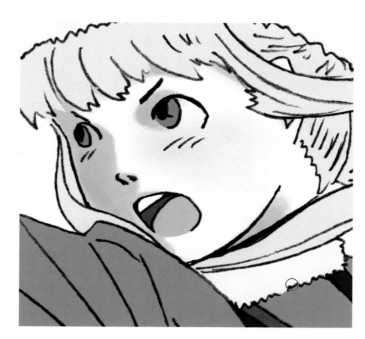

Adding red to the cheek. When adding a hint of colour, check it thoroughly to prevent over-painting. Over-painting often happens when you are working on the computer.

you to keep the base layer intact when painting shadows and other elements, and to store them in separate layers for later editing.

I recommend this when you don't need to worry about the file size. Also you can use it to create various colour variations out of one single master file.

THE BASE LAYER

Pick the base colour and shadow colour, and colour the base layer. I use a round brush with 20 per cent opacity. Brush the colour over and over to paint. Repeating colouring with low opacity gives you more control over the blending than a soft brush. I find it better to think that shadows are there to give a sense of volume rather than actual shadows. Therefore, if you feel that your shadowing is odd, you should change it no matter how physically correct it is.

When creating a tint, be careful not to over-paint and keep the consistency of the colour.

Adding details comes last. Here, I painted white on the eyes and lips.

Fine-tuning the Image

Add details and highlights. With this last comes the fine-tuning of the image, such as colour adjustment, and tweaking the colour curve. The whole procedure is virtually the same for all media, whether digital or manual.

Adding shadows to the hair.

Brighten up the tips of the hair. This lightens the hair.

PAINTING HAIR

Hair can be painted in many different ways. I usually try to depict the overall volume of the head rather than individual strokes of hair. The location to paint shadow 1 is just under where the highlight would be. Paint a shadow with lighter colour to brighten the impression and give a sense of light.

The highlight is painted and smudged with the Smudge Tool (shortcut 'R'). Spatter brush best suits this purpose. Retouch the shadow and check the overall image.

PAINTING DIFFERENT MATERIALS

Different materials need to be painted in different ways. Shiny materials such as silk and plastic have a strong contrast between base and shadow colours, and create a bright reflection of light. On the other hand, matte materials, such as wool and cotton, have less contrast of base and shadow colours and reflection.

Smudge the highlight to depict the flow of hair.

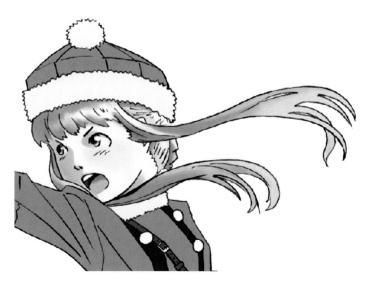

Finished hair. It is always hard to find out how much and where you should paint shadows and highlights.

The contrast of colours and reflections is more important than texture in distinguishing the material and overall impression. Cyl's sling is made of leather, with no reflection, and there is only a weak contrast of base and shadow.

Using Smudge Tool creates hair or fur. Along with the Spatter brush, the Smudge Tool is best suited to creating hair.

Her belts are made of the same leather. However, they are shiny and there is a strong contrast of colours.

Paint shadows.

The bag is made of canvas and leather. The leather parts are made deliberately shiny to create a contrast between the two materials.

Smudge the shadow.

PAINTING FUR

To create fur, unlock the transparent pixels of the layer. Make the line layer invisible and using Smudge Tool, draw the hairs.
Lock the transparency again, and paint the shadow and then smudge it again.

You can first paint the shadow while the transparency is locked and smudge the base and shadow at once. However, this method does not have as good a control as the first method over the shadow and shape.

Finished fur.

Buttons, before adding highlights.

Underpainting creates texture and a subtle hint of colour. This shows Darc's shoulder guards under paint.

After highlights are applied. The highlight works best when hiding lines.

Finished shoulder guards.

PAINTING HIGHLIGHTS

Highlights are usually painted on the layer created on the top of the layer stack. This works really well to create the sense of light, but try not to overuse it.

PAINTING TEXTURE

Underpainting is a good way to create a texture. With the choice of underpaint, you can create a surprisingly good effect.

If you feel the image looks flat, add whiter colour to the base. The illustration shows Krelia's face: I have added whiter colour to it, because in general, a face looks better if the forehead, nose and upper cheeks are whiter.

I wanted Krelia's blade transparent, like glass. I flattened Darc's layers and copied it on to the page, then placed the image and

Krelia's face with whiter paint is applied to depict the contours of her face. Although it is very hard to see, these whiter parts create the sense of a three-dimensional figure.

Copy of Darc's image, placed on to Krelia's figure. The opacity mode is 'Multiply'.

This is what remained of the copied Darc.

Change the opacity mode to Overlay.

erased the parts that didn't overlap with the blade. The location of the new layer is on top of the blade layer.

Set the opacity mode as Overlay.

Pick Eraser Tool (shortcut 'E'), select a soft brush and set the opacity at 20–30 per cent. Erase the new area to look like the part that is actually behind the blade.

Finishing Off

The colouring is now finished, yet there is still a great deal to do before finishing the whole document. I felt the area where the three figures overlapped looked too flat and had no sense of depth; however, placing purple on Cyl and Darc's figures pushed them back.

Colour the lines to finish the work. Lock the transparent pixels of the line layers. Pick dark brown as a colour, and go to Edit > Fill to colour the line.

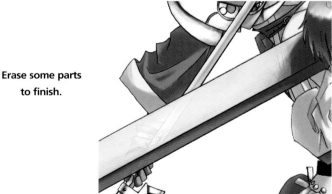

Erase some parts to finish.

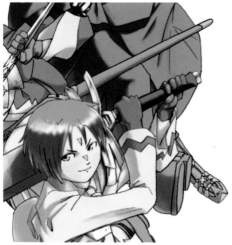

The part where three figures overlap. There is no sense of depth, and all three figures seem to collide in the air.

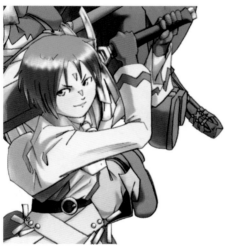

Adding a dark colour (in this case, purple) helps to create depth by pushing back the applied area. This is on the same principle of using tones to push back an area.

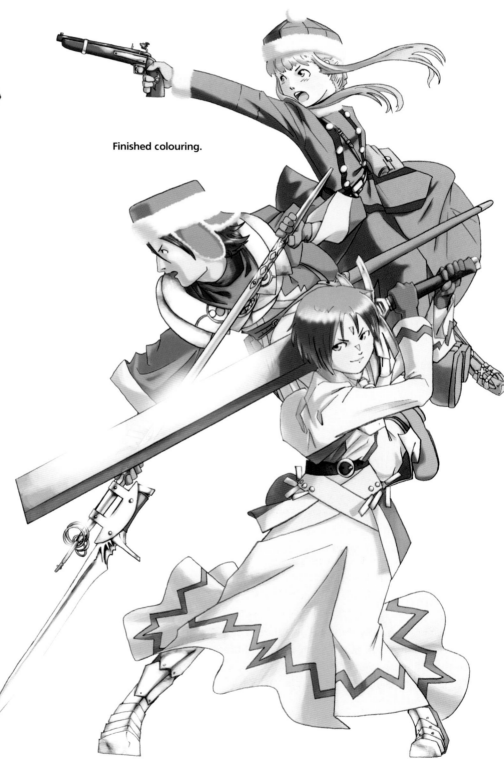

Finished colouring.

Coloured lines.

Mode changed to Multiply.

Painting lines. This shows that lines on cheeks have been painted.

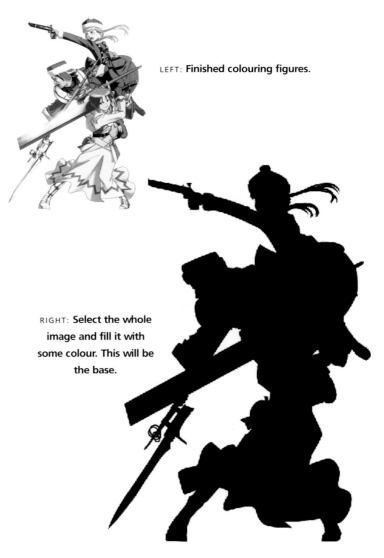

LEFT: **Finished colouring figures.**

RIGHT: **Select the whole image and fill it with some colour. This will be the base.**

Change the opacity mode to Multiply to blend the lines to coloured layers underneath.

Fine-tune the colour of the lines for better results. Switch to Brush Tool and set the opacity as 100 per cent. Paint over the part you want to be a different colour for the lines.

Adding a Background

I was initially planning to finish with creating the image, but when it was done, it looked too plain without a background, so I decided to add one.

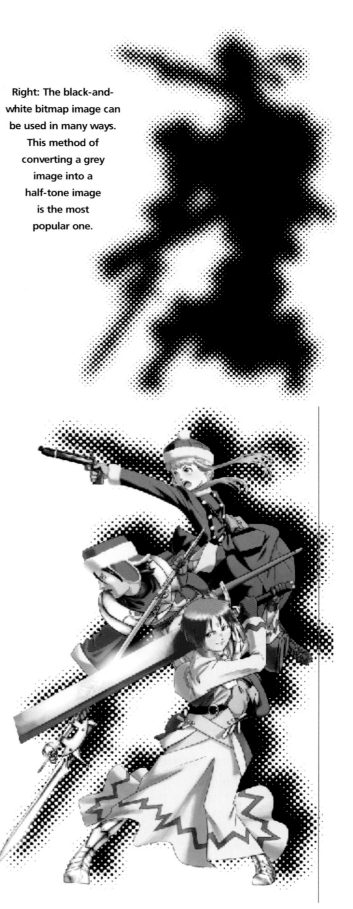

Right: The black-and-white bitmap image can be used in many ways. This method of converting a grey image into a half-tone image is the most popular one.

ABOVE: **Playing with the position of the shadow. The top left-hand side is the one I chose for the final illustration. The bottom left one was another candidate for the final illustration, but the position of the shadow seems to unbalance the whole image. The two images on the right-hand side look as if the figures are floating.**

RIGHT: **Bitmap shadow placed on to the document.**

Click on all the layer icons in Layer Palette while pressing down 'Ctrl + shift' to select the whole image area. Fill in the selection in the new layer. The colour can be anything, but black or white is a better choice. These colours don't have any hue so you don't have to think about how the colour would behave when a new opacity mode is applied.

Duplicate the layer and keep the original as a spare. I moved the duplicated area to check the impression.

Drag the background image on to another document for manipulation. Here the image is expanded and blurred. It is then converted to a half-tone bitmap image.

Drop the image on to the first document.

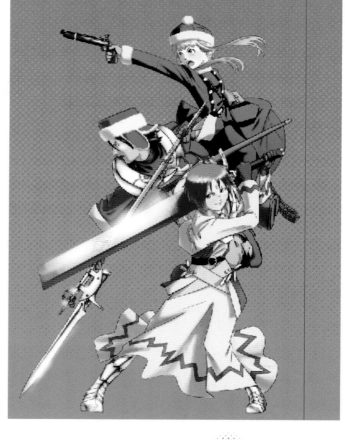

ABOVE: **Dot gradation.**

ABOVE RIGHT: **Place the gradation image on to the main document.**

RIGHT: **Change the opacity mode to 'Screen' and the layer
can only be seen where the images of the layers are underneath.
Using black as the layer underneath keeps the layer's
colour unchanged.**

Creating Tone Gradation

Create a black gradation and convert it to a half-tone bitmap
image. Extract the image and fill it with the desired colour. Fill a
new layer for the base, and merge two layers into one.
Drop the image on to the layer and set the opacity mode as
Screen; selecting Lighten or Line Dodge mode produces a simi-
lar result. Move the colour layer to check no moiré is created,
and tweak the colours.

I found the colour and the dot gradation weren't right. I
played with the colours until I picked the right one. For the final
colour, I chose pale blue and pink. When applied, I used the
Brush Tool to paint some places to fit into the main images.

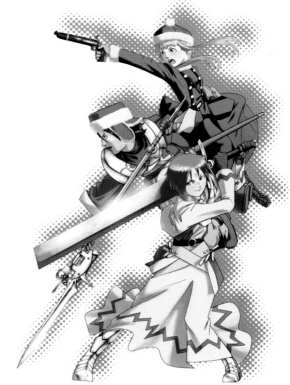

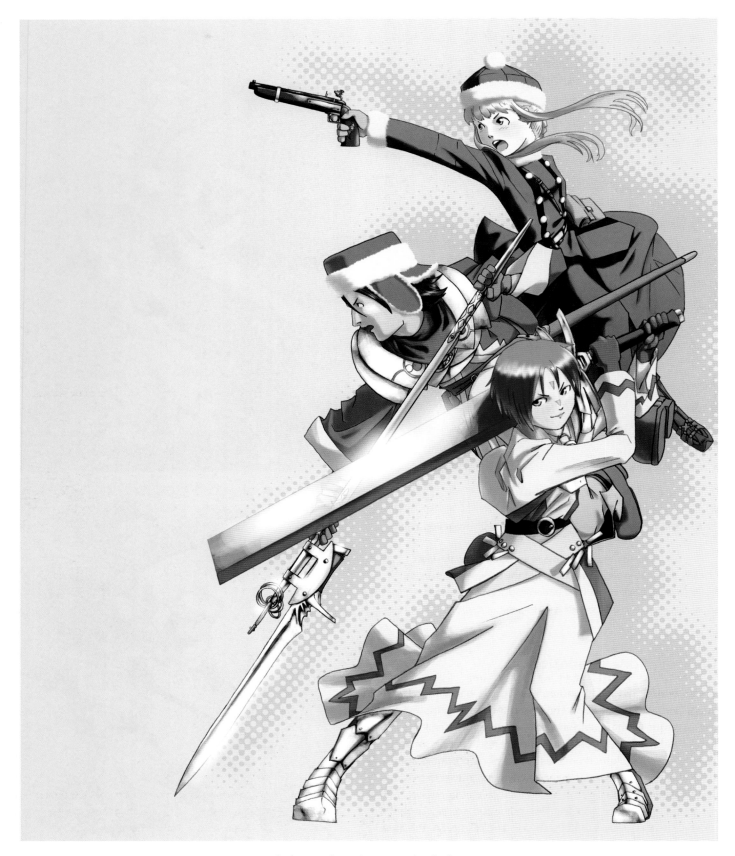

Placing another colour on to the shadow.

The dots on Darc's sleeve look detached and need to be erased.

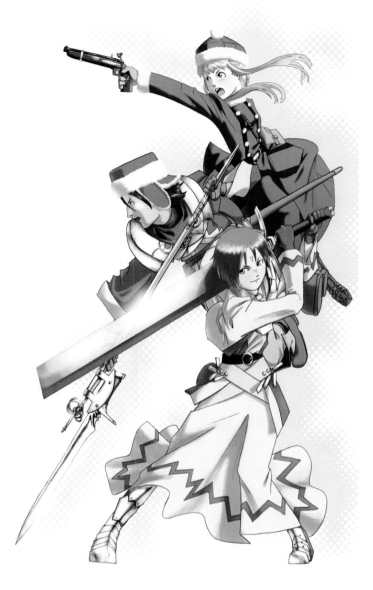

The new colours applied on to the shadow.

Dots erased. You can leave them as they were, but if you have enough time to fine-tune the image, correcting these small points improves the final outcome.

Check the image and apply any finishing touches. Here, there are some dots over Darc's sleeve. These dots look detached from the other part of the image and need to be erased.

Check the image again and save the file. The example's background is quite simple but in most cases, the background is more time-consuming than the main figure itself.

The next day I checked the image again, and felt it was too light. Placing a strong colour at the bottom would help tighten it up. I picked the Rectangular Tool (shortcut 'U') and added a red line on the bottom. This line works as a solid ground for the figures and tightens up the image.

I recommend that you check the image you created a few

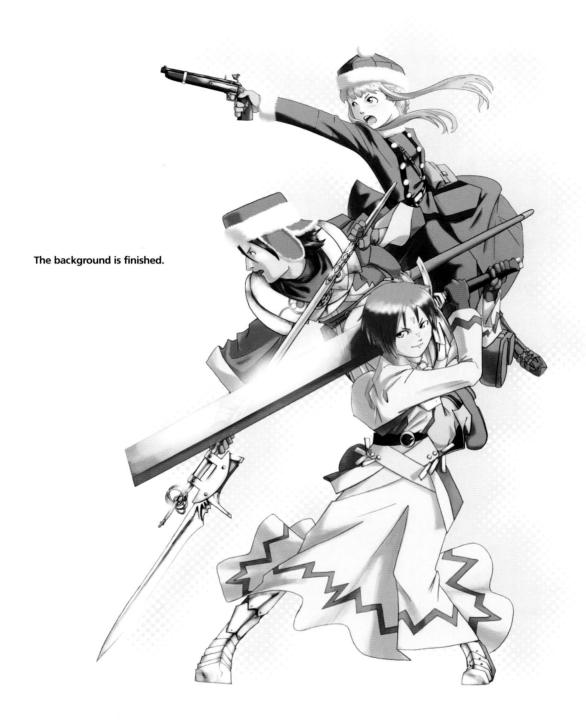

The background is finished.

days after you have finished it. Time cools your head and you can see the image with calmer eyes.

Save the file and flatten all the layers. Crop the image at the guides, and change the colour mode as CMYK. Save the file under another name to finish.

The layers of this illustration are:

Background:	7 layers (3 layers visible)
Cyl:	38 layers
Darc:	42 layers
Krelia:	29 layers
Total:	115 layers

This is slightly below the average for three figures. If the image has a complicated background, it might go up to 150–180 layers. The file size is 693.9 megabytes in RGB mode.

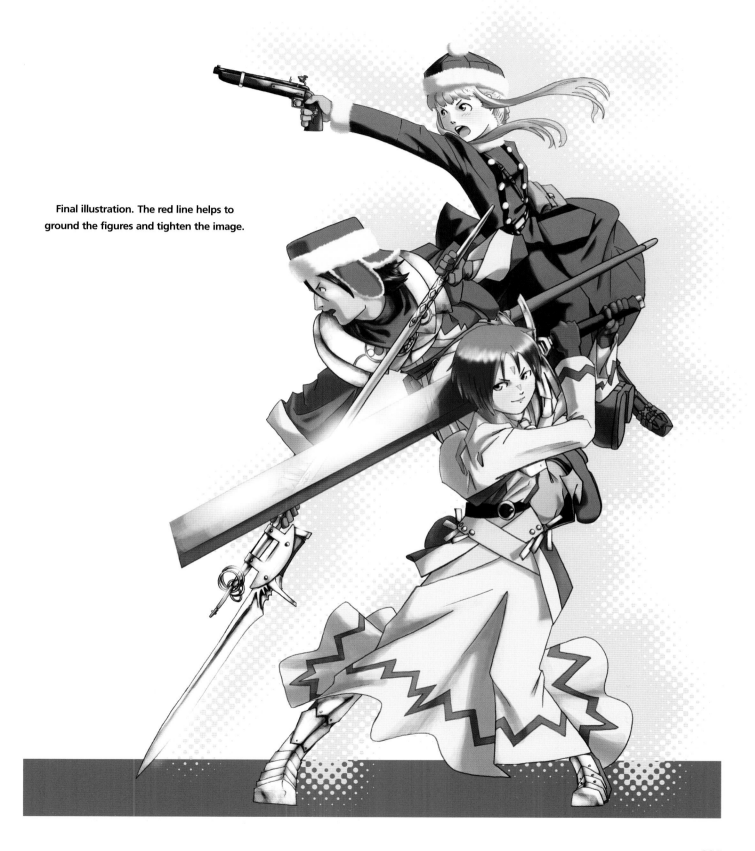

Final illustration. The red line helps to
ground the figures and tighten the image.

REFERENCES

Manga

JoJo's Bizarre Adventure – Manga by Hirohiko Araki, originally published by Shueisha in Japan in 1987, and later in English by Viz Media. Also available as a series of DVDs. It features unique sound effects, costume designs and postures inspired by avant-garde fashion.

Manga Shakespeare series – the abridged original text of Shakespeare, presented in Manga format, published in the UK by SelfMadeHero, and in the USA by Amulet Books. The series includes the author's *Othello*.

Ghost in the Shell – a series of Manga created by Masamune Shirou, and first published in *Young Magazine* (Kodansha Ltd). The series has been adapted into anime films and video games. This series also inspired the *Matrix* series of films.

Negima! – Manga and anime series by Ken Akamatsu, published in Japan by Kodansha and in English by Del Ray Manga. The series is directly inspired by the Harry Potter books and films.

Computer Programs

Adobe Illustrator (www.adobe.com) – a computer program that specializes in creating and editing a vector image (an image that is created by mathematical equations). This is very useful when creating patterns and lines.

Adobe Photoshop (www.adobe.com) – the most popular image-editing computer program in the world. This program works the best with pixelated images.

LightWave 3D (www.newtek.com) – a program that creates and renders 3D computer graphics. Ken Akamatsu uses this to create background images for his Manga, *Negima!*

Manga Studio (www.my.smithmicro.com) – a computer program created by Celsys (the Japanese name of the program is, interestingly, Comic Studio). This program does everything you need to create Manga on computer and creates the most beautiful line with tablets. The major drawback of this program is it does not manage coloured images well.

INDEX